DATE DUE

NOV 1 3 2000			
JAN 2 5 2001			

Demco

PRINTS OF NEW ENGLAND

Prints of New England

Edited by Georgia Brady Barnhill

WORCESTER

AMERICAN ANTIQUARIAN SOCIETY

1991

Proceedings of a conference held by
the American Antiquarian Society and the Worcester Art Museum,
May 14 and 15, 1976

LIBRARY OF CONGRESS CATALOGING-IN-PUBLICATION
DATA

Prints of New England.

Includes index.
Contents: James Turner, silversmith-engraver / Martha
Gandy Fales—William Bentley / Stefanie Munsing Winkel-
bauer—Effigies curiously engraven / Wendy Wick Reaves—
[etc.]
1. Prints, American—New England. 2. Prints—18th cen-
tury—New England. 3. Prints—19th century—New England.
I. Barnhill, Georgia Brady (Georgia Brady), 1944– . II.
American Antiquarian Society.
NE510.P74 1991 769.974 87–1019
ISBN 0–912296–92–5

The paper used in this publication meets the minimum requirements of American National
Standard for Information Sciences—Permanence of Paper for Printed Library Materials,
ANSI z39.48–1984.

Printed in the United States of America

CONTENTS

Prints of New England was a logical theme for the American Antiquarian Society (AAS) to offer for a conference on American prints held on May 14 and 15 in 1976. The Worcester Art Museum joined the Society in this endeavor, providing gallery space for a joint exhibition and facilities for the lectures. The theme of the conference was sufficiently broad to include research on New England printmakers and prints about New England. The subjects of the papers given at this conference demonstrate this diversity, which in turn reflects the history of New England, the history of the graphic arts in the region, and the collections of the American Antiquarian Society.

The Society's founder, Isaiah Thomas, held prints in his own collection at the time he founded AAS in 1812. The bequest of the Reverend Mr. William Bentley of Salem in 1819 added many important eighteenth-century portrait prints to the collection. Since then, the collection has continued to grow by gift, bequest, and purchase, and includes American prints of all kinds dating from the colonial era through 1876. The Worcester Art Museum acquired the Charles E. Goodspeed Collection in 1910 and the following years. Numbering approximately 3,653 items, it is a smaller collection than that of the Society, but it contains many rare American prints of the eighteenth and early nineteenth centuries. Fortuitously, the two collections complement each other with few duplicates between them.

One of the privileges of a conference organizer is to invite one's colleagues to present the fruits of their research. Martha Gandy Fales had been working on the relationship between New England silversmiths and engravers for some time, and she had presented a paper on heraldic engraving at the conference on colonial Boston prints that was hosted by the Colonial Society of Massachusetts in 1971. Because Stefanie Munsing Winkelbauer had conducted research on William Bentley of Salem for her master's degree through the Henry Francis Du Pont Winterthur Museum, convincing her to take on the task of writing about William Bentley's collection of prints was easy. Since Bentley's collection came to the Society in 1819, Ms. Winkelbauer's essay is, in essence, a chapter in the early history of the Society's print collection. Wendy Wick Reaves attended her first print conference in 1974 at Colonial Williamsburg, just as she was embarking on her career as print curator at the National Portrait Gallery. She soon started compiling research materials on eighteenth-century American portrait prints and prepared a lecture based on that research for the conference. Although she has not published this large body of material, it remains a useful and well-organized research tool. David Tatham had long been a regular researcher at AAS, but I knew little of his hobby—climbing in the White Mountains—until the conference, when he presented his paper on Franklin Leavitt, a cartographer, folk artist, and would-be poet. Perhaps it was his paper that awakened my own latent interest in the White Mountains. A year after the conference I began

making my own plans to tread in the footsteps of Franklin Leavitt and David Tatham. Marcus McCorison, director and librarian of AAS, thought a paper on textile printing would diversify the conference. This subject is of interest to the Society since we have in the graphic arts department a growing collection of broadsides, maps, prints, and newspaper issues printed on fabrics. Jane Kaufmann presented a broad overview of the textile industry but was not able to find any secrets to explain whether there are any differences between traditional textile printing, that is, printing of fabrics to be used as furnishings or clothing, and the printing of texts on silk or linen. Jay Cantor presented a paper on landscape prints of New England that was related to his research at Old Sturbridge Village on images of the New England landscape. He focused particularly on James Kidder, a landscape artist, engraver, and lithographer of Boston. Unfortunately Mr. Cantor was unable to revise his lecture for this volume. Marcus McCorison's own contribution to the conference described the publication of the illustrations that were included in the first volume published by the Society in 1820. I can only say, that despite my own snail's pace on the publication of this volume, I faced fewer problems than Isaiah Thomas did. At the time that the conference was being planned, I was immersed in the cataloguing of the Society's collection of lithographed political cartoons. A presentation on political cartoons relating to New England seemed to be a logical choice for me.

Although more than a decade has passed between the delivery of these lectures and their publication, these contributions to the history of American graphic arts remain valid, based as they are on original research. They represent the first detailed studies of these aspects of New England prints, a value only increased by the lengthy period of anticipation.

The conference was accompanied by two exhibitions. Timothy Riggs, then curator of prints at the Worcester Art Museum, and I spent many hours combing our respective collections for the separately published prints that graced the gallery at the art museum. The resulting exhibition was a visual feast for those who attended the conference. From the collections at the Society, I selected prints of a smaller format to complement the lectures by Martha Gandy Fales, Wendy Wick Reaves, Jay Cantor, and myself. Checklists of both exhibitions are presented in this volume.

I would like to acknowledge the patience of the contributors to this volume as well as the assistance of my colleagues at the Society. We offer special thanks to Kenneth M. Newman of the Old Print Shop and William H. Helfand, a collector, for making financial contributions towards the publication of this volume. Audrey T. Zook ably assisted me at the time of the conference and in the preparation of several of the manuscripts for Sheila McAvey, who performed the copyediting with skill and interest.

GEORGIA BRADY BARNHILL

James Turner, Silversmith-Engraver

MARTHA G. FALES

JAMES TURNER (1722–59) was called 'the best engraver . . . in the colonies' by the distinguished founder of the American Antiquarian Society, Isaiah Thomas, in his *History of Printing in America*.[1] Nevertheless, in spite of the great diversity and merit of his work, Turner has never before enjoyed the benefit of a biographical study. One factor contributing to the lack of attention paid him may be that he carried on two distinct trades and worked in at least two different cities. Furthermore, his origins have been so elusive that at times he has been believed to be two and even three different men. In addition, the relatively short duration of his career may help to explain why his work was not mentioned by William Dunlap in his *History of the Rise and Progress of the Arts of Design in the United States* in 1834.[2]

The exhibition of early American engravings at the Museum of Fine Arts, Boston, in 1904 included four examples of Turner's work.[3] In 1945, an exhibition at the John Carter Brown Library further increased the stature of James Turner by bringing together seven significant examples of his work.[4] Today, there are twenty-five examples of work definitely assigned to him, as well as several others attributed to him.

In all probability, James Turner was born on March 18, 1722, the son of Isaac and Mary Turner of Marblehead, Massachusetts.[5] Nothing is known of his early life, nor is it known to whom he was apprenticed. It is tempting to think of such possible masters as Thomas Johnston, Peter Pelham, or Nathaniel Morse. From visual evidence, Turner's training appears to have been in the tradition of the silversmith-engraver represented by men such as John Hull, Jeremiah Dummer, John Coney, Nathaniel Morse, the Hurds, and Paul Revere, as opposed to the painter-engraver tradition of William Burgis, Peter Pelham, John Greenwood, and Thomas Johnston. Turner's was a useful trade: he cut his plates to suit the designs of others, rather than from his own invention. He described the full range of his capabilities in an advertisement in the June 24, 1745, issue of the *Boston Evening Post*:

James Turner, Silversmith & Engraver, Near the Town-House in Cornhill, Boston, Engraves all sorts of Copper Plates for the Rolling Press, all sorts of Stamps in Brass or Pewter for the common Printing Press, Coats of Arms, Crests, Cyphers, &c., on Gold, Silver, Steel, Copper, Brass or Pewter. He likewise makes Watch Faces, makes and cuts Seals in Gold, Silver, or Steel: or makes Steel Faces for Seals, and sets them handsomely in Gold or Silver. He cuts all sorts of Steel Stamps, Brass Rolls and Stamps for Sadlers and

Bookbinders and does all other sorts of work in Gold and silver. All after the best and neatest manner, and at most Reasonable Rates.

Turner also worked as a copperplate printer, for he was responsible for printing John Greenwood's mezzotint of *Jersey Nanny* for J. Buck in 1748.

By 1743, when Turner had reached his majority, he was established in Boston. John Reps has suggested that Turner may have been responsible for the revisions of the 1728 William Burgis view of Boston, reissued and advertised by William Price in the *Boston News-Letter* on September 22, 1743.[6] Indeed, there are certain common bonds in the inclusion of new buildings such as Faneuil Hall between the revisions in the Burgis work and Turner's earliest known, signed work (fig. 1.1), the headpiece for *The American Magazine and Historical Chronicle* which began publication in September 1743. This illustration was a type-metal relief cut of a view of Boston from

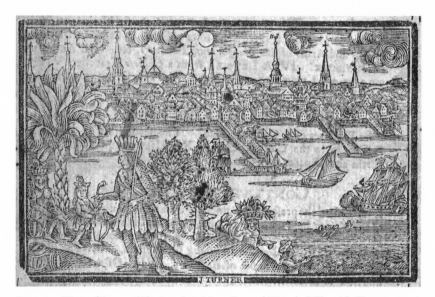

FIG. 1.1. View of Boston, *The American Magazine and Historical Chronicle* (Boston, 1744). American Antiquarian Society. Gift of Matt B. Jones, 1930.

the North End to Fort Hill. Turner also produced a copperplate engraving (fig. 1.2) for the title page of the same publication, a work that has been described as 'one of the earliest and rarest of the Boston views.'[7] In addition, both Turner engravings depicted the newly built Faneuil Hall, as did the revised Burgis view.[8]

Turner's two engravings in the *American Magazine* include a variety of ships in the foreground and very circular cumulus clouds overhead. Both also depict Indian scenes, palm trees, a pine tree with a stag beneath, as well as scenes of daily life. The Indian and the pine tree had been symbols of the colony of Massachusetts since the seventeenth century and appeared on the earliest coins and paper money issued.

[2]

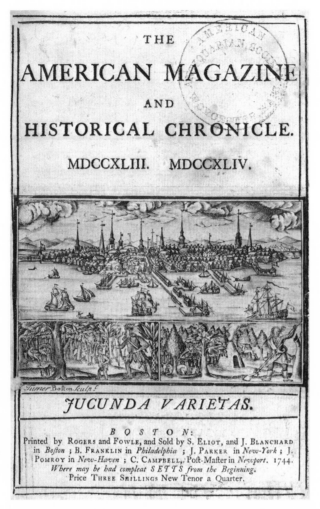

FIG. 1.2. Title page, *The American Magazine and Historical Chronicle* (Boston, 1744). American Antiquarian Society. Gift of Matt. B. Jones, 1930.

The title page of the *American Magazine* states that the Philadelphia agent for this publication was Benjamin Franklin. Franklin may have met Turner through his brother John Franklin, whose handsome bookplate (fig. 1.3) was engraved by Turner. Charles Dexter Allen pronounced the bookplate's design 'very ornate, and . . . perhaps the rarest of our early Americans.'[9] Such is the virtuosity of the design that it would appear that Turner was attempting to show John Franklin a compendium of his engraving abilities.

Apparently Benjamin Franklin was impressed with Turner's talents and considered him superior to any engraver in Philadelphia or elsewhere. When Franklin published *An Account of the New Invented Pennsylvanian Fire-Places* in 1744, he employed James Turner to cut the unsigned illustrations that accompanied the text

(fig. 1.4). In his account book on December 17, 1744, among the itemized expenses for publishing this pamphlet, Franklin recorded 'paying the Boston engraver for work for the new-invented Fire-Place.'[10]

Also attributed to James Turner during these early years are small woodcuts illustrating *The History of the Holy Jesus*, a children's book advertised in the *Boston News-Letter* on January 31, 1745, as just published and later as 'adorn'd with sixteen Cuts.' No copies of the first printing of this book are known, but the 1746 edition printed for B. Gray in Boston contains one woodcut, signed JT in the upper left corner. On the basis of this, Albert Carlos Bates and Elizabeth Carroll Reilly have attributed all sixteen woodcut illustrations in this edition to Turner. Sinclair Hamilton noted the similarity of the handling of the cloud effects to Turner's signed view of Boston and pointed out that these illustrations 'appear to be the work of one who had some real knowledge of his craft.'[11] Hamilton also observed that, although the cut is said to represent 'Herod slaying the Innocent Children,' it must have been copied from a design that originally represented something entirely different. The other unsigned cuts in *The History of the Holy Jesus* display enough stylistic differences to warrant some further investigation before they are attributed to Turner.

According to Isaiah Thomas, Turner also made some cuts for an edition of Aesop's fables during this period, one of which showed a boy looking at himself in a mirror.[12] This same cut was later reused by Samuel Kneeland and appeared in the title of the *Boston Gazette, or Weekly Advertiser* in 1753.[13] However, no copy of

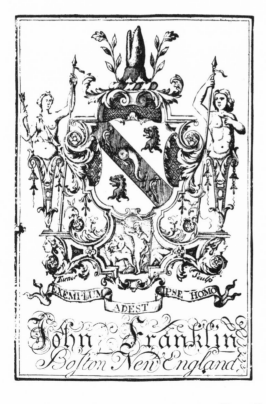

FIG. 1.3. Bookplate of John Franklin (Boston, ca. 1743). American Antiquarian Society.

FIG. 1.4. Illustration for Benjamin Franklin's *Account of the New Invented Pennsylvanian Fire-Places* (Philadelphia, 1744). Courtesy, the John Carter Brown Library, Brown University.

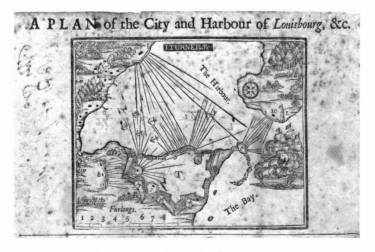

FIG. 1.5. *Plan of the City and Harbour of Louisbourg* (Boston, 1745). American Antiquarian Society. Gift of the General Artemas Ward Memorial Fund Museum.

a mid-eighteenth-century edition of Aesop's fables, printed in Boston, is known to exist.

In the summer of 1745, Thomas Fleet of Boston issued the broadside *A Plan of the City and Harbour of Louisbourg, &c.* that was illustrated with a plan signed by James Turner (fig. 1.5). Circular clouds, stylistically similar to those in his earlier view of Boston, surround the British ships in the bay. This cut also appeared in the *Boston Evening Post* on July 8, 1745. Another version of the Louisburg plan appeared in the *American Magazine* in June 1745. Turner's plan is simple when compared with the plan produced the following year by Peter Pelham; for the latter shows the contours of the land as well as soundings in the harbor. But it was Turner's ability to produce an accurate and spirited design, one that could be put quickly into print when it was needed, that counted.

Turner's talent for cutting printing blocks led to his further employment by local newspapers. Beginning with the issue of June 11, 1750, the *Boston Post-Boy* began using a newly designed masthead. Along with the cut of a postboy, signed J. T., is a cut

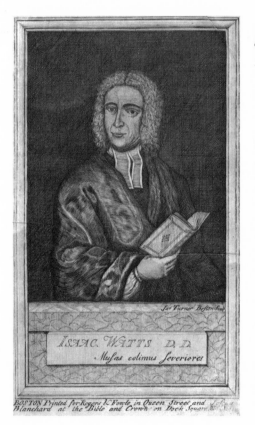

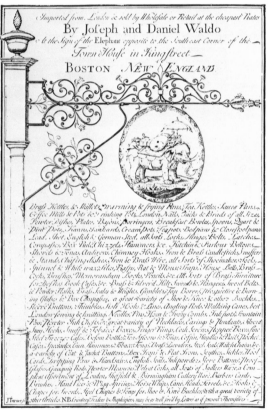

FIG. 1.6. Frontispiece portrait of Dr. Isaac Watts engraved for his *Sermons on Various Subjects* (Boston, 1746). American Antiquarian Society. Bequest of Samuel A. Green, 1949.

FIG. 1.7. Joseph and Daniel Waldo's trade card (Boston, 1748). American Antiquarian Society. Purchase, 1950.

of a ship, presumably bringing the news from abroad. Both cuts are presented within lovely light rococo frames. Although the ship cut is unsigned, both were doubtless the work of Turner.[14]

Portraiture was soon added to Turner's repertoire. He engraved the likeness of Dr. Isaac Watts (fig. 1.6) to accompany his *Sermons*, published in Boston in 1746 by Rogers & Fowle. This book was advertised in the *Boston Weekly News-Letter* on August 21, 1746, as just published, with 'the Doctor's Effigies, curiously Engraven,' intimating that the engraving was artfully or neatly executed. Certainly for the period and the place, Turner's work was neat and somewhat skillful. Even though the portrait is a line engraving, Turner imitated the current vogue for mezzotint portraiture by closely cross-hatching the entire background. Dr. Watts holds in his rather flaccid hand (characteristic of the work of all but the most accomplished artists at the time) a book that is nicely detailed in the decoration of its binding and the heading on the page.

Looking at this portrait through a magnifying glass, one can see that Watts's face is carefully delineated with a sincere attempt made to handle the contours of the face. However, one of the most difficult areas of portraiture is the treatment of the eyes, and Turner's engraving shows a lack of artistic accomplishment. In this work, the doctor's eyes look as though they belong to two different men. One eye is larger and set slightly lower on the face than the other, so that covering either of the eyes improves the entire portrait. Turner's difficulty in this aspect of portrait engraving was a weakness that is also apparent in the work of other contemporary native American engravers such as Nathaniel Hurd.

On March 14, 1748, James Turner and John Bushell advertised in the *Boston Evening Post* the publication of 'A Treatise, proving (*a Posteriori*) that most of the Disorders incident to the *Fair Sex*, are owing to *Flatulencies* not seasonally vented.' When this work was published in London in 1744, it was more boldly titled and proved to be the scatalogical spoofing of no less a literary luminary than Jonathan Swift.[15] Turner's version of the treatise was to be sold by John Bushell, a printer in Newbury Street, Boston. Trying to locate a copy of the American imprint caused me some consternation until the aid of Walter Whitehill was enlisted. With both chivalry and some glee, he make the proper inquiries for me in the American field, but no copies of the American version are known to exist. Although Turner claimed in the advertisement to have done a copperplate for the frontispiece 'with the Author's Effigies, & c.,' the English edition in the British Library includes no frontispiece.

James Turner signed his only extant trade card (fig. 1.7) in 1748 for Joseph and Daniel Waldo, who had a hardware business in Boston in the southeast corner of the Town House in King Street between 1748 and 1770. The advertisement is designed in the form of a signpost with a neatly turned wooden column, surmounted by the same sort of corkscrew finial that adorned Boston furniture of the period. Attached to the post is an exquisitely detailed ornamental iron bracket from which the 'Sign of the Elephant' is suspended in a florid oval frame. The Marco Poloesque sign shows a large elephant bearing a platform laden with goods and three natives, two of whom

have a large umbrella to shade them from the tropical sun. At center top are the initials of Joseph and Daniel Waldo, JWD, and below is the date 1748. The entire area beneath the bracketed signpost is filled with a closely spaced listing of the enormous variety of items (about 250 in all) imported from London that could be found in the Waldo shop, ranging from teakettles and coffeemills, to pewter wares and mousetraps, knitting needles, jewelry, ink powder, and velvet corks!

During this period, Benjamin Franklin entered more directly into the life of James Turner. Franklin had asked Turner to make a seal for James Read, clerk of the Crown and prothonotary of the Supreme Court of Pennsylvania. Turner's letter included the following remarks:

Herewith I send the Seal which you so long ago Spoke to me for, for Mr. Read. The Occasion of my sending it to you and not directly to him was because that the Seal being very heavy might cause him a great Charge which I thought he might be eased of by my sending it to you as you are Postmaster. . . . I have sent with the Seal 2 Impressions from it one on wax taken off by hand the other on a Wafer taken off in Colonel B. Pollards Press. The Letters show best on the latter because of its being such a large body of Metal that it chils the Wax before it can enter the Letters, but I think that either of 'em are legible enough.

Turner explained that he should have charged fifteen pounds instead of twelve pounds, but that he trusted to the gentleman's generosity. He pointed out that 'it

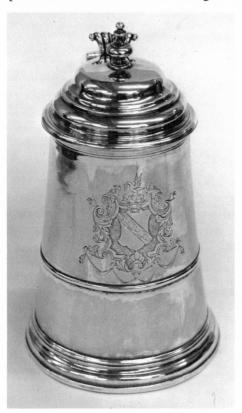

FIG. 1.8. Silver tankard, marked by Turner, made about 1746 for Richard Derby whose coat of arms Turner engraved on the front of the tankard. Private collection, photograph courtesy of the Essex Institute, Salem, Mass.

was but a guess as I had never done one of this Size and but one great or small in Steel before.' He concluded his letter to Franklin by remarking, 'If you or any Other Gentlemen wants any graveing work done of any Sort I should be glad of an Oppertunity.'[16]

In the same letter, Turner complained, 'It has been my Ill fortune ever Since I have been for my Self to be Involved in a great deal of large Unprofitable Silver Smiths work which was particularly my Case when your Brother Mr. J. Franklyn procured me a large Job of Engraveing.'[17] One of the 'large unprofitable' objects he may have been referring to was a tankard he made for Capt. Richard Derby, quite probably the same tankard for which Turner billed Derby on October 22, 1746 (fig. 1.8). It was purchased along with a pair of canns and weighed over twenty-eight ounces. In addition to the cost of the silver, the charge for making the tankard and engraving it was fifteen pounds.[18]

A close study of the coat of arms engraved on a large two-handled covered cup, now in the Essex Institute, made by William Swan and presented in 1749 to Benjamin Pickman of Salem for his contributions to the Battle of Louisburg, makes it possible to suggest that Turner was also the engraver of the Pickman arms. It has long seemed unlikely that Swan did the engraving himself, since there is not a consistent recurrence of such decoration on other examples of his work.

In the First Church of Marblehead there are two flagons, one engraved with the Barnard arms and the other with the Hooper arms, that were made in 1748–49 by Samuel Burt of Boston. These two have strong stylistic similarities to the arms on the Derby tankard that bears Turner's mark. Since Turner is believed to have been born in Marblehead, it is reasonable that he would have had Essex County patrons. Indeed, a bill to the estate of William Lynde, dated September 2, 1752, Marblehead, shows that James Turner provided eight escutcheons for Lynde's funeral, an inscription on the breastplate of the coffin, and nine enameled rings.[19]

Because of his preference for printmaking, very little silver marked by Turner is extant.[20] In addition to the Derby tankard, there is an octagonal caster with a prettily pierced lid bearing his name mark at the Yale University Art Gallery. A cann once owned by the same family as the caster bears remnants of Turner's mark, but its present location is unknown.[21]

The only other extant piece of silver attributed to James Turner is the seal of the Pennsylvania Hospital, whose *Minutes* for October 23, 1751, record that 'B. Franklin undertook to write to Boston tomorrow to get a seal for the Corporation engraved.' Twelve days later, on November 4, 1751, John Franklin wrote from Boston to his brother, 'I have spoke with Turner about your seal. He thinks he cant git the Designe Compleated before the post going but will have it Ready against the next.'[22] Four different draughts for a design showing the Good Samaritan were ultimately sent from Boston and submitted by Benjamin Franklin to the hospital's Board of Managers for their approval. A few changes were made and the design was finally cut into a silver seal (fig. 1.9) measuring two inches in diameter. The seal was received by the hospital in February 1754, at a cost of ten pounds, five shillings, and eight pence.[23] The design shows the Good Samaritan taking charge of the sick man and

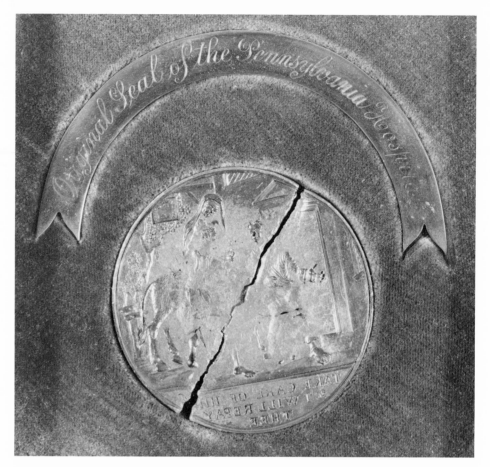

FIG. 1.9. Silver seal of the Pennsylvania Hospital, 1751. Courtesy, Pennsylvania Hospital.

delivering him to the innkeeper. The legend states, 'Take care of him and I will repay thee.' In June 1833, when the seal became worn, it was broken in half and replaced by one made of steel.[24]

Again, it was Benjamin Franklin who suggested to the lawyer James Alexander that James Turner engrave the maps of New Jersey that were to be used by the East Jersey Proprietors in a 1745 land suit in chancery. On August 15, 1745, Franklin wrote to Alexander in New Jersey, 'I return you herewith your Draughts, with a copy of one of them per Mr. Evans and a few Lines relating to it from him. I wrote to Mr. Parker last Post that they might be got done in Boston by one Turner who is said to be a good Engraver. Our only tolerable Engraver here will not undertake the Jobb. And for my own Part I would rather chuse you should get them done there, or by Mr. Evans.' James Turner did get the job, which resulted in three maps of the sections of New Jersey (fig. 1.10). They were printed in *A Bill in the Chancery of New-Jersey*, published for the subscribers by James Parker in New York in 1747, and copies were to be sold by Parker and by Franklin in Philadelphia.[25]

F IG . 1.10. Map of New Jersey from *A Bill in the Chancery of New-Jersey* (New York, 1747). American Antiquarian Society. Exchange, the John Carter Brown Library, 1946.

Parker wrote Franklin on September 7, 1747: 'As to what relates to the Copper Plate, tis thus; The Engraver is a Silversmith [in New York]. During the Proposing of the Thing I gave him some silver to make me two Silver Spoons; but he has not done 'em yet. I have been at him several Times: but one time he has been sick, another Time his Wife is sick, & c. I tell him we want him to go about the Plate, but I fear he is an idle lazy Fellow. I will try him again this Week, and I think if he don't go on it, as he is well enough now, we may despair of getting him to do it at all.' It is clear that Turner's promptness in executing work was much in his favor.[26]

Turner was also employed by Franklin to engrave at least one plate for the 1748 Philadelphia edition of George Fisher's *The Young Man's Best Companion*, which Franklin retitled *The American Instructor*. One of the fold-in engravings consists of geometrical figures and is signed by Turner. There is a possibility that the other fold-in engraving of twelve cyphers, while unsigned, is also Turner's work.[27]

In 1752 Turner engraved plates for John Barnard's *A New Version of the Psalms of David*, published in Boston. John Barnard was the pastor of the church in Marblehead and one of the two donors of the silver flagons with engraved arms attributed to Turner. Sixteen pages of forty-nine tunes are bound in at the end of Barnard's book, page one of which carries the imprint 'Engrav'd Printed & Sold by James Turner near the Town House.'

During this period of his life, Turner was responsible for producing a number of significant maps and charts, one of the most interesting being the *Chart of the*

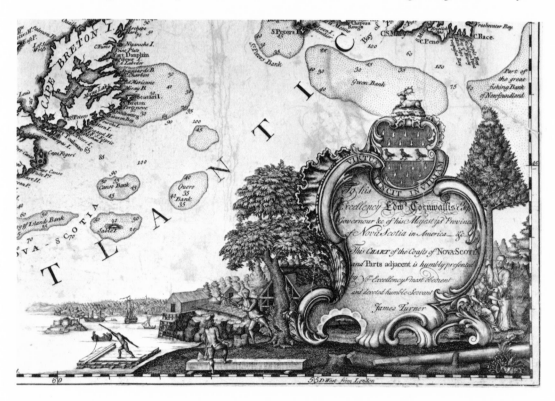

FIG. 1.11. Cartouche of *Chart of the Coasts of Nova-Scotia* (Boston, 1750). American Antiquarian Society. From the library of John W. Farwell, 1944.

Coasts of Nova Scotia (fig. 1.11). Signed in the cartouche that bears a dedication to Gov. Edward Cornwallis, the map was probably first issued in 1750 and, with many additions, in 1759, 1760, and 1776. The chart's design was based upon 'Carte de la Partie Orientale de la Nouvelle France' that appeared in Charlevoix's, *Histoire et*

FIG. 1.12. *Chart of Delaware Bay* (Philadelphia, 1756). Courtesy, the John Carter Brown Library, Brown University.

description générale.[28] A plan of Halifax is included as one of the insets and suggests the purpose for the issuing of the engraving, since Halifax had just been established by the British in 1749 in an effort to offset the French fortress at Louisburg. An inset of Boston is also shown and is almost identical with the view Turner had done for the *American Magazine*.[29]

The cartouche is the most decorative part of the chart. Above the dedication, Turner emblazoned the arms of Cornwallis. In addition to the heraldically correct arms, there is a motto 'Virtus vincit in vidiam.' Below and on each side of the cartouche are scenes showing the building of Halifax. The fort in the harbor displays the British flag, and a variety of boats, as well as a large wooden raft, traverse the entrance. Fish houses and fish flakes represent the major local industry, and an Indian hews a tree next to a colonist with an axe. On September 27, 1750, Benjamin Franklin wrote to his brother John, thanking him for his letter of September 17 in which he had enclosed the plan of Halifax. This was possibly a reference to Turner's *Chart of the Coasts of Nova Scotia*.

It may well have been Franklin's interest in Turner's work that caused the engraver to move from Boston to Philadelphia about 1754, where he was married on December 19, 1756, to Elizabeth MacKay.[30] 'James Turner in Philadelphia' is the

signature used in 1755 for his important and complex engraving of *A General Map of the Middle British Colonies*. Considered to be his most notable work and one of the most important American-made maps of the eighteenth century,[31] this map shows the North American continent from the Atlantic Ocean, New France, and the eastern Great Lakes south to Virginia and west to the Ohio territory.

Lewis Evans who drew this map had also designed the three maps for the *Bill in the Chancery of New Jersey*. The map was issued in Evan's *Geographical, Historical, Political, Philosophical, and Mechanical Essays*, published by Franklin and Hall in 1755.[32] Full of distance tables and footnotes, this cartographical triumph includes information on the seats of the Indian tribes; it also establishes America's correct longitudinal position with regard to London, and contains an inset of a sketch of part of the Ohio River. Evans dedicated the map to Thomas Pownall, who had assisted him with the map, and Turner engraved a simplified version of the Pownall arms in the upper left corner.

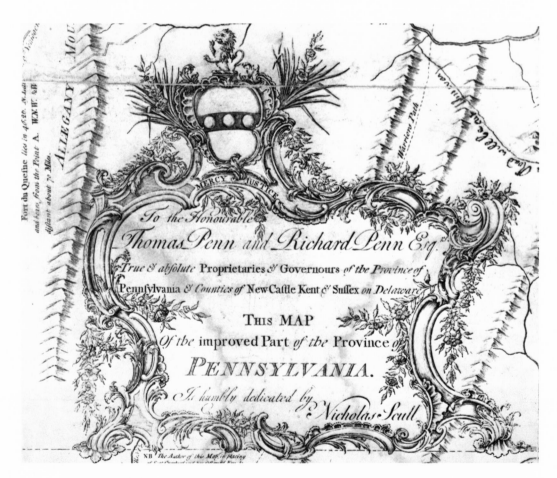

FIG. 1.13. Cartouche of Nicholas Scull's *Map of the Improved Part of the Province of Pennsylvania* (Philadelphia, 1759). Courtesy, the Historical Society of Pennsylvania.

In the following year, 1756, Turner engraved Joshua Fisher's *Chart of Delaware Bay and River* (fig. 1.12), printed in Philadelphia by John Davis, who, a few years later, printed another map engraved by Turner.[33] This chart was important to the merchants and insurers of ships traveling through Delaware Bay, since it corrected the mistakes of previous draughts. Above the delicately foliated dedicatory cartouche is the Penn coat of arms and the motto 'Mercy Justice.'

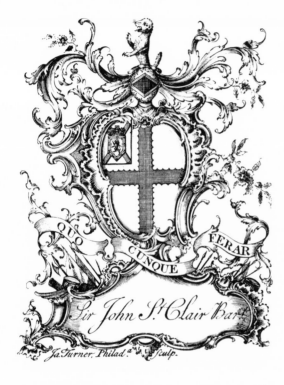

FIG. 1.14. Bookplate of Sir John St. Clair Bart. (Philadelphia, 1755). American Antiquarian Society.

The same arms and motto on the Fisher chart appear on Nicholas Scull's *Map of the Improved Part of the Province of Pennsylvania*, engraved by Turner and printed by John Davis in 1759 (fig. 1.13). Wroth called it an 'important task of an excellent and enterprising craftsman.'[34] This large map was dedicated to Thomas and Richard Penn and, like the Delaware Bay chart, due to its tactical significance, was subsequently copied and issued in London by Sayer and Bennett at the beginning of the Revolutionary War.

Heraldic engraving remained one of Turner's great fortes. In addition to the bookplate prepared for John Franklin, Turner engraved a plate for J. Leddel sometime during the 1740s. The arms are contained in a baroque cartouche enhanced by imbrication, diapering, and a symmetrical shell at the base. Although it was not listed by Charles Dexter Allen in *American Book-Plates*, the Leddel bookplate was shown at the Museum of Fine Arts in Boston in 1904.[35]

Three bookplates signed by Turner during his Philadelphia period are known. The arms of two are placed in asymmetrical and delicate rococo cartouches above

ruffled and scrolled bases bearing the owner's name. The bookplate of Sir John St. Clair Bart. (fig. 1.14), a British officer under Braddock, depicts battle arms behind the top of the name bracket and a helmet above the coat of arms. Isaac Norris's bookplate is more lightly drawn with a vase of flowers perched to the right of the name bracket. This plate was later altered to read 'Charles Norris.' Just what Turner used as a source for his depiction of arms is difficult to say. Norris's arms are not given in John Guillim's popular *Display of Heraldry*, the seventh edition of which was published in London in 1724 and was widely used in this country.[36] The third bookplate was designed for John Ross of Philadelphia. The Ross arms are enclosed by a heavily scrolled cartouche with an abundance of undulating leafage supporting the crest.

Another bookplate is attributed to Turner by Allen, perhaps because of its superficial similarity to the Norris plate, but it is much less detailed and is unsigned, so that its attribution is open to question. The identity of its owner, James Hall, also remains a mystery. Suggestions range from a James Hall of Massachusetts to James Hall, lawyer and author of Philadelphia, and, most likely, to James Hall of Jamaica in the West Indies.[37]

In 1759 James Turner cut and signed the stamp of the Penn arms to be used as the masthead for the *Pennsylvania Gazette* (fig. 1.15). Amazingly refined in its cutting, the masthead design was probably cut in brass. In 1745, Turner had advertised that he made both brass and pewter stamps for common printing. This was the third masthead to be used by the *Pennsylvania Gazette* and it made its first appearance in the issue dated April 12, 1759.

In this weekly publication, Benjamin Franklin produced several innovations in newspaper history, one of which was the greater use of illustrative ideas in the advertisements. Prior to 1756, the cuts in the ads were restricted primarily to the use of ships with sailing notices. After that date, more interesting cuts were occasionally printed. No doubt, Turner's residence in Philadelphia accounted for some of the

FIG. 1.15. Penn Family coat of arms, used as part of the masthead for *The Pennsylvania Gazette* (Philadelphia, 1759). American Antiquarian Society.

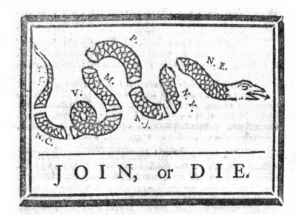

embellishments to the advertisements. Among the dozen new and decorative cuts that made their appearance in this newspaper from January 1756 until November 1759, those most likely to be the work of Turner include the following: the illustration of the Microcosm (January 15, 1756), John Elliot's sign of the dressing glass and bell (October 7, 1756), the advertisement of B. Jackson, mustard and chocolate maker, which includes the Penn seal of approval (August 10, 1758), that of Nathaniel Allen, sealer of measures, which also contains the Penn arms (December 28, 1758), and the notice for stage wagon service (November 1, 1759).

It is also feasible to suggest that Franklin engaged Turner to cut the first American political cartoon (fig. 1.16)—the segmented snake, with each section labeled to represent the various colonies, and below the sections the motto 'Join or Die.' This cartoon appeared on May 9, 1754, in the *Pennsylvania Gazette* and in the *Boston Gazette* twelve days later on May 21, 1754, bearing the words 'Unite and Conquer.' It is not beyond the realm of possibility that Turner could also have cut the design for the Boston paper and sent the block by post so that it could appear within two weeks in both cities.

During his years in Philadelphia, Turner had at least one other worker, perhaps two, in his shop. Henry Dawkins began business for himself in January 1758, advertising as an engraver from London who 'lately wrought with Mr. James Turner.' Late in the same year an engraved portrait of Frederick the Third of Prussia was published in *Father Abraham's Almanack* for 1759. The portrait was engraved by 'J. M. AE. 14' and was 'Sold by J. Turner, in Arch Street, Philad.'[a 38] The identity of this youthful engraver is not known.

On October 10, 1759, an advertisement appeared in the *Pennsylvania Journal and Weekly Advertiser* stating that 'to-Morrow will be published by James Turner Engraver, two doors above the Sign of Admiral Boscawen, in Arch-street, Handsomely Embellished and printed on the best paper, . . . a map of Nova Scotia, etc.' This was undoubtedly the revised issue of the *Chart of the Coasts of Nova Scotia*.

Shortly thereafter James Turner died of smallpox. On December 10, 1759, the *Boston Evening Post* carried a notice of Turner's death and on the thirteenth the

Pennsylvania Gazette announced the sale 'at the late Dwelling house of James Turner, Engraver, deceased, in Arch street, sundry sorts of Household Furniture, engraving Tools, a number of Copper plates and Pictures.' Since Turner died intestate, an administrative bond was procured for William Muir, the Philadelphia bookbinder. Turner's widow, Elizabeth, signed her mark to the following statement: 'As Mr. William Muir appears to be the Greatest Creditor to the Estate of my late Husband James Turner, I have with the advice of Friends desir'd him to Administer he giving the Necessary Security.'[39]

Turner's death in 1759 deprived Philadelphia of an experienced American engraver during the politically important years preceding the Revolutionary War. Although Henry Dawkins had been trained in England before working in Turner's shop, he was unable to fill the void. There are a few pre-Revolutionary prints attributed to Philadelphia hands, including *The Election* and *Liberty Triumphant*.[40] However, in comparison with the engravings of such Boston men as Nathaniel Hurd and Paul Revere, Philadelphia's product was meager. Had James Turner been born a few years later or had he lived a few years longer, he well might have assumed an important role as the conveyer of political and patriotic ideas. His ability as an engraver and silversmith was certainly equal to that of Paul Revere, and under Benjamin Franklin's patronage, he was already producing maps that took on greater significance when it came to waging the War for Independence.

Indeed, James Turner was well aware of Franklin's importance to his career. Not long before his death, Turner had written to Benjamin Franklin's wife Deborah, asking her permission to engrave a mezzotint portrait of Franklin from a miniature portrait of him. In this letter, dated May 1, 1758, Turner extolls Franklin for his important philosophical discoveries and his undaunted zeal in the cause of liberty, calling him 'the boast of Boston' and 'the blessing of Philadelphia.' Then he speaks of his own personal regard for Franklin, noting 'my grateful sense of the many instances of Mr. Franklin's goodness to myself, his benevolent endeavors in private life, to promote the interest of any person, though no way connected with his own, and to advance by his candid remarks and wise advice every useful art in America.'[41]

Turner's was a very useful art, and Franklin, like Isaiah Thomas, had recognized at once the skill and ability that it has taken the rest of us two centuries to appreciate.

NOTES

1. Isaiah Thomas, *The History of Printing in America*, ed. Marcus A. McCorison (New York: Weathervane Books, 1970), p. 256.

2. William Dunlap, *History of the Rise and Progress of the Arts of Design in the United States*, 2 vols., ed. Rita Weiss (New York: Dover Publications, Inc., 1969).

3. Museum of Fine Arts, Boston, *A Descriptive Catalogue of an Exhibition of Early Engraving in America* (Cambridge, Mass.: Museum of Fine Arts, Boston, 1904).

4. Lawrence C. Wroth and Marion W. Adams, comps., *American Woodcuts and Engravings 1670–1800* (Providence: The John Carter Brown Library, 1945).

5. *Vital Records of Marblehead, Massachusetts to the End of the Year 1849*, 2 vols. (Salem, Mass.: Essex Institute, 1903), 1 (Births). Harold Bowditch, 'Early Water-Color Paintings of New England Coats of Arms,' *Publications of the Colonial Society of Massachusetts* 35 (1944): 179–81, believed that there were two different James Turners, one from Boston and one from Marblehead. Charles K. Bolton, in his manuscript notes 'Workers in Line and Color in New England,' n.d., vol. 3, p. 181, Charles K. Bolton Papers, Boston Athenaeum, gives Turner's birthdate as March 18, 1721/22 in Marblehead. Bolton believed he was the same engraver and silversmith who worked in Boston in 1745. Deeds and wills contained in the court records have been checked for corroborating evidence about James Turner's location and lineage, without success.

6. John W. Reps, 'Boston By Bostonians: The Printed Plans and Views of the Colonial City by Its Artists, Cartographers, Engravers and Publishers,' in *Boston Prints and Printmakers 1670–1775*, ed. Walter Muir Whitehill and Sinclair Hitchings, Collections of the Colonial Society of Massachusetts 46 (1973): 24–25.

7. I. N. Phelps Stokes and Daniel C. Haskell, *American Historical Prints* (New York: New York Public Library, 1933), p. 16. Daniel Fowle, who published the *American Magazine* with Gamaliel Rogers, later moved to Portsmouth, New Hampshire, and used this relief cut on a broadside produced in 1775.

8. Reps, 'Boston by Bostonians,' pp. 41–42.

9. Charles Dexter Allen, *American Book-Plates* (New York: Macmillan and Co., 1894), no. 287, pp. 204–5.

10. Wroth and Adams, *American Woodcuts and Engravings*, no. 13, p. 20.

11. Sinclair Hamilton, *Early American Book Illustrators and Wood Engravers 1670–1870* (Princeton: Princeton University Library, 1958), pp. xxiv, 8–10, 22. Albert Carlos Bates, *The History of the Holy Jesus* (Hartford: The Case, Lockwood & Brainard Co., 1911), p. [5]. Elizabeth Carroll Reilly, *A Dictionary of Colonial American Printers' Ornaments and Illustrations* (Worcester: American Antiquarian Society, 1975), pp. 302–10.

12. Thomas, *History of Printing*, p. 256.

13. Hamilton, *Early American Book Illustrators*, p. 8.

14. These two cuts and the preceding plan of Louisburg were brought to my attention by Georgia B. Barnhill, curator of graphic arts at the American Antiquarian Society.

15. *The Benefit of Farting*, by Don Fartinando Puff-indorst, is listed as possibly the work of Jonathan Swift in the British Library's *General Catalogue of Printed Books* (London, 1964), item 233, col. 477. Charles Evans, *American Bibliography* (Chicago: Blakely Press, 1903–59), lists the publication as no. 6253, *Treatise Proving That Most Disorders Incident to the Fair Sex are Owing to Flatuencies Not Personally Vented*.

16. Leonard W. Labaree and Whitfield J. Bell, Jr., eds, *The Papers of Benjamin Franklin*, 14 vols. (New Haven: Yale University Press, 1976), 3: 144–46.

17. Ibid., p. 145.

18. Derby MSS., Library, Essex Institute, Salem, Mass.

19. *The Heraldic Journal*, 2 (1866): 94; Bowditch, 'Early Water-Color Paintings,' pp. 179–81.

20. In the 1906 exhibition catalogue of the Museum of Fine Arts, Boston, *American Silver, the Work of Seventeenth and Eighteenth Century Silversmiths* (Boston, 1906) a rat-tail spoon was listed as the work of *John* Turner, Boston, 1744, with the mark IT in shaped shield. The citation includes a reference to page 21 of the introduc-

tory text that discusses *James* Turner as the same man. The IT in a shaped shield is given in Ernest M. Currier's *Marks of Early American Silversmiths* (Portland, Maine: Southworth-Anthoenson Press, 1938) as the mark of John Tanner of Newport; no mark is given by Currier for Turner. Stephen G. C. Ensko's *American Silversmiths and Their Marks* (1927; repr. New York: privately printed, 1948) describes the IT in a shaped shield as the mark of John Tanner, of Newport, 1740, and gives an IT in a heart as the mark of Turner. Hollis French, in *A List of Early American Silversmiths and Their Marks* (New York: Walpole Society, 1917), illustrates both the IT in a shaped shield and an IT in a small rectangle as suggesting they might be Turner's marks. However, only the J. Turner in shaped cartouche mark can be substantiated as James Turner's touch.

21. Kathryn C. Buhler and Graham Hood, *American Silver Garvan and Other Collections in the Yale University Art Gallery*, 2 vols. (New Haven: Yale University Press, 1970), 1: 211.

22. Labaree and Bell, *The Papers of Benjamin Franklin*, 4: 205–6.

23. Manuscript, Pennsylvania Hospital (Philadelphia), 'Minutes,' 1: 125.

24. Thomas A. Morton, *The History of the Pennsylvania Hospital 1751–1895* (Philadelphia: Times Printing House, 1897), pp. 33–34.

25. Labaree and Bell, *The Papers of Benjamin Franklin*, 3: 32.

26. Ibid., pp. 172–73.

27. C. William Miller, *Benjamin Franklin's Philadelphia Printing* (Philadelphia: American Philosophical Society, 1974), nos. 439, 440; letter from Miller to author, March 17, 1980.

28. Le P. Pierre-François-Xavier de Charlevoix, *Histoire et Description Générale de la Nouvelle France*, 3 vols. (Paris, 1744), illus. 2, opposite p. 237. Wroth and Adams, *American Woodcuts and Engravings*, no. 16, p. 22.

29. Reps, *'Boston by Bostonians,'* p. 45.

30. Typescript, Pennsylvania Marriages, Christ Church, Philadelphia.

31. Wroth and Adams, *American Woodcuts and Engravings*, no. 17, p. 22.

32. Evans notes on page 25 of this work, 'My Map was begun engraving in November 1754, and finished towards the end of June 1755' (Philadelphia, 1755), no. 2, p. 25. This suggests

that Turner arrived in Philadelphia prior to Nov. 1754.

33. Lawrence C. Wroth, 'Chart of Delaware Bay and River,' *The Pennsylvania Magazine of History and Biography* 74 (1950): 90–109.

34. The Scull plan of Philadelphia, issued on Nov. 1, 1762, was attributed to Turner by Stauffer, but this is at odds with the fact that Turner had been dead for two years. Stokes and Haskell, *American Historical Prints*, p. 20.

35. Museum of Fine Arts, Boston, *A Descriptive Catalogue*, p. 122.

36. American Art Galleries, *Catalogue of the Collection of Dr. Henry C. Eno* (New York: American Art Association, Publs., 1916), no. 463.

37. Allen, *American Book-Plates*, no. 340, p. 213; In notes by Frank Marshall, on file at the American Antiquarian Society, there is an example of the James Hall bookplate that bears an unidentified pencil inscription stating that the plate was probably engraved by James Kirke. See also Vere L. Oliver, *West Indian Bookplates* (London: Mitchell Hughes and Clarke, 1914), p. 46.

38. *Pennsylvania Journal or Weekly Advertiser*, Jan. 19, 1758. Groce and Wallace suggest that 'J. M.,' the fourteen-year-old engraver of the portrait of Frederick the Great, which was published in Hugh Gaines's *New York Almanac* for 1759 and sold by James Turner of Philadelphia, may have been an apprentice of Turner. George C. Groce and David H. Wallace, *The New-York Historical Society's Dictionary of Artists in America* (New Haven: Yale University Press, 1957), p. 409.

39. Records Department, City Hall, Philadelphia. This document and the court appointment of Muir were misfiled under the name of *William* Turner. I am indebted to John Platt, librarian at The Historical Society of Pennsylvania, for locating them.

40. Edgar P. Richardson, 'Four American Political Prints, *The American Art Journal* 6 (1974): 36–44, and Edgar P. Richardson, 'The Birth of Political Caricature,' in *Philadelphia Printmaking: American Prints before 1860* (Philadelphia; Free Library of Philadelphia, 1974).

41. Labaree and Bell, *The Papers of Benjamin Franklin*, 8: 59.

William Bentley:
Connoisseur and Print Collector

STEFANIE MUNSING WINKELBAUER

THE AMERICAN ANTIQUARIAN SOCIETY is very fortunate to have a spectacular collection of New England prints, especially portrait engravings. What makes the Society's collection particularly interesting is that many of the prints themselves have been described in detail by their collector and donor, the Reverend William Bentley, D.D., pastor of the East Church at Salem, Massachusetts. His portrait hangs in Antiquarian Hall at the American Antiquarian Society (fig. 2.1).

Bentley was born in Boston on June 22, 1759. His maternal grandfather, the Boston merchant, William Paine, financed his education at Harvard, which Bentley entered in 1773, at the age of fourteen. He excelled in his study of classics and literature, a grounding that was to become part of his lifelong passion. Upon his graduation in 1777, Bentley became assistant master in grammar in his earlier alma mater, the South Grammar School in Boston. However, Bentley returned to Harvard three years later as tutor of Latin and Greek, at the same time preparing himself for the ministry. From 1780 until 1783, he also assumed the position of assistant librarian in the Harvard College library, a post that gave him expertise in his lifelong hobby of book collecting.

Bentley's religious career actually began on a temporary basis in 1778, when he preached at churches in the Boston area. He must have made a particular impression on the congregation of East Church in Salem, for in July of 1783 he was invited to become an assistant to its preacher, James Diman (1707–88). Bentley's fresh and liberal ideas soon jarred with the strict Calvinistic tenets of his colleague, and it was a credit to the congregation that the senior pastor was asked to leave. Bentley remained as minister to the East Church congregation until his death in 1819.

It was during the early years of his ministry that Bentley began his voluminous diary, a joy to scholars of the Federal era. The diary is rich in copious descriptions of New England people, places, events, and objects. Mercifully for the scholar, Bentley did not waste paper on philosophical introspection and sentiment. As he wrote, 'Being bred a C[ollegian] I followed early the practice of writing my experiences. . . . But cool reflection told me a few devout prayers & well conceived reflections were better than whole volumes of confessions of feelings & of vanity.'[1]

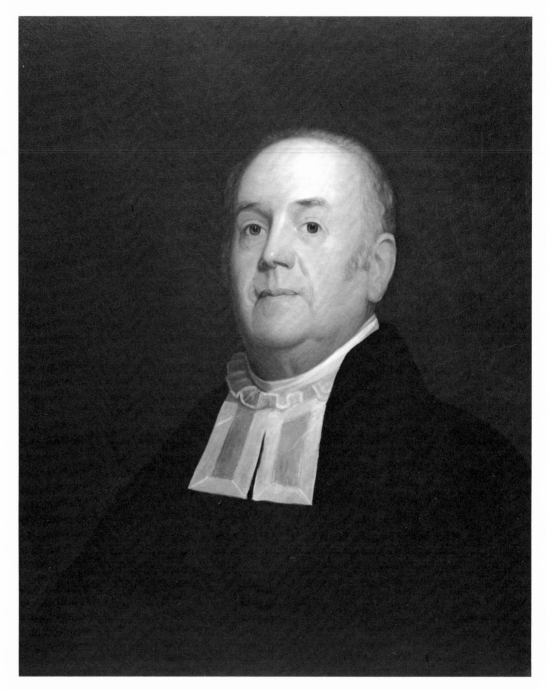

FIG. 2.1. James Frothingham (1786–1864). William Bentley. Oil on canvas. American Antiquarian Society. Gift of Hannah A. Kittridge, 1916.

Through the pages of his diary, which Bentley undertook almost as a daily discipline (it was his habit to write standing up), we learn of his enthusiastic and seemingly tireless participation in the life of his day, not only in Salem but in towns and villages throughout the area. He traveled to Boston frequently, and often exchanged with other preachers on Sundays, thereby gaining exposure to a variety of New England social groups. His own religious tolerance brought him into contact with people of many faiths. Bentley was, however, sufficiently outspoken on religious and political issues (he was a staunch Republican in the middle of highly Federalist Salem), and his diary is dotted with admonitions to himself to curb his tongue. 'I must never speak from passion or judge at the moment. I must remember that my temper in the public opinion has been imprudent, & take council even from my enemies.'[2] However, he could, and frequently did, vent his spleen in his diary.

On top of his busy parochial duties, Bentley continued to cultivate a truly astonishing variety of talents: mastering some twenty languages, developing his book collection (the best private collection in the United States next to that of Thomas Jefferson), maintaining a voluminous and virtually world-wide correspondence, assembling a cabinet of curios, tracing local history, and supporting the arts.

The climate of the times was particularly conducive to a cultivation of the arts. The battles of the Revolution had been fought and won, commerce was establishing itself slowly but surely, and a growing number of practicing artists were expanding the flourishing native school in New England. In addition, many foreign-born artists came to the new nation as the result of political upheavals in Europe. The French Revolution also provided Bentley with opportunities to expand his collections. In his diary for October 15, 1795, he commented on the varying quality of the collectors' items arriving from France:

The revolution in France has rendered cheap the Clocks, & the pictures of that Nation. And the cheapness has multiplied them in our Country. The decimal division has made them ready to dispose of the old Clocks of 12 hours, & several fine clocks have been an easy purchase to our Seaman. The disposal of so many estates has made pictures also very cheap. Such as have already arrived had some good pieces, but in general they have been ill chosen. Capt. Carnes carried me to see a collection made by his Brother Charles. There were two fine views of Vesuvius & of Aetna, & well coloured. They exceeded the painting in the Chamber at Cambridge. The other pieces were fancy & not all of the most chaste character. One of them was inscribed Que ni est si encore, & another il dort. A few on silk were upon the revolution, fancy pieces.[3]

Boston was perhaps three or four hours from Salem by post-chaise, and Bentley was frequently able to avail himself of its proximity to visit artists, museums, libraries, and public and private art collections. Bentley could casually mention a dinner after a Masonic parade honoring George Washington with Paul Revere, Isaiah Thomas, and Jacob Perkins. We can only imagine with curious envy their table talk.[4]

Most of Salem's substantial mercantile community lived in houses elegantly decorated by Samuel McIntire, whose services Bentley also patronized for carved

sculptures (fig. 2.2). Older houses survived changing tastes, and we learn of Bentley's deep love for the past when, in 1796, he noted with sadness the passing of a Salem indigent whose house and furnishings had been a strong link with the seventeenth century. Bentley did not pass up the chance to comment on details that today fascinate the scholar: 'The windows of this house are of small glass with lead in diamonds & open upon hinges. The doors open with wooden latches. The Chairs are the upright high arm chairs, & common chairs are the short backed. The tables small & oval, the chest of drawers with knobs, & short swelled legs. The large fire places, & the iron for the lamp. . . . The Press for pewter plates with round holes over the door of it. . . . Old Dutch maps & map mondes highly coloured above a Century old. The Beds very low, & the curtains hung upon walls.'5 A few days later Bentley commented: 'I grieved to see the connection between the last & the present century so entirely lost. There is something agreeable, if not great, in the primitive manners. . . . I would purchase all the furniture of the house if I could dispose of it with convenience in some place. There are proper materials for a Cabinet. From the Spoon to the broad platter, from the Shoe to the Whole of the Wardrobe, from the chair to the bed. Everything in its own likeness, & away, far away from the present fashion.'6 If more devotees of history had shared Bentley's convictions for preservation, present-day curators and historians would have an easier job of reconstructing and interpreting the past.

It was this desire to preserve a sense of the past that formed much of the reason behind Bentley's collection of New England portraits. In 1797, he noted in his diary:

[May] 19. It has been my wish to preserve the heads of the first Settlers. This is a mem[oran-dum] to know where they may be found. Gov. Endicott is in the hands of the family 2/3 l., much defaced, tho' the countenance is preserved. Col. [Benjamin] Pickman has a copy in fine order & well imitated. There is a picture of Pynchon at Springfield and a good copy of it, ½, at Mrs. Pynchon's at her daughters Orne's. Higginson is in the Council Chamber. Judge Sewall & his wife have been given by the late Mrs. Higginson, a daughter deceased last Month at Beverly, to her Daughter Lee, in Beverly. I have a miniature of Governour Winthrop from the original. Epes is in the hands of his descendants now living in town. There is in the Bradstreet family one of the Gov. which I have not seen.*7

Bentley later had many of these portraits copied for himself in oil or crayon, and most of the copies are now to be seen on the walls of the American Antiquarian Society.

Bentley was indefatigable in his efforts to track down original portraits and to verify his information. At one point, he wrote in his diary, 'June 1 [1804]. I waited on Mr. [Samuel] Bradstreet of Charleston, to be informed whether the portrait of Gov. Bradstreet was the real Governour. He did not appear to have paid much attention to the subject but conversation supplied some facts, which tended to remove my doubts. The portrait is a more modern dress than 1697, when Gov. Bradstreet died at 94 years of age. The likeness must have been taken in youth & when he was very corpulent.'

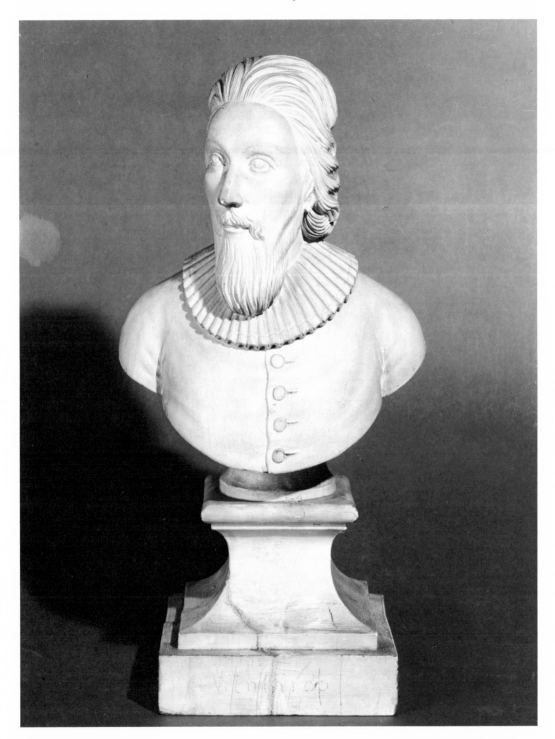

FIG. 2.2. Samuel McIntire (1757–1811). Wooden bust of John Winthrop. American Antiquarian Society. Bequest of William Bentley, 1819.

Not all of Bentley's researches were fruitful, and some of the interviews must have been downright frustrating, as the following entry attests:

[March] 5 [,1798]. Visited the County Registry of the Court of Sessions & Pleas, but added little to my stock of information. In the afternoon I visited Mr. Curwen but obtained little from him from his age and want of memory. A contemporary, by comparing ideas, might even now get much from him. He was a Son of the Rev. G. Curwin & from early life was fond of possessing & noticing every thing curious and has saved from distruction many curious things, but leaving the Country in the Civil war, his Books and Papers fell into unworthy hands & were dispersed or distroyed. He has a very rich three quarter portrait of old George Curwin who came to Salem in 1633. He had a round large forehead, large nose, high cheek bones, grey eye. His dress was a wrought and flowing neckcloth & a belt or sash covered with lace, a coat with short cuffs & reaching half way between the wrist and elbow, the shirt in plaits below, a cane, & on the ring finger an octagon ring. This dress was preserved till the present Century & was stolen & the lace ripped off & sold, for which the offender was publickly whipped.[8]

Bentley's waste book records that the Curwen portrait cost $4.00, paid to George Ropes, a local deaf-mute who worked with Michael Corné.[9] Corné figures frequently in Bentley's diary and account books. He copied several portraits in oil for Bentley;

FIG. 2.3. Michel Felice Corné (ca. 1752–1845). John Leverett. Oil on canvas. American Antiquarian Society. Bequest of William Bentley, 1819.

that of John Leverett cost Bentley $6.00 in 1803[10] (fig. 2.3). Less successfully, Corné undertook painting conservation; when Bentley exchanged his painting of the Reverend Curwin, Sr., for 'a mean painting of Gov. Burnet of 1729,' he noted that 'this picture of Curwin was a ¾ length and much defaced. I cut out the part representing the head & employed Corné to supply the part injuried, but he did it in a very clumsy manner. At length H. C. [Hannah Crowninshield, Bentley's pupil] undertook it & with the band before her with great success.'[11]

Several years earlier, in 1808, Bentley had noted that 'Mr. Corné continued to enjoy his reputation as a painter of Ships. In every house we see the ships of our harbour delineated for those who navigated them. Painting before unknown, in its first efforts, is now common among our children.'[12]

A few years later, however, Bentley was somewhat less enchanted with the increasingly well-established artist:

December 1 [,1809]. Went with my young females H[annah] C[rowninshield] H. H[odges] & M[ary] W[illiams], to see Corney's Bay of Naples. Found it only a copy of the Common plates at the entrance neither showing the City nor Basin & without one stroke of originality. The Claim on the public notice was from a display of the American Ship Constitution dressed in flags of all nations with the six Gun boats lent by the King of Naples in the affair of Preble ag[ainst] Tripoli. Just such a parade he made of Columbus & his egg which proved, as this painting, to be only on a larger scale, the Etching of Hogarth, without the single addition of a single stroke of the pencil. A copy of the last is now in the Museum of the East India Society, Salem [now in the Essex Institute]. These things seem to speak the infancy of the Arts. And yet it is said to have had unbounded admiration in Boston & is exhibited in Salem at ¼ D [25 cents admission]. It is about 10 by 8 feet probably & as the Keeper says looks best at a distance. I shall never forget his mending the Neck cloth of Curwin & daubing one of the best Antiques of our Country. He is a very well meaning man & is indebted to all times for his share of reputation.[13]

Other barbs were directed at the painters John Coles and Benjamin Blythe, whom Bentley termed 'wretched daubers at best' for their unfinished portrait of General Fiske. Bentley complained that 'none of their portraits are finished but they have sometimes taken likenesses. . . . That of Fiske very bad. It is servile.'[14]

Samuel Harris, an artist who received Bentley's unstinting praise, not only provided Bentley with the red chalk drawings now at the American Antiquarian Society, but he also supplied Bentley with prints, such as a mezzotint of Joseph Warren, and Samuel Oakey mezzotint of Samuel Adams.[15] Bentley noted in his diary of September 18, 1805, 'Mr. [Samuel] Turrell has proposed his young friend for the Historical Society. He mentions a young Samuel Harris, Engraver from Boston, who has displayed taste in his profession & an inclination for Oriental Literature. Who can say that I shall now see American genius ripen in my own times?'[16]

Among the portrait subjects Harris drew for Bentley were Simon Bradstreet, Rev. Jeremy Belknap, Governor Winthrop, Sir Francis Drake, Sir Walter Raleigh, John Smith, the Elisha Cookes, father and son, and Mather Byles Junior (figs. 2.4

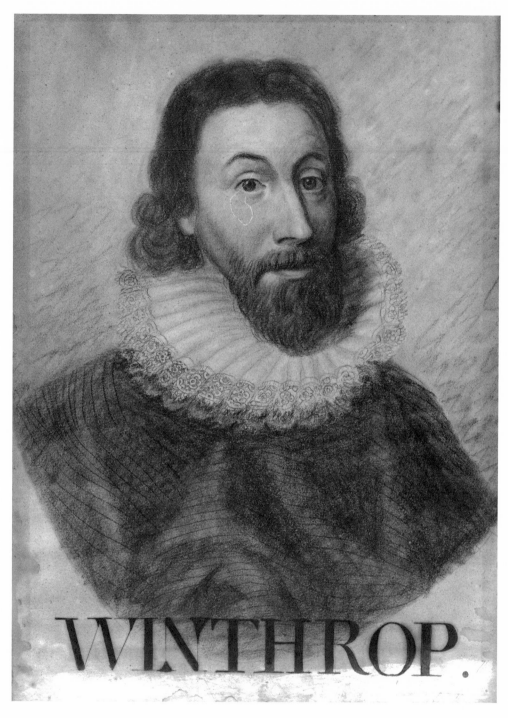

FIG. 2.4. Samuel Harris (1783–1810). Red chalk drawing of John Winthrop. American Antiquarian Society. Bequest of William Bentley, 1819.

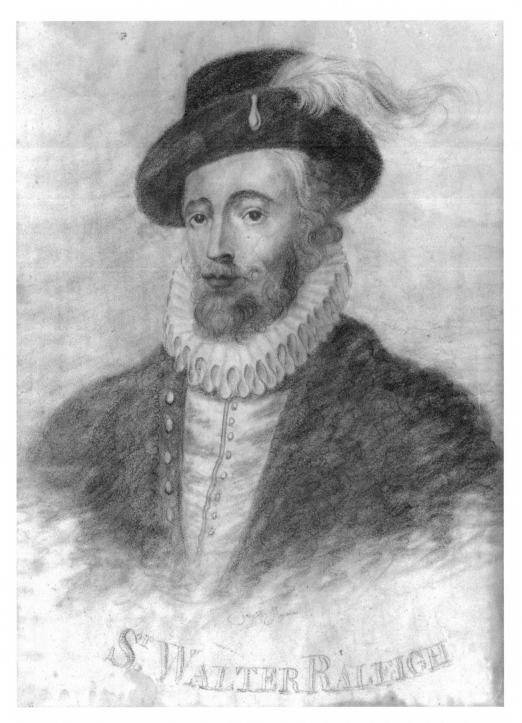

FIG. 2.5. Samuel Harris. Red chalk drawing of Sir Walter Raleigh. American Antiquarian Society. Bequest of William Bentley, 1819.

and 2.5). The inscription in Arabic on the drawing of Byles gives evidence of Harris's interest in Arabic, for which Bentley had great hopes. Sadly, less than five years after their initial acquaintance, Bentley had to record in his diary, 'This day proved the melancholy day of the exit of my young friend Samuel Harris. He was drowned when bathing this morning in the Charles near the College. He was to graduate this Commencement & had a Hebrew oration assigned him He has furnished me with my best painting & engravings, with some rare copies of some ingenuous oriental curiosities & with many curious letters. . . . From no man had I greater expectations as my attentions during his life time abundantly prove. In a moment our thoughts perish.'[17] The self-taught Harris had also engraved numerous portraits, largely of clerics, for the *Polyanthos* magazine during the two years prior to his untimely death.

Gifts were another form of acquisition for Bentley's collection. In 1803, his pupil, Benjamin Crowninshield, then in Virginia, sent him 'a head of MADISON, illumined, Or, on Glass, & also a head of GALLATIN, in the same manner.'[18] The following day, Benjamin's father, Jacob Crowninshield, gave Bentley a companion head of Jefferson.[19] The gilt, reverse-glass portrait profiles of Madison and Gallatin may be seen at the American Antiquarian Society (fig. 2.6). Crowninshield made frequent gifts of books and prints to his mentor, including a St. Memin profile of Jefferson.[20]

Among the prints for which Bentley is known to have subscribed was a portrait of Alexander Hamilton[21] and the elegant engraving by F. J. Renault of Cornwallis's surrender at Yorktown, produced in New York in 1806 at a cost of $12.00 per copy (for which Bentley paid one dollar in advance).[22] But possibly the best source of portrait engravings for Bentley's collection was his nephew, William Bentley Fowle in Boston, who sent his uncle a steady stream of works portraying American clerics, statesmen, and military heroes. Among the works were engravings of the following men: the Reverend E. D. Griffin, engraved by W. S. Leney after Wood; R. T. Paine, engraved by Elkanah Tisdale, after Gilbert Stuart; William Bainbridge, Isaac Hull, and William Heath, all engraved by J. R. Smith.[23] In addition, Bentley's art collection even helped to make a civic contribution for festive occasions. One such event was the Fourth of July celebration at Salem in 1804. Bentley's diary entry for that date noted:

In the morning a collection of Ladies of Taste began the decoration of the Meeting House. The Gallery was festooned, the Pillars wreathed & every flower of the season displayed itself. The front of the Pulpit was decorated with the arms of the United States, inscribed American Independance. Below was an elegant engraving of Jefferson, who was also displayed on the front gallery, on glass in gold. On his right hand was Washington & on his left a beautiful figure of Liberty. On the sides of the Arms of State were in Gold, Madison & Gallatin, below Gen. Gates, the immortal hero of the Northern Army. To give a presence of our venerable ancestors on the interesting occasion a Painting of the venerable Gov. Endicott & another of the worthy Gov. Leverett, both done by M. Corné, an Italian, appeared on the right, & on the left the paintings of the worthy Higginson, Minister of Salem, . . . & Capt. George Corwin, the first Merchant of Salem & first Master of Horse

*in New England, the man who gave character which has so long distinguished Salem.
. . . In the front below, in a Bust cut by Mr. Macintire, an ingenious artist of Salem, was
Gov. Winthrop & a likeness taken by Haslitt. The ornaments were displayed with great
judgement & excellent effect.*[24]

Thirteen years later, in 1817, some of the same pictures were offered to adorn a hall
for the Salem visit of President Monroe. But taste had obviously changed, much to
Bentley's chagrin. His diary records the following:

*[July] 7 [1817]. In decorating the hall for the reception of the President on the morrow it
was my purpose to encourage a display of portraits such as could be found of the fathers of
Mass. particularly of the County of Essex. I could supply in paintings, Endicott, &
Leverett, & Cap. Curwen, our first Merchant and Captain of Horse, & F. Higginson,
our first Minister. I could give in Chalks, Winthrop, & Bradstreet, the first & last old
Charter Governour, besides W. Raleigh, the first Discoverer on the Atlantic & Drake on
the western Ocean. I had Curwen, g. son of Capt. C., the minister of Salem, the Mathers,
& several Boston ministers of the past century, with many characters of the revolution,
Army & navy, & Civil list. But it was overruled in favour of history paintings such as of
naval actions. & c.*[25]

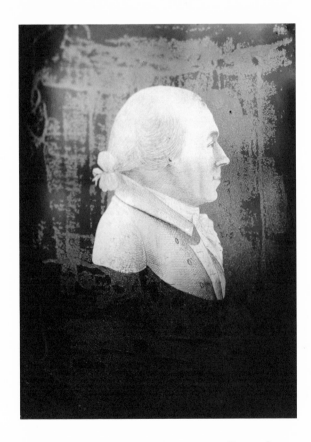

FIG. 2.6. Charles Peale Polk (1767–
1822). Verre églomisé of James
Madison (ca. 1802–3). American
Antiquarian Society. Bequest of
William Bentley, 1819.

Bentley might be described as a voracious culture collector in his pursuit of knowledge. His diary is filled with references of frequent visits to private and public libraries, museums, and collections. His comments give us a detailed insight into aspects of New England cultural life ranging from bizarre showmanship to genuine attempts at raising the level of native American art consciousness. In February 1790, Bentley described the pleasure of seeing a 'complete collection of Hogarth's paintings in some admirable engravings' at the home of the Marblehead Episcopal minister, Rev. Thomas Fitch Oliver.[26] The collection of Mr. Joseph Barrell in Charlestown afforded 'large & elegant arrangements for amusement, & philosophical experiments. His birds played in a globe surrounded with a globe of water in which the fish play. He has an excellent portrait of Dr Cooper from the original with the Governor. He has an original of Mr Clarke. He has a variety of paintings, engravings, & representations in clay from China.'[27] Barrell's American Indian artifacts, elegant furniture, garden statuary, and summer house in the Chinese manner further impressed the minister from Salem. Whenever he was in Cambridge, Bentley enjoyed poring over the volumes of engravings illustrating Herculaneum excavations and travels to far-flung corners of the world. He considered Harvard's collection of Wedgwood jasperware medallions 'a great success.'[28] On Cape Ann, the house of Captain and Mrs. Beach, Bentley admired the portraits on the walls: 'elegantly in frames & glass all the representations & cuts of Cooke's Voyages, besides a full portrait of Capt. Beach upon an eminence, with a painting of the death of Hector. At the Father's we have an Italian view taken from a painting in the Pamphili palace of Rome, richly colored.'[29] Engravings from Raphael's paintings adorned numerous libraries that Bentley visited, and also presented views of ancient cities, natural history, and antiquities.[30]

In the course of several visits to Daniel Bowen's Columbian Museum in Boston, Bentley viewed Patience Wright's celebrated wax figures, menageries of bored animals, musical clocks, paintings, wax tableaux, and tapestries depicting the death of Louis XIV (which did not, however, impress him as much as a painting of the resignation of Washington).[31]

Bentley diligently visited church vestries to inspect the portrait engravings of New England clergy, including those of Drs. Timothy Culter, John Breynton of Halifax, Nova Scotia, and Henry Caner [by Pelham] at Christ Church, Boston.[32] Religious paintings also came under Bentley's interested scrutiny as he made the rounds of local churches. An altarpiece by Henry Sargeant at the new Catholic Church of the Holy Cross elicited only a mixed reaction. 'It has undoubtedly great merit in such circumstances, but the rising breast & knees did not agree with my ideas of Anatomy.'[33]

Churches were not the only location for viewing paintings with large-scale themes; not infrequently, prints were the sources of local attempts at art self-education. In 1812 Bentley wrote:

Thursday I visited Rev. N. Fisher, at the request of his Son Theodore, to see a painting in Imitation of Claude Lorrain's Temple of Apollo, from an engraving by Wootton. Mr.

Fisher has enlarged it to 6 feet square. The natural scenery is excellent. His animals well done. The temple & worshippers rather too strong colours. But the Grove below is pure nature & the execution compared with his former paintings discovers the rapid progress of his improvement. As my acknowledgement I presented to him the engraving from which he has executed this work & urged him that it might be displayed in the Athenaeum or E. India Museum. As my pupil H[annah] C[rowninshield] had imitated the engraving from Salvator Rosa's Philosophers & also an Engraving from Michael Angelo Buonorato of the Holy Family, I gave these engravings to her as the testimony of my approbation of her genius & her progress.[34]

The War of 1812 provided unexpected opportunities for art connoisseurs through the many sales of cargo from captured ships. One such sale is recorded by Bentley in June 1815:

Was at the store upon invitation of G. C[rowninshield] to see the wonderful assortment in the Bark Adeona taken by the America & ordered to this port. The variety of Stationery & the great elegance in which the books were bound, was my first attraction. The paintings were good, two scripture pieces of the Nativity & Holy family had claims, but the best one in the Dutch way was the pursuit of the maroons in Jamaica. The sceneries in England & Scotland were good & the heads of several military characters were interesting but could not compare with a collection shewn me from Mr. Palmer containing in a quarto one hundred heads of persons belonging to the Legion of Honour. The Assorted Cargo of the Adeona exhibited every kind of furniture of the light sort & some elegant silver & plated ware.[35]

Visits to Boston afforded Bentley many opportunities to visit exhibitions of paintings. The minister from Salem did not limit himself to portrait or religious or historical paintings. During an 1817 trip to Boston, Bentley viewed Vanderlyn's famous nude 'Ariadne' and commented, 'The expression was happy & in a higher style of execution & effect than I had ever seen.'[36]

Although Bentley's huge library contained numerous books of engravings of classical antiquities, engravings after Raphael, and books of costumes, medals, and travel illustrations, Bentley's decorative print collection seems to have consisted entirely of portrait heads, many of which were issued as frontispieces of books. In June 1794, he made a list of his possessions, including '36 pictures framed & glazed of various sizes, 2 miniatures, 2 bustes, ½ dozen small black-framed pictures, 3 metal-gilt framed pitures . . . [a] Half dozen of elegant large Engravings with mahogany mouldings.'[37] By the end of his life, Bentley's study must have been hung in a floor-to-ceiling manner in order to accommodate the collection that he had made his life's work. Two highly descriptive passages from Bentley's manuscript day books illustrate his achievements. He penned them a year before his death in December 1819, possibly in an unconscious effort to set his collection in order. On November 25, 1818, he wrote:

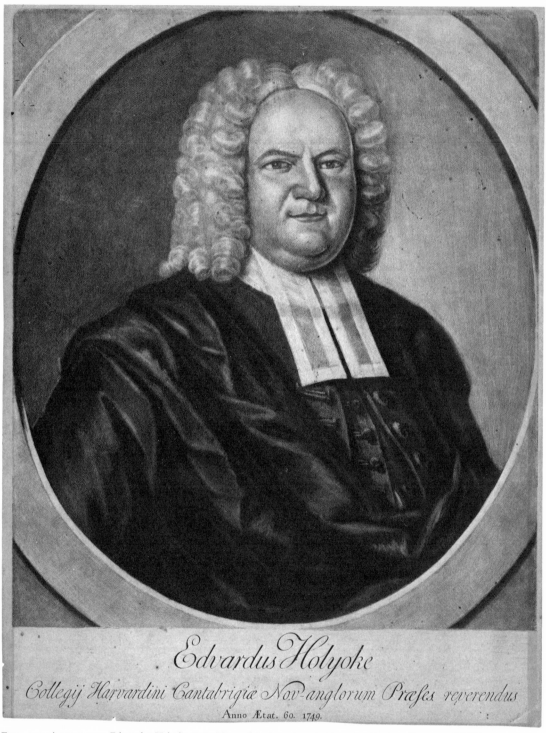

Edvardus Holyoke

Collegij Harvardini Cantabrigiæ Nov-anglorum Præses reverendus

Anno Ætat. 60. 1749.

FIG. 2.7. Anonymous. *Edwardus Holyoke*. 1769. Mezzotint. American Antiquarian Society. Bequest of William Bentley, 1819.

FIG. 2.8. Peter Pelham (ca. 1697–1751). *The Reverend Benjamin Colman D.D.* (Boston, 1735). American Antiquarian Society. Bequest of William Bentley, 1819.

I have been long wishing to complete this Life with the five presidents Franklin, Gates,
Waine, Eaton, Hancock, Adams, Smith, Endicott, Winthrops, Leverett, Bradstreet,
Raleigh, Drake, Penn, Vane, Saltonstal, Hollis, Pitt, Stark, Pepperell, Wolfe, Amherst,
Legge, Pocock, Curwin & I have added names of eminent clergy, Higginson, Curwin,
Williams, Mathers, Peters, Belnap, Byles, Coleman, Sewall, Willard, Holyoke (fig. 2.7),
Welsted, Westley, Whitefield, Hopkins, Prince, Thacher, Styles, Lathrop, Freeman, Eliot,
Cummings, Clark, &c. Besides such of the English Communion, Cutler, Brockwell, Caner.
In these I include all who have been active in American affairs in whatever way their
services may have been employed. Besides these many of whom I have portraits are not
exhibited on my walls.[38]

The other passage was dated February 28, 1818. In this entry, Bentley provides a
detailed description of a number of his possessions:

Received of my Nephew WB Fowle half a dozen Mezzotintos of Coleman & Sewall (fig.
2.8). He paid one Dollar a dozen. These are from Smibert's Paintings, & Pelham's plates
10 by eight inches. About the middle of the 18 Century, these two artists encouraged this
token of respect in Boston. In the family of the Mathers was a collection of the four successive
preachers of New England, Richard, Increase, Cotton & Samuel & of Richard's son
Samuel of Dublin, & of Richards Son Nathaniel of London. Of Francis Higginson was a
painting left & it is still in the Court House of Massachusetts. I have seen no others of the
first generation. I have seen one of the first Thatcher who died in 1670 at Rev.ᵈ Robbins,
Milton & one of President Wadsworth who died 1737. The first of the Old South Boston &
the last of the Old Church Boston. I have one of President Willard of the Old South who
died 1707 from GV der Gucht but I know nothing of the painting from which it was taken.
I have a portrait from a wooden Block of Richard Mather who died 1669, with his name
printed below. It has the black cap and collar/queue band, the book in one hand & bow
spectacles in the other, in extreme simplicity of execution. I have an engraving of Thomas
Prince of the Old South who died 1758, the painting from John Greenwood & the plate from
P. Pelham.

I have another of Coleman aet. 30/1703 with his family arms below. 7 by 4 inches &
another the same size of Increase Mather, when 80 years of age, 1719. & another of E:
Pemberton the father, published with his Sermons in 1725. At the time of Pelham I have
seen S. Mather, W. Cooper, Andrew Eliot, W. Welsteed, W. Hooper & E. Pemberton the
Son, & I have in my possession three of the Epic Clergy.

That [of] Timothy Cutler & Ch. Brockwell were both painted & eng. by P. Pelham.
That of Dr. Henry Caner was painted by Smibert & the plate from Pelham. I have seen
one of Cotton Mather but remember not its history. After this period several were engraved
One of Mather Byles Sen. & son. One of Dr. Walter, one of Dr. S. Cooper, of J. Morehead,
one of Jonᵒ Mayhew, &c. That of Dr. S. Cooper I have from an excellent painting in the
possession of Gov. Hancock who once put the painting at the foot of the table in memory of
our common friend. It was engraved by V. Green his Brit. Majesty's engraver in 1784. I
have an engraving of John Davenport who died minister of the First Church in Boston
1670. It was engraved for Trumbull's H. of Conn. as he was M[inister] in New Haven

from 1638 to 1668. Since the Revolution many portraits have been taken & plates from them & I have those of Dr. Styles, Dr. M. Byles, Dr. Thacher &c. I have one of President Holyoke taken when he was 60, in 1749, & one of Whitfield, the best Pulpit Orator who visited our Country tho' not as famed for eloquence as elocution. This was imported by his friends. G. Beard painted it & J. Faber made the plate. It was taken in his youth. I have an engraving of W.^m Peters of Salem taken from his life by Bp Peters & copied by my pupil H. C. I have a Copy of I H conformed to the character of John Higginson. I have a painting of Rev.^d S. Curwen from the family painting, I have one of John Clarke of the Old Church Boston by W. Lovett p. & G Graham engraver. My worthy young friend S. Harris engraved a Dr. Belnap & my female pupil H. C. supplied another. A most admirable ptg. by Steuart is in the family of Dr. Lathrop, as is another of Dr. Pemberton my other minister. We had in our family two paintings, of Gray & Welsteed, but at present they are not at my disposal. I have profiles of Dr. Tiernan, & Eliot, of Dr. Cummings of Bilerica, as well as Dr. Lathrop & Mr. Cary of Newbury Port. Mr. Carey had one copy of the painting, of Grey & Mr. Thayer of Braintree another. I am not without hopes of rendering my own collection still more complete. I have excellent chalks from my friend Harris both of Dr. Byles & Belnap & would have been still better provided had his life been spared. He executed these of Mr. Byles & Thacher & had begun a series of engravings for a periodical work to which they belonged & from which he sent these to me.[39]

Bentley died of a heart condition on December 29, 1819. His will left his German books, New England printed books, his paintings and engravings, his cabinet of curiosities and manuscripts 'not in his own hand' to the American Antiquarian Society. His classical and theological books, lexicons and Bibles went to Allegheny College in Meadville, Pennsylvania, founded by his old friend Timothy Alden. He charged his nephew, William Bentley Fowle, who had provided him with so many books and prints for the collection, with the destruction of all his own manuscript writings. Fowle had, perhaps, inherited his uncle's sense of history and appreciation for the past, and we have him to thank for the preservation of one of the Federal era's most fascinating documents, without which this extraordinary print collection would not have come alive.

NOTES

The manuscripts of William Bentley's diary are located at the American Antiquarian Society. All quotations from the diaries cited in this paper are taken from William Bentley, *The Diary of William Bentley D. D.*, 4 vols. (1905–14; repr. Gloucester, Mass.: Peter Smith, 1962). The chronology of the diaries is as follows: vol. 1 (Apr. 1784–Dec. 1792); vol. 2 (Jan. 1793–Dec. 1802); vol. 3 (Jan. 1803–Dec. 1810); vol. 4 (Jan. 1811–Dec. 1819).

1. *Diary*, July 30, 1798 (vol. 2: 277).

2. *Diary*, Feb. 28, 1791 (vol. 1: 235).

3. *Diary*, Oct. 15, 1795 (vol. 2: 162).

4. *Diary*, Feb. 11, 1800 (vol. 2: 329).

5. *Diary*, Feb. 5, 1796 (vol. 2: 172).

6. *Diary*, Feb. 8, 1796 (vol. 2: 172).

7. *Diary*, May 19, 1797 (vol. 2: 223).

8. *Diary*, Mar. 5, 1798 (vol. 2: 259–60).

9. All manuscript sources from the day/account books of William Bentley are located at the American Antiquarian Society. 'Account book,' Dec. 8, 1804 (folio vol. 4: 183).

10. 'Account book,' Apr. 15, 1803 (folio vol. 4: 29). There is another copy of Endicott by Corné, for which Bentley paid $13.00. This is noted in 'Daybook,' Oct. 12, 1802 (folio vol. 4: 27).

11. *Diary*, Nov. 30, 1819 (vol. 4: 631).

12. *Diary*, Jan. 6, 1804 (vol. 3: 68).

13. *Diary*, Dec. 1, 1809 (vol. 3: 481–82).

14. *Diary*, Oct. 25, 1809 (vol. 3: 470).

15. 'Daybook,' Nov. 11, 1806 (folio vol. 4: 75).

16. *Diary*, Sept. 18, 1805 (vol. 3: 191).

17. *Diary*, July 7, 1810 (vol. 3: 530).

18. 'Daybook,' May 18, 1803 (folio vol. 4: 94).

19. 'Daybook,' May 19, 1803 (folio vol. 4: 94).

20. 'Daybook,' Mar. 22, 1805 (folio vol. 4: 89).

21. 'Daybook,' Dec. 21, 1804 (folio vol. 4: 84).

22. 'Daybook,' Oct. 27, 1806 (folio vol. 4: 76).

23. 'Book Accounts,' 1818 (octavo vol. 14: 59, 69).

24. *Diary*, July 4, 1804, (vol. 3: 96).

25. *Diary*, July 7, 1817 (vol. 4: 463).

26. At the home of Thomas Fitch Oliver, Episcopal minister of St. Michael's Church, Marblehead. *Diary*, Feb. 4, 1790 (vol. 1: 140).

27. *Diary*, June 12, 1791 (vol. 1: 264).

28. *Diary*, July 21, 1791 (vol. 2: 278).

29. *Diary*, Apr. 5, 1792 (vol. 1: 360).

30. For example, the library of Mr. Winship of Brighton, Massachusetts, was well-appointed with engraved portraits. *Diary*, Aug. 25, 1813 (vol. 4: 192).

31. *Diary*, Mar. 12, 1798 (vol. 2: 261).

32. *Diary*, Apr. 20, 1802 (vol. 2: 427).

33. *Diary*, Oct. 7, 1803 (vol. 3: 51).

34. *Diary*, Nov. 7, 1812 (vol. 4: 129–30). On June 27, 1819, Bentley records the untimely death of Theodore Fisher at the age of thirty.

35. *Diary*, June 9, 1815 (vol. 4: 334).

36. *Diary*, Nov. 13, 1817 (vol. 4: 486). Bentley also viewed Sargeant's 'Landing of the Forefathers' and 'Entry of Jesus into Jerusalem' that same day.

37. 'Commonplace book,' 1783–95 (octavo vol. 17, n.p.).

38. 'Book Accounts,' Nov. 25, 1818 (octavo vol. 14: 69).

39. Ibid., pp. 11–12.

Effigies Curiously Engraven:
Eighteenth-Century American Portrait Prints

WENDY WICK REAVES

Dᴜʀɪɴɢ ᴛʜᴇ ᴄᴏᴜʀsᴇ of its history, some rather extravagant claims have been made for portrait engraving. There is, for instance, the opinion of the English collector James Granger that 'no invention has better answered the end of perpetuating the memory of illustrious men, than the modern art of engraving A methodical collection of engraved heads will serve as a visible representation of past events, become a kind of speaking chronicle . . . , will delight the eye, recreate the mind, impress the imagination, fix the memory, and thereby yield no small assistance to the judgment.'[1] Praising the contemporary English engravers in 1634, Henry Peacham wrote that their portrait prints were 'cut to the life, a thing practised but of late yeares: their pieces will best instruct you in the countenance, for the naturall shadowes thereof, the cast and forme of the eye, the touch of the mouth, the true fall, turning and curling of the hair, for ruffes, Armor, &c.'[2] The portrait prints of Albrecht Dürer easily justify these claims. Dürer's portrait of the reformer Melancthon does assist our judgment of the man and does instruct us in his countenance. Certainly it impresses the imagination and delights the eye. Judgment of character is not greatly assisted, however, by some of the crudely made American portrait prints of the eighteenth century. In engravings by Paul Revere or John Norman, the 'cast of the eye' and the 'touch of the mouth' are indeed suspect; and some of the primitive relief cut portraits may appear more distressing than delighting to the eye.

If these works are not great art, if they are not necessarily accurate contemporary likenesses, students of Americana must ask themselves what gives these treasured images their charm and their significance. How do they fit into the tradition of the engraved portrait, and what purpose did they serve?

Let us look first at the background of the printed portrait, which was, as A. Hyatt Mayor has pointed out, 'one of the best paid and most dependable specialties of printmaking until about 1900.'[3] Although portrait engraving began in the fifteenth century, Dürer securely established the profession in the 1520s with a series of six portraits combining technical competence, psychological insight, and accurate representation of a human visage. From that time on, portrait prints became a standard element of the printmaker's trade.

Many of the early portrait engravings were commissioned by wealthy patrons, monarchs, or officials. Catherine de Médicis, for example, requested portraits of

herself and her courtiers for presentation to other courts. If not commissioned, portrait engravings were sometimes a commercial venture to celebrate an event in the life of a famous person. Frequently, they were reproductions of the work of a noted painter. From the sixteenth century onwards, engravers supplied the market with portrait prints after Raphael, Rubens, or Van Dyck, leading up to the flood of mezzotints after Reynolds and the eighteenth-century English portraitists.

The use of portraits as frontispieces and book illustrations developed along with the separately published print. A major stimulus to this growth in seventeenth-century England, where portraiture completely dominated the field of engraving, was the publication of two important volumes of engraved portraits, the *Baziliologia* of 1618, which was a series of engravings of the English kings, and the *Herologia* of 1620, containing the likenesses of English intellectuals and celebrities. These portraits were highly regarded by their contemporaries and seemed to have stimulated a demand from book publishers for engraved portraits to use as frontispieces and illustrations.

With this background in mind, let us now consider the American prints that have descended from these European traditions. Through examining the format, subject matter, technique, and source of these portraits, we can attempt to establish some chronology of the changes from the beginning to the end of the century and determine where and why these images appear.

The story of North American portrait engraving begins with a primitive woodcut of Richard Mather, a minister in Dorchester who was the progenitor of the famous Mather clan. It is the first known American portrait print and our only example from the seventeenth century. The woodcut of Mather introduces a number of characteristics common to the American portrait prints that followed. The subject matter, in the first place, is typical. Since clergymen played such a dominant role in colonial life, they were most frequently the figures that the community wanted to commemorate in prints. Authors portrayed in the frontispieces of the largely theological literature of the period also tended to be ministers. The direct, unembellished style of the Mather cut is also characteristic of these prints. Finally, despite the scarcity of painted portraiture, it seems that these images were attempts at accurate likenesses far more often than would be expected.

It is not known whether the Mather portrait was conceived as a book illustration. The print that appears to be the earliest impression was bound into a pamphlet published just after Mather's death in 1669, but no other copies of this pamphlet contain the print.[4] Nevertheless, the close connection between the printed portrait and the book trade is well established by the fact that the print was cut by John Foster, who became the first printer in Boston in 1675. In general, printers and publishers, well aware of the book illustrations in English volumes, provided the major impetus in the production of portrait prints. Foster may have made the block around 1670, as a commemorative portrait. He knew Mather, and in fact had been baptized by him; so perhaps the cut was his tribute, intended for distribution among the members of the Mather family.

Despite its primitive qualities, the Mather cut conveys the idea that there was,

from the beginning, a concern for creating an accurate likeness of the subject, especially if the individual was a contemporary. The printed image is a careful copy of the American Antiquarian Society's painting of Mather, also probably executed by Foster, just before Mather died. This portrait has been in poor condition at least since 1804, when William Bentley commented on it in his diary. But assuming that it was somewhat less damaged then, it is interesting that Bentley attests to the accuracy of the print when he commented on the painting, 'That of Richard will soon be gone. It agrees as well as possible with my block print.'[5] Obviously, Bentley was a proud and interested owner of the print himself. Thus, more than one hundred and thirty years after its creation, this naïve woodcut was not merely a chance survivor but a carefully treasured likeness of a Puritan divine. One can only imagine its value to its original owners.

The naïveté of the Mather cut imparts a quality of directness and forcefulness that seems to become a stylistic tradition for the eighteenth-century American portrait print. Of course, not all colonial engravers were untrained, and many were practicing artists in Europe before their emigration to America. If one can propose any generalization at all, it might be that, for the majority of these prints, decorative conventions are kept to a minimum. While elaborate architectural backgrounds,

FIG. 3.1. Thomas Emmes. *Increase Mather* (Boston, 1702). Courtesy, Metropolitan Museum of Art. Bequest of Charles Allen Munn, 1924 (24.90.1821)

embellished frames, sumptuous costumes and jewels, and surrounding rococo fantasies are all common elements of European portrait prints, most of these embellishments are omitted or only suggested in the American portrait print. It becomes, therefore, a more concentrated representation of a human face.

The book trade, in the eighteenth century, stimulated the growth of portrait engraving. The first copperplate engraving made in America, with the exception of Massachusetts currency, was the portrait of Increase Mather (fig. 3.1), found in three publications by that prolific writer. The first state of the engraving is found in the latest of the pamphlets. Having printed several impressions without the hatched background, the engraver must have discarded them and improved upon his plate. At a later date, the publisher apparently decided to use these first impressions in one more Mather publication, an indication of the value put upon these images.

The Increase Mather print, copied from an English engraving of Mather, and engraved by Thomas Emmes in 1701, introduced the typical format of the portrait frontispiece. The small English portrait, so firmly established by the seventeenth-century frontispieces, followed a general formula. Usually, it was a half-length image or a bust enclosed in an oval frame within a rectangle. The oval frame, sometimes highly embellished, was set on a pedestal or in a quasi-architectural setting. Nathaniel Morse's engraving of Matthew Henry (fig. 3.2), published in *The Communicants Companion* (Boston, 1731), is a typical American derivation of this basic style. A common variation was the half-length portrait in a rectangle (see James Turner's *Isaac Watts*, fig. 1.6). By the last decade of the century, the formula had evolved into a simple bust-length likeness silhouetted against a stippled background and enclosed in an oval frame.

The inclusion of a portrait frontispiece of the author, frequently copied from the engraving in an English edition, became an increasingly common practice in the book trade. The publishers who went to the expense of including a frontispiece were always optimistic about the commercial benefits that would result. The Boston publishers Rogers and Fowles, for instance, referring to the engraving of Isaac Watts just mentioned, advertised that 'the Doctor's effigies, curiously engraven', was 'prefix'd' to their seventh edition of the author's *Sermons on Various Subjects, Divine and Moral* (Boston, 1746).[7]

Sometimes the engraved English frontispiece was copied as a relief cut for the American edition of the book. The portraits in Hugh Peter's *A Dying Fathers Last Legacy* (Boston, 1717) and in *Hodder's Arithmetick: or, That Necessary Art Made Most Easy* (Boston, 1719), by James Hodder, are two examples. The portrait of Hugh Peter, copied from the engraving in the 1660 English edition of the same book, is in the typical oval portrait format. In the lower corner, it bears the incription 'J. F. Sculp.' Both prints have been attributed to James Franklin, printer of *Hodder's Arithmetick*.[8]

Like Foster, James Franklin was a printer and publisher. Having just returned from his apprenticeship in London in 1717, he would have been aware of the vogue for author frontispieces. Lacking trained engravers in Boston, he probably executed these two relief cuts himself. The cut of James Hodder (fig. 3.3) is a copy of the engraving by Gaywood in an English edition, but the translation into a different

FIG. 3.2. Nathaniel Morse (1688–1748). Engraving of Matthew Henry in *The Communicant's Companion* (Boston, 1731). American Antiquarian Society. Purchase, 1973.

FIG. 3.3. James Franklin (1697–1735). Portrait of James Hodder in *Hodder's Arithmetick* (Boston, 1719). American Antiquarian Society. Gift of Charles H. Taylor, 1931.

medium has curious results. In an attempt to render the work exactly, the artist imitated the horizontal lines of the background shading from the English engraving. Because of the thickness of the relief line, however, it gave a completely different effect. Instead of suggesting atmosphere or depth, it became a flat, dense screen of lines, against which the face is silhouetted.

Lawrence Wroth and Marion Adams have pointed out that the Franklin cuts were made with a graver on metal, rather than on wood using a knife.[9] They also noted that the technique of white-line engraving in relief continued throughout the century. The Franklin cuts are a reminder that the technological innovations of wood engraving in the 1790s, which produced such an increase in inexpensive book illustra-

tion, have precedence in the white-line metal cuts of early children's books, almanacs, and other cheap publications.

Relief cuts were generally made in the printer's shop, and only rarely were they made by someone competent in the technique. Indeed, the 'J. F.' plates seem quite sophisticated in comparison to some of the relief cuts that followed. In multiple American editions, where the portrait was copied numerous times, the image sometimes degenerated beyond recognition. Any curiosity about the appearance of the subject remained unsatisfied. Nonetheless, the crudest of frontispieces was thought better than none at all. Sometimes, the author's portrait appeared even when his name did not. *The History of the Holy Jesus* (Boston, 1749), for instance, was illustrated with a print of 'The Author,' but on the title page the writer was identified to the children only as a 'lover of their precious souls.'

So strong was the publisher's impulse to include any author frontispiece, that a portrait, no matter how unrecognizable, would appear in edition after edition. One image that was copied by many untrained hands was that of the grammarian Thomas Dilworth. Widely read and frequently republished, Dilworth's schoolbooks rarely appeared without some attempt at a portrait. In some editions, the prints were beautifully copied from an English engraving, even including the Gothic lettering of the name (as in *A New Guide to the English Tongue* [Philadelphia: Hall and Sellers, 1768]). However, judging from the various versions of the figure published from Massachusetts to Delaware, the quality of the engraving almost seems to decline with each subsequent publication. In *The Schoolmasters Assistant*, published in Wilmington, Delaware, at the end of the century, the print is scarcely recognizable as a human figure (fig. 3.4).[10] Although the artist made a valiant effort at modeling the face and depicting shells, cartouches, and asymmetrical borders, any attempt to consider the plate a likeness is ludicrous.

Publishers were evidently convinced that any frontispiece was better than none, but if the portrait was really poor, the readers would begin to complain. Noah Webster, who was well known to American school children for his spelling and grammar books long before he became famous for his dictionary, was represented by a crude, relief-cut frontispiece in each of the many editions published by Thomas and Andrews. When the first cut wore out, a copy was substituted that was even worse than the first. It was no wonder that William Cobbett in a mock 'Will and Testament' of 1797 wrote the following bequest: 'To my dear fellow laborer Noah Webster . . . , six Spanish milled dollars, to be expended on a new plate of his portrait at the head of the spelling book, that which graces it now being so ugly that it scares the children from their lessons.'[11] Clearly, by that time, people were beginning to expect something a bit more sophisticated.

The inexpensive almanac was another frequent source for small relief-cut portraits. Almanacs were as ubiquitous as the Bible in colonial households, and individual editions enjoyed a wide distribution. Providing astrological calculations, schedules, and calendars, they also included topical stories or essays that were sometimes illustrated with relief-cut portraits. In addition to their practical utility, therefore, the almanacs became a chronicle of contemporary events and a barometer of

FIG. 3.4. Portrait of Thomas Dilworth in *The Schoolmasters Assistant* (Wilmington, 1799). American Antiquarian Society. Purchase, 1908.

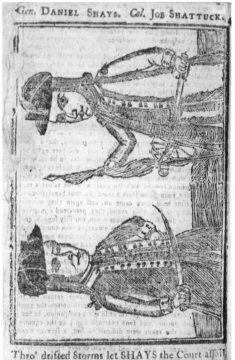

FIG. 3.5. Portraits of Daniel Shays and Job Shattuck in *Bickerstaff's Boston Almanack for 1787* (Boston, 1786). Courtesy, National Portrait Gallery.

public opinion. The little cuts often have an immediacy and a historical significance lacking in more sophisticated prints. It is particularly appropriate, for instance, that the only known contemporary portrait of Daniel Shays, the instigator of Shays's Rebellion—and someone who would not be likely to have his portrait painted—is the cut that appeared in the third edition of *Bickerstaff's Boston Almanack* for 1787 (fig. 3.5). The earliest portraits of this type were two cuts of Queen Anne, based on an English mezzotint, which appeared in different editions of the *Farmers Almanack* for 1714, compiled by Nathaniel Whittemore. Later in the century, Paul Revere made cuts of John Dickinson and Catharine MacCauley for Nathaniel Ames's *An Astronomical Diary; or Almanack* for 1772. Other portrait subjects ranged from Emma Leach, a dwarf 'that lately made her Appearance in Boston' (Ames's *An Astronomical Diary for 1772*), to the better-known James Otis (*Bickerstaff's Boston Almanack* for 1770) and William Pitt (*Bickerstaff's Boston Almanack* for 1772).

Some publishers of relief cuts had what now seems an unconscionable attitude toward the identity of the image. The portrait of Benjamin Keach, published in the 1744 Boston edition of his *Progress of Sin*, also did service as 'The Patriotic Bishop

Dr. Jonathan Shipley' on the title page of *Daboll's New England Almanack* for 1778 (New London, 1777). In the *History of America Abridged for the Use of Children* (Philadelphia, 1795), most of the portrait cuts were used two or three times to represent different Revolutionary War heroes.

Some publishers would include any available cut and, without identifying the portrait, imply that it was the protagonist or author who was thus represented. This practice led to some ludicrous iconography. A portrait of the young lady with a rifle who started life as Hanna Snell, the female soldier (*Thomas's New-England Almanack* for 1775) was used as 'Miss Fanny's Maid' (*A New Gift for Children* [Boston, 1762]) and also as Mrs. Mary Rowlandson (*Narrative of . . . Mrs. Mary Rowlandson* [Boston, 1770]).[12] This image had almost as adventurous a career as the lady soldier herself: copied and reversed, the same figure ended up as Marie Antoinette on the broadside 'The Tragedy of Louis Capet' (Boston, ca. 1793).

What is more remarkable than these indiscretions by the publishers is the number of instances where the relief cuts do represent a specific person and an attempt has been made to secure an accurate likeness. The cut of John Hancock (fig. 3.6) in *Bickerstaff's Boston Almanack* for 1777 (Boston, 1776) is clearly a portrait of Hancock, probably based on a print after the half-length painting by Copley.[13] The compiler of the almanac proudly notes in the preface, 'My present Printer has procured for

FIG. 3.6. Portrait of John Hancock in *Bickerstaff's Boston Almanack for 1777* (Boston, 1776). Courtesy, National Portrait Gallery.

FIG. 3.7. John Norman (ca. 1748–1817). Portrait of John Hancock in *An Impartial History of the War*, vol. 1 (Boston, 1781). American Antiquarian Society.

this work, at a great expense, a number of plates, curiously engraven.' Eighteen years later, at Hancock's death, the same publisher, Ezekiel Russell, used the cut to illustrate the broadside 'Character and Funeral Procession of Our Late Excellent and Worthy Governor Hancock.' Even for modest relief-cut portraits, in other words, there was a concerted effort to find accurate likenesses to copy. For a well-known figure like Hancock, the publisher would feel all the more compelled to present the real image.

Engraved portrait frontispieces were generally of better quality and more complex design than the relief cuts. Portraits like *Matthew Henry* (1731) and *Isaac Watts* (1746), mentioned earlier, are rare in the first half of the century, but after the Revolution such frontispieces began to proliferate. The quality of engraving improved, and the printmakers began to borrow more from American as well as English sources. While portraits were often the standard bust-in-oval format, full-length figures within specific settings became more popular. Robert Scot depicted Martin Luther in his study, Thackera and Vallance engraved Baron von Trenck in his dungeon, and Elisha Gallaudet portrayed George Whitefield sermonizing at his pulpit with arms upraised.[14] Frontispieces for contemporary dramas combined portraiture and illustration by depicting identified actors and actresses in the roles they performed. Thus Snelling Powell impersonates Sir George Airy in *The Busy Body* (Boston, 1794), and Mrs. Lewis Hallam appears as Marianne in a frontispiece to *The Dramatist* (New York, 1793).

The engravings, like the relief cuts, did not always present a reliable likeness. The 1772 edition of *The Entertaining History of King Philip's War* was illustrated by Paul Revere with two portraits, one of the author and one of King Philip himself. There were no portraits in the original edition to copy, but Revere was never hampered by the lack of a source. Along with many other engravers, he borrowed frequently from English periodicals. For the print of the author Benjamin Church, Revere simply copied an engraving of Charles Churchill that was published four years before in the September 1768 issue of the *Court Miscellany and Gentleman and Lady's Magazine* (London, 1768).[15] Although, at first glance, it is hard to believe that the figure of King Philip was anything but a figment of Paul Revere's imagination, the engraving was actually copied from a series of mezzotints known as the 'Four Indian Kings,' engraved in England by John Simon in 1710.[16] The stance, costume, and features of King Philip were taken from the depiction of *Ho Nee Yeath Taw No Row* and the forearm and gun from *Sa Ga Yeath Qua Pieth Tow*. One can only imagine that the flecking of King Philip's skin was an attempt to suggest the Indian's darker complexion, which by any standards has to be recorded as a failure. However, much to his credit, Revere did make a conscious effort to depict an actual North American Indian in features, complexion, customs, and costume.

The portrait engravings by John Norman are particularly interesting to examine in terms of sources and the accuracy of likenesses. Norman, who worked in Philadelphia before he moved to Boston in 1780, was especially active in producing portrait engravings. One of the Boston titles he illustrated was *An Impartial History of the War in America*, published in three volumes between 1781 and 1784. In several English

editions of this work, the engraved illustrations of officers from both sides are either bust-size portraits in oval frames or full-length figures. Since Norman borrowed from both of these sets of engravings for his American editions, it is necessary to determine the sources for the English prints. For the depiction of American officers of the war, the English printmakers borrowed from a completely inaccurate but extremely influential series of mezzotints that had been published in London between 1775 and 1778.[17] Issued by the fictitious publishers 'Thomas Hart,' 'C. Shepherd,' and 'John Morris,' these portraits of American officers were the first readily available likenesses in Europe of the new heroes, and they were widely copied. Certain characteristics of the series, such as the round, generalized facial features, and tricornered hats, gorgets, and sashes appear in a number of European prints of the period.

The English illustrations of American officers in the *Impartial History* are based largely on the Shepherd-Hart-Morris series, and Norman copied details of the former for his own illustrations in the Boston edition. He departed from the usual practice, however, by not copying the English engravings entirely. Instead, he made a decided attempt to find an accurate likeness. In his plate of John Hancock, for instance (fig. 3.7), the stance of the figure and the setting were copied from an engraving in a 1780 London edition of the *Impartial History*. The face, however, is much closer to the Copley painting.

Despite Norman's best efforts, his portraits for the *Impartial History* were criticized by a correspondent to the *Freeman's Journal* in 1795:

The expense of copper plates, however, might be spared, unless they could be executed in a different stile from those in the history of the American War, printed at Boston in 1781 and 82. There gen Knox and Sam Adams, are represented more frightful than lord Blackney on a London ale house sign, and gen Greene the exact resemblance of Jonathan Wild, in the frontispiece of a two penny history. Surely such extraordinary figures are not intended to give the rising generation an improved taste in the arts of designing and sculpture.[18]

Even during his own time, the limits of Norman's artistic abilities were obvious. His effort toward an accurate likeness, however, cannot be denied.

For the *Royal American Magazine* in March and April 1774, Paul Revere also engraved portraits of John Hancock and Samuel Adams, and he used a similar combination of accurate likeness and borrowed embellishment. The title page of the magazine describes the first as 'The Bust of John Hancock, Esq.; supported by the Goddess of Liberty and an ancient Briton.' The allegorical embellishment, used for both Hancock and Adams, was copied by Revere from an English engraving of Richard, Earl Temple, which appeared in *The Scots Scourge*, volume 1 (London, 1765), as well as in *The North Briton Extraordinary*, no. 1763, (no date). The faces of Hancock and Adams, however, are clearly taken from the Copley paintings, or more likely, from the prints derived from them. In other words, even John Norman and Paul Revere, who thought nothing of using one face to portray another, were more prone to accuracy when dealing with famous contemporary Bostonians. It is, of course, also intriguing to consider the impact of these repeated images of a public figure. Of the many prints of Hancock published separately or in almanacs, magazines,

broadsides, and books, almost all of them look like Hancock. This is extraordinary recognition for a figure of his era, and it could only have enhanced his remarkable popularity.

Another engraver who was always very conscientious about the accuracy of his engravings was Amos Doolittle. When he illustrated Benjamin Trumbull's *Complete History of Connecticut* (New Haven, 1797), he chose to portray three historical figures whose painted portraits were available to him. His engravings of John Davenport and Gurdon Saltonstall were both taken from paintings 'in the Museum at Yale College.' The third portrait, that of John Winthrop, was copied from a painting held by the Winthrop family. In each case, the source of the print was carefully noted in the inscription. In two other instances, Doolittle also sought out paintings to copy in producing author frontispieces for books. The engraving of Ezra Stiles in *A History of the Three Judges* (Hartford, 1794) was derived from a painting by Reuben Moulthrop, and the image of Jonathan Edwards, published in two of his works, *The Millenium* (Elizabeth Town, 1794) and *History of Redemption* (New York, 1793), appears to be taken from a portrait by Joseph Badger. Both of these paintings are in what Doolittle called the 'Museum at Yale College.' Doolittle was one of the first artists in America to make use of a public collection as a source for engraved portraits.

As author frontispieces increased, so did portrait engravings in American magazines. The *Royal American Magazine* was the first to offer a series of portraits, and several others followed. However, financial instability was a way of life for the periodicals, and the cost of the engravings had to be balanced against their great popularity. On January 2, 1797, the publishers of the *American Universal Magazine* announced that 'portraits are preparing for this work in the same elegant stile as our first,' but they worried about the 'very great expense [to] be supported by so cheap a work.' Nevertheless, they managed to overcome the difficulties and publish a portrait in nearly every issue.

Sometimes, magazine publishers tried to omit the engravings and were generally greeted with public outrage. One of the publishers of the *Boston Magazine* was John Norman, who also engraved the series of portraits in the magazine. When the magazine was sold to Edmund Freeman and Thomas Greenleaf, Norman's engravings continued for a few months and then were discontinued. In answer to the public's inquiries, the publishers made the following announcement in the issue of February 1785: 'Many of the customers having found great fault with the Cuts, as being badly executed, has induced the Publishers to omit them, untill an Engraver can be procured to do them in an elegant manner.' In the meantime, the publishers felt compelled to reduce the price of each issue. John Norman's version of the story suggests that the new publishers simply refused to pay him. He explained that when his situation forced him 'to seek redress through the law, the publishers found it an oeconomical measure to omit the plates.'[19] In a similar instance, the *Massachusetts Magazine* attempted to substitute eight pages of letterpress in lieu of plates. The issue for March 1792 noted the results: 'Three months experience was decisive: The admirers of this polite art earnestly called for their resumption: They were instantly gratified.'

The September 1796 issue of the *Massachusetts Magazine* contained an unusual portrait image that was meant to be cut out and used as a decorative ornament. The engraving was called a 'Puzzle of Portraits.' Hidden in the outline of the trees and the large urn were profile portraits described as 'Striking likenesses of the late King & Queen, Dauphin and Dauphiness of France.' The publisher evidently felt that the answer to this curious puzzle was too intriguing to be delayed until the publication of the next issue of the magazine. In the text that explains the plate, the reader is informed that 'to gratify the secret desire of preserving the features of a race revered, the annexed ingenious puzzle of portraits was contrived to grace the cover of the favorite snuff box. It exhibits on the left hand the king, and on the right the Queen of France contemplating an urn. Behind the first is the dauphiness, shrouded by a weeping willow: and over the last is their son the Dauphin (like a former King of England, France, and Ireland) concealed in the "Royal Oak." The profiles are preserved with great accuracy.'

Of course, not all portrait engravings were bound together with a text. Separately issued prints were published to be framed, 'glazed,' and hung on the wall, or simply to be collected as mementos. Some were commemorative images of the recently deceased; others served as news items depicting the general who had just won a battle or the politician who had recently been elected. Most of them were merely celebrations of the famous, intended to satisfy the public's curiosity while making the printmakers some money. In general, separately issued prints were better executed, less derivative, and more expensive than book or magazine illustrations. There were, consequently, far fewer of them.

Many of the earliest separately issued portrait engravings were commemorative. Nathaniel Hurd's portrait of Joseph Sewall and Paul Revere's engraving of Jonathan Mayhew both include the death dates in the inscriptions and both were published soon after the demise of the subjects. Although Revere knew Mayhew personally, he copied his face from a mezzotint portrait by Richard Jennys. Instead of the rich, dark background of the mezzotint, however, he substituted the usual engraved frontispiece format of an oval frame on a pedestal. Hurd engraved the portrait of Joseph Sewall in a similar format, with the addition of a cartouche.

Quite different, however, were two other portraits by Nathaniel Hurd. The 1762 engraving of George III with William Pitt and James Wolfe was a tribute containing the injunction 'Britons Behold the Best of Kings.' Its purpose was revealed in Hurd's advertisement in the *Boston Evening Post* (December 27, 1762): 'Engraved and Sold by Nath. Hurd, a striking Likeness of his Majesty King George the Third, Mr. Pitt, and General Wolfe, fit for a Picture or for Gentlemen and Ladies to put in their Watches.' The portraits were designed in a circular format so that they could be cut out and placed in the back of a watch case. (Of course, one can hardly imagine most Bostonians tucking pictures of King George in their pockets by 1765, but that was the original purpose.)

Another unusual depiction was Nathaniel Hurd's engraved broadside, *H-ds-n's Speech from the Pillory* (1762). Dr. Seth Hudson was a swindler and counterfeiter who was publicly pilloried for his crimes. For the few townsfolk who had missed the

excitement, Hurd depicted the whole scene in the background of the portrait. The distorted profile of Hudson is clearly a caricature in keeping with the satiric verse beneath it.

Separately issued portraits sometimes appeared on the market as a by-product of textual publications. One example is Paul Revere's engraving of William Pitt at the top of a broadside.[20] Boston publisher Edes and Gill had printed one of Pitt's speeches in the *Boston Gazette* on February 4, 1771. In the same issue, they announced, 'At the desire of a Number of our Readers we shall publish Lord Chatham's Speech in a separate Sheet on Wednesday next, with an elegant Copper Plate Print of that great Patriot at the Head of it.' James Smither's engraving of John Dickinson was similarly advertised in the *Pennsylvania Gazette* (October 12–17, 1768), where Dickinson's influential 'Letters from a Farmer in Pennsylvania' had first appeared in serial form. It was separately published by Robert Bell, the bookseller, who also issued Dickinson's letters as a pamphlet. The engraving was probably available in Boston as well, since Paul Revere used it as a model for his almanac cut of Dickinson.

One intriguing early portrait engraving is Henry Dawkins's image of the eccentric Quaker reformer Benjamin Lay (fig. 3.8). Lay was an extremist whose bizarre antics and peculiarities often led to ridicule; and the distorted figure in this print has been called a caricature.[21] But, in fact, Lay was physically deformed, with slender legs, a hump back, and a very large head. Furthermore, for all his bizarre actions, his causes were just, and many people admired him for his pious devotion to his principles. His antislavery pamphlets had considerable influence, particularly on Quaker attitudes towards abolition. The image was probably not a caricature, therefore, but an honest depiction of a man whose strange appearance and behavior generated curiosity and controversy in the community. The print is based on a painting by William Williams that is in the Smithsonian's National Portrait Gallery. It depicts Lay in front of a cave, where he supposedly lived an ascetic existence at one point. The basket of fruit or vegetables undoubtedly refers to his vegetarianism. People might well have laughed at the man's deformities and eccentricities, but it seems clear that the engraving was not meant to be satiric.

One reason for the scarcity of engraved portraits during this period (that is, copperplate images produced by a combination of etching and line engraving) was the popularity of the mezzotint technique. The rich tonal qualities of the mezzotint, made by scraping and burnishing highlights on a roughened plate, were ideal for the subtle shading of portraiture. The mezzotint was particularly popular in England in the eighteenth century, where an entire industry developed to supply the demand for prints after the best English portraitists. These prints were also exported to the colonies, where they were highly regarded and treasured. Inventories from the period often distinguished the more expensive mezzotints from the other prints in the house. One interesting reference — which proves the frailty of all these images — was in the will of Henry Snood of North Carolina. Listed among numerous other pictures were '21 Metzotincete ble frames pretty much defaced by the Cock roaches.'[22]

The first person to respond to the challenge of the imported mezzotints was the London-trained engraver Peter Pelham, who emigrated to Boston and published

W.Williams Pinx.￼ HD, Fecit.

BENJAMIN LAY.

LIVED to the Age of 80, in the Latter Part of Which, he Observ'd extreem Temperance, in his Eating, and Drinking.
his Fondness, for a Particularity, in Dress, and Customs, at times Subjected him, to the Redicule of the Ignorant, but his Friends
who, were Intimate with Him, thought Him, an Honest Religious man.

FIG. 3.8. Henry Dawkins. *Benjamin Lay* (Philadelphia, 1763). American Antiquarian Society. Gift of Mrs. Joseph Carson, 1954.

the first American mezzotint in 1728. Like the first woodcut and the first engraving, the first mezzotint subject was a Mather and a minister, recently deceased. In February 1728, *The Boston Gazette* announced Pelham's proposals to publish a print of the late Reverend Dr. Cotton Mather. The detailed proposal provides a good introduction to the production of mezzotints in the eighteenth century. Pelham's first promise is that the charges will be high. He therefore was soliciting subscriptions and would not commence his labors until a 'Handsome Number' were procured. The price, for the subscribers, was to be five shillings. To further convince the prospective buyer, Pelham included all other possible details: the size—'14 Inches by 10'; the paper—'the best Royal Paper'; the source—'the Original Painting after the life by the said Pelham'; and the expected date of delivery—'two months.'

Many of the details of Pelham's proposal were typical of mezzotint production in America. The technique required more skill, time, and labor than other types of engraving. Thus, the results were more expensive, and the prints were frequently sold by subscription. Mezzotints were almost always based on painted portraits, sometimes, as in Pelham's *Cotton Mather*, painted by the engraver himself. The likeness was therefore reliable, and the prints were greatly valued. Generally, they were framed and hung.

Between 1728 and 1751, Pelham produced fourteen mezzotint portraits of famous contemporaries.[23] With little else on the market, these prints must have made quite an impact. They are lively and specific likenesses drawn with rich, dark tones. Most of Pelham's prints are bust-length portraits of New England ministers set in an oval frame within a rectangle. The white clerical collars against the black robes provided a dramatic contrast of light and dark values. The likenesses, according to contemporaries, were excellent. The son-in-law of Benjamin Coleman wrote of Coleman's portrait, 'His picture drawn in the Year 1734 by the greatest master our country has ever seen, Mr. John Smibert, shows both the face and the Air to perfection; And a very Considerable Resemblance is given us in Metsotinto done from it by Mr. P. Pelham, which is in many of our houses.'[24] Pelham's prints of Sir William Pepperrell and Gov. William Shirley, published in 1747 after the reduction of Louisbourg had brought them great recognition, were both striking three-quarter length mezzotints. Based on paintings by John Smibert, these handsome prints of contemporary heroes must have been highly prized indeed.

The young painter John Greenwood was undoubtedly trained by Pelham, but his first print was radically different from his master's formal and dignified faces framed by spandrels. Little is known about Ann Arnold, but Greenwood's depiction of her in a 1748 mezzotint entitled *Jersey Nanny* (fig. 3.9) makes her memorable.[25] Greenwood drew this humorous and sympathetic portrait from life. Arnold's clothes are simply draped around her and pinned, dangerously it would seem, at one side. The verse beneath the portrait sets the tone of the print:

> *Nature her Various Skill displays*
> *In thousand Shapes, a thousand Ways;*
> *Tho' one form differs from another,*

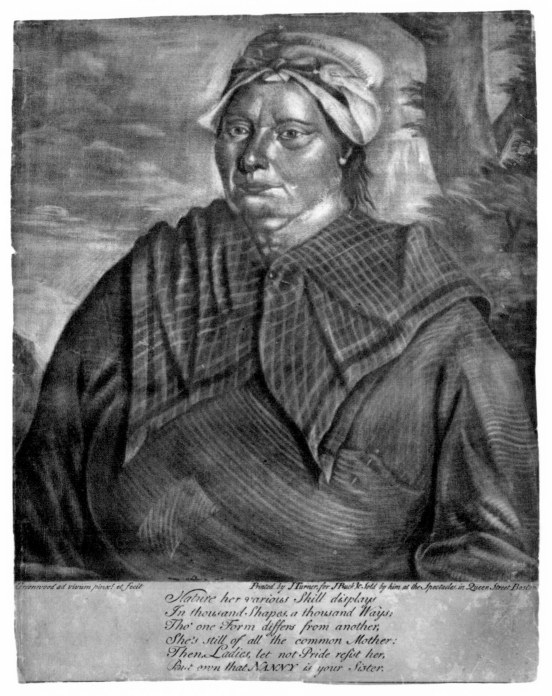

FIG. 3.9. John Greenwood (1727–92). *Jersey Nanny* (Boston, 1748). Courtesy, Museum of Fine Arts, Boston. Gift of Henry Lee Shattuck.

FIG. 3.10. Samuel Okey. *Mr. Samuel Adams* (Newport, 1773). Courtesy, National Portrait Gallery.

She's still of all the common Mother;
Then Ladies, let not pride resist her,
But own that Nanny is your Sister.

Several portrait painters experimented briefly with the mezzotint technique. Pelham's stepson, the painter John Singleton Copley, made only a single attempt at a mezzotint in his portrait of William Welsteed. The similarity between Copley's and Pelham's work was not simply a matter of influence. Copley actually reengraved Pelham's plate of William Cooper, changing only the head, the hands, and the name to make a new image. This first experiment must have convinced Copley of the difficulty and time involved in mezzotint engraving, and apparently he chose to concentrate on painting. There is also only one known example of a mezzotint by Richard Jennys. His mezzotint of Jonathan Mayhew was copied from his own painting and advertised for sale just after Mayhew's death in 1766.

Samuel Okey, on the other hand, was trained as a mezzotint artist in England before coming to Newport, Rhode Island, in the 1770s. Like Peter Pelham, Okey's first problem was finding a painted portrait to use as his source. In his letters to Henry Pelham, Peter's son and Copley's half-brother, Okey wrote of his trip to Boston to find a good likeness from which to make a mezzotint of Samuel Adams (fig. 3. 10). He finally had to settle for a painting derived from Copley's portrait, done by a Mr. Mitchell, but he implied that he did not think it was a very good copy. In fact, Okey asked that Henry Pelham's own drawing of the Copley portrait be sent to Newport so that he could work on the face. Shortly afterwards, Okey wrote to Pelham, 'We shall publish in About a Month a Poster sized plate of Mr. Sam Addams from a picture I had of Mr. Mitchel's Painting. wee have copied it well enouf and are not afraid of the Success of it; but A plate done Properly should be from a good Picture.'[26] It might be noted that many surviving impressions of Okey's work were printed from extremely worn plates. Okey himself went back to England, but his plates remained in Rhode Island to be reprinted over and over again.

Later in the century, the work of the painter Charles Willson Peale brought mezzotint engraving to the peak of its artistic development. Peale learned the technique on a visit to London, where he published a large portrait of William Pitt in 1768.[27] A decade later he was planning a series of mezzotints of the 'Principal Characters' of the Revolutionary War, based on his own paintings. In 1778, Peale made a small mezzotint head of George Washington, of which no copy is now known. On several occasions in the following two years, he asked his friends traveling to Europe to send him copperplates 'prepared for metzotinto,' 'paper proper for that sort of work,' and 'i sett of Grounding Tools for Midtzotinto prints.'[28] Although he probably never got his supplies, he produced another mezzotint of George Washington in 1780 (fig. 3.11) that was based on his 1779 oil painting.[29] It was a masterpiece, a sensitive and beautiful likeness, which tells us more about the commander-in-chief than perhaps any other printed portrait.

After the 1780 Washington portrait, Peale did not make another print for seven years. He was undoubtedly discouraged by the lack of sales. In contrast to England, where the mezzotint trade was an established industry, American engravers did not

FIG. 3.11. Charles Willson Peale (1741–1827). *His Excellency George Washington Esquire. Commander in Chief of the Federal Army* (Philadelphia, 1780). Courtesy, National Portrait Gallery.

FIG. 3.12. Edward Savage (1761–1817). *David Rittenhouse. L.L.D. F.R.S. President of the American Philosophical Society* (Philadelphia, 1796). Courtesy, National Portrait Gallery.

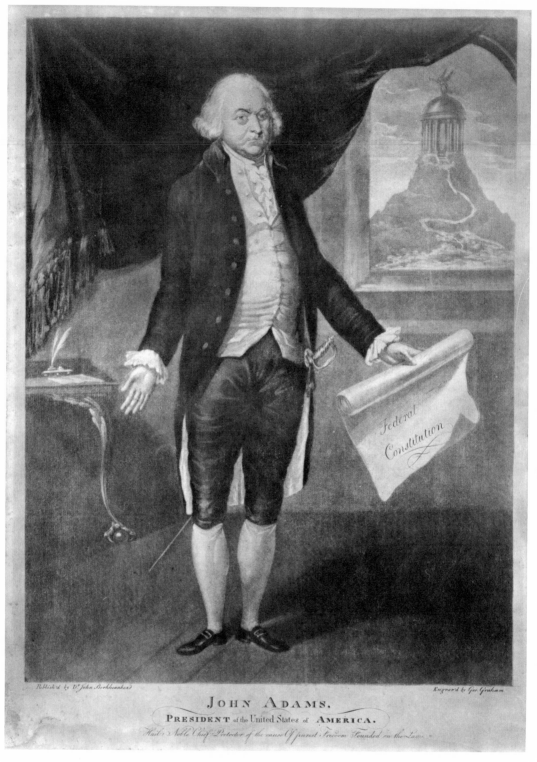

FIG. 3.13. George Graham (active 1797 – ca. 1813). *John Adams, President of the United States of America* (Philadelphia, ca. 1798). Courtesy, National Portrait Gallery.

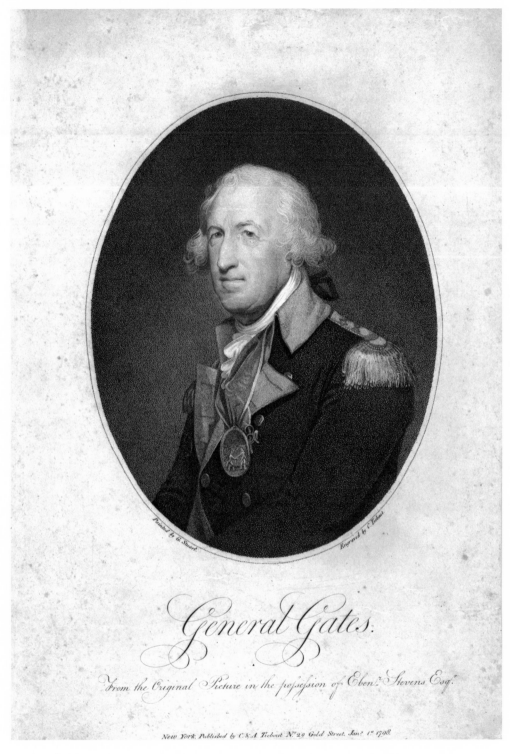

FIG. 3.14. Cornelius Tiebout (ca. 1773–1832). *General Gates* (New York, 1798). American Antiquarian Society. Gift of Rev. R. B. Hall, 1851.

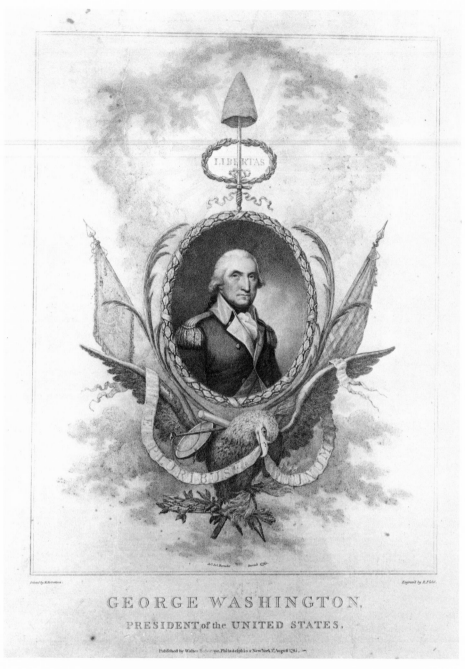

FIG. 3.15. Robert Field (ca. 1769–1819). *George Washington, President of the United States* (Philadelphia and New York, 1795). Courtesy, the Historical Society of Pennsylvania.

have skilled portraitists supplying original paintings, assistants to prepare the plates, suppliers for ink, plates, paper, and tools, or experienced, mezzotint printers, publishers, printsellers, and buyers. Making a profit was obviously a daunting task.

But Peale persevered. In 1787, he announced in a letter that he had 'begun one other great work, the making of Mezzotinto prints from my collection of portraits of Illustrious Personages. This undertaking will cost me much labour as I am obliged to take the plates from the rough and doing the whole business myself, even the impressing The price of each print will be 3 dollars in a double oval Frame, the inner part of the framed border under the Glass to be gilt—to each print without framing One Dollar.'[30] Peale completed prints of Joseph Pilmore, Benjamin Franklin, Lafayette, and, once again, George Washington. He even experimented with printing the Washington plate in red and brown inks, as well as black. But his hopes for financial success were soon dashed. In November 1787, Peale wrote to Benjamin West in London, 'This is a work which I mean to pursue when I have no other business to do, for the sale is not such as to induce me to pursue it otherwise.'[31]

Of course, a man like Peale was never without 'business to do,' and he never returned to mezzotint engraving. This is particularly unfortunate because his mezzotints, in their own modest way, are quite remarkable. Because Peale made the original painting, each mezzotint has the qualities of a life portrait. You come one step closer to meeting Washington when you see the mezzotint of him by Charles Willson Peale. You could not ask for more from any portrait.

Although Peale was never really excelled in the quality of the likeness, other American artists would produce larger and more elaborate mezzotints. The painter Edward Savage also published a series of mezzotint portraits. He, too, learned the technique in London, where he issued prints of George Washington and Benjamin Franklin in 1793. Back in America, he published several mezzotints between 1796 and 1801 of such notables as David Rittenhouse (fig. 3.12), the eminent scientist and astronomer. Various assistants and apprentices, including John Wesley Jarvis and David Edwin, helped Savage produce his plates, and it is unclear exactly how much of the engraving was done by his own hand.[32] In any case, Savage planned and supervised the production of some elegant prints that are strong characterizations of their subjects. One early writer on mezzotint portraits had commented, 'Some Effigies are so well done to the life that they may be put in competition with the best painting.' The same could be said for these prints by Peale and Savage.[33]

At the same time that Savage was producing his portraits, George Graham was beginning a series of mezzotints. His full-length image of John Adams (fig. 3.13), who is depicted with a document labeled 'Federal Constitution' in his hand and a temple of fame in the background, is not quite as finely executed as Savage's prints but is still of great interest. Graham was one of the few engravers who was still working in mezzotint after most engravers had turned to other less laborious techniques.

Towards the end of the century, mezzotint was beginning to be supplanted by stipple engraving as the popular medium for portraiture. Because of its tonal effects, stippling had long been used for facial features in prints that otherwise imitated line

FIG. 3.16. Charles Balthazar Julien Fevret de Saint-Mémin (1770–1852). Theodosia Burr. Courtesy, National Portrait Gallery.

engraving. By the end of the century, however, engravers were recognizing the sophisticated results possible from a primarily stippled plate. The popularity of engravings by Francesco Bartolozzi and his followers in England encouraged American artists to try this technique, which was considerably faster and therefore less expensive than mezzotint. Although few American artists used the 'crayon manner' in imitation of chalk drawings, many began to use stippling for portraiture. The production of stippled portraits would greatly increase in the nineteenth century, but the trend started in the 1790s. Cornelius Tiebout was one American artist who learned the stipple technique in London where he published his *John Jay* in April 1796. Equally handsome is his stippled portrait of Horatio Gates (fig. 3.14), published in 1798 after his return to America. Based on a painting by Gilbert Stuart, it must have been a good advertisement both for Tiebout's skills and for the potential of the stipple technique.

The stipple portrait became very common for book frontispieces in the 1790s, but it was used more frequently for larger, separately published prints. A three-quarter length portrait of John Adams was produced by a newly arrived Irish engraver, H. H. Houston, in 1797. The London-trained artist Robert Field also made extensive use of stipple for his elegant 1795 print of George Washington. This image was based on a miniature by Walter Robertson and an allegorical design by John James Barralet (fig. 3.15). Although the eagle and framing device are overlaid with line in this print, the stipple technique was effectively used for the portrait as well as for the celestial atmosphere of delicate clouds and radiating light. This imagery suggests an apotheosis theme, which was common for commemorative prints after Washington's death, but Field's print was published during the president's controversial second term. It was probably quite new and striking in 1795, and the subtlety of the stipple technique played no small part in its effect.

Particularly well known for his prolific career as a portrait engraver in stipple was another London-trained artist, David Edwin. Edwin arrived in America in 1797 and the following year was working on Edward Savage's stipple engraving of *The Wash-*

ington Family. Edwin seems to have specialized in Washington portraiture between 1798 and 1800.[34] Although his name did not appear on Savage's family print, he was producing other Washington prints at the same time, mostly based on Gilbert Stuart likenesses. These prints—ranging from an impressive military portrait to a tiny but exquisite Washington engraving made to ornament patriotic song sheets—displayed the versatility of the stipple technique in the hands of a competent craftsman. Most of his Washington prints were based on Stuart's Athenæum portrait, and they undoubtedly helped to establish that painting as a preeminent likeness. Edwin and Tiebout, along with artists arriving from the British Isles, did much to establish the stipple portrait in America.

Another important development in the art of engraved portraiture was the arrival of Charles Balthazar Julien Févret de Saint-Mémin in the United States in 1793.[35] Saint-Mémin was very prolific, producing over eight hundred portraits as he traveled up and down the East Coast. His usual practice was to draw a profile outline of his sitter with the help of a physiognotrace and finish the chalk drawing by hand. He then reduced the profile with the aid of a pantograph onto a two-inch-square copperplate and engraved a small circular print (fig. 3.16). These exquisite little portraits, meant to be given to family and friends, must have been greatly treasured by their owners. Saint-Mémin's work, however, is different from other portrait prints in two important ways. His prints were private portraits, almost like miniatures, instead of salable likenesses of famous people. In addition, Saint-Mémin used a French engraving technique combining etching and engraving with the use of a roulette to create a soft background tone. This portrait style was not unusual in France; Gilles-Louis Chrétien and Edmé Quénédey both produced similar engravings in Paris. However, aside from the work of a few associates of Saint-Mémin, this engraving technique did not become common in America. The engravings of Saint-Mémin were certainly of great importance to the overall story, but his influence was general rather than specific. He undoubtedly encouraged the growing popularity of the profile, for instance, and he introduced the idea of a mechanically accurate likeness, but he did not change the direction of portrait engraving.

The story of eighteenth-century portrait prints begins in Massachusetts and expands to include many American cities by the end of the century. This survey has been an attempt to suggest the character and range of these portraits from naive almanac cuts to sophisticated mezzotints. Not all of them will enchant us. But the more we know about these images, the more we will appreciate the small bits of Americana that have survived the menacing ravages of time, obscurity, and the 'Cock Roaches.'

NOTES

1. James Granger, *A Biographical History of England*, 2 vols. (London: T. Davies, 1769), 1: preface.

2. Henry Peacham, *The Compleat Gentleman* (London: Francis Constable, 1634), p. 129.

3. A. Hyatt Mayor, *Prints and People* (New York: Metropolitan Museum of Art, 1971), fig. 282.

4. For further discussion, see Gillett Griffin, 'John Foster's Woodcut of Richard Mather,' *Printing & Graphic Arts* 7 (1959): 1–19.

5. *Diary of William Bentley*, 4 vols. (Salem, Mass.: Essex Institute, 1905–14), 3: 104.

6. For further discussion, see Kenneth B. Murdock, *The Portraits of Increase Mather* (Cleveland: William Gwinn Mather, 1924).

7. *The Boston Weekly Newsletter* Aug. 21, 1746.

8. Lawrence C. Wroth and Marion W. Adams, *American Woodcuts and Engravings, 1670–1800* (Providence: John Carter Brown Library, 1946), pp. 41–44.

9. Ibid., p. 12.

10. The crude Wilmington cut is found in three Dilworth books issued before the turn of the century: *The Schoolmaster's Assistant* (Wilmington: Peter Brynberg, 1796); *The Schoolmaster's Assistant* (Wilmington; Bonsal and Niles, [1799]); and *A New Guide to the English Tongue* (Wilmington: Peter Brynberg, 1799). Another edition of *The New Guide* (Evans 15782) has been catalogued as Philadelphia, Aitken, 1778, but there is no title page and on the basis of the portrait, the evidence suggests that it is not a Philadelphia edition.

11. William Cobbett, *Porcupine's Political Censor*, (Philadelphia: William Cobbett, 1797), p. 110.

12. Elizabeth Reilly explains that although the cut identified as Snell is the latest of the three appearances, it must have appeared in an earlier, now missing, imprint, since it was obviously intended to represent the lady soldier. Elizabeth Carroll Reilly, *A Dictionary of Colonial American Printers Ornaments and Illustrations* (Worcester: American Antiquarian Society, 1975), p. 373.

13. The Hancock cut was probably copied from either the English mezzotint by William Smith, published in 1775, or the American mezzotint by Joseph Hiller, which is undated but from approximately the same period. Paul Revere's engraving of Hancock in the *Royal American Magazine* (1774) was also derived

from the Copley portrait, but it is clearly not a source for this cut. For paintings by John Singleton Copley referred to throughout this paper, see Jules David Prown, *John Singleton Copley*, 2 vols. (Cambridge, Mass.: Harvard University Press, 1966). No attempt has been made to distinguish between different replicas in citing a Copley painting as the source for the print.

14. Frontispieces to Evangelical Lutheran Church, *Erbauliche Lieder-Samlung* (Germantown, Pa. Liebert & Billmeyer, 1786); Friedrich, Freiherr von Trenck, *The Life of Baron von Trenck* (Philadelphia: William Spotswood, 1789); and John Gillies, *Memoirs . . . of George Whitefield* (New York: Hodge and Shober, 1774).

15. Clarence S. Brigham, *Paul Revere's Engravings* (Worcester: American Antiquarian Society, 1954), pp. 74–75. The engraving from the *Court Miscellany* was in turn copied from an engraving in Smollett's *Continuation of the History of England*, 5 vols. (London: Rivington & Fletcher, 1765), 5: 118.

16. For further discussion of Revere's engraving, see Bradford F. Swan, *An Indian's an Indian, or The Several Sources of Paul Revere's Engraved Portrait of King Philip* (Providence: The Roger Williams Press, 1959). For the history of the 'Four Indian Kings' mezzotints, see R.W.G. Vail, 'Portraits of "The Four Kings of Canada," a Bibliographic Footnote,' in *To Doctor R.*, comp. Percy Lawlor (Philadelphia: Rosenbach Co., 1946), pp. 219–21.

17. Charles Henry Hart, 'Frauds in Historical Portraiture,' *Annual Report of the American Historical Association* 1 (1913): 94; and William Loring Andrews, *An Essay on the Portraiture of the American Revolutionary War* (New York: Gillis Bros., 1896), pp. 32–33, 55–56. For reproductions of these mezzotints as well as plates from the English and American editions of the *Impartial History*, see Donald Cresswell, *The American Revolution in Drawings and Prints* (Washington D.C.: U.S. Government Printing Office, 1975).

18. Quoted in Andrews, *An Essay on the Portraiture of the American Revolutionary War*, p. 27.

19. *The Gentleman and Lady's Town and Country Magazine* (Boston, Dec. 1784).

20. Revere's portrait seems to have been copied from an English engraving of William Pitt by Isaac Basire that was bound into *Father*

Abraham's Almanac for 1760 (Philadelphia: W. Dunlap, 1759).

21. William Murrell, *A History of American Graphic Humor*, 2 vols. (New York: Whitney Museum of American Art, 1933), 1: 21. For biographical details about Lay, see *Dictionary of American Biography*, s. v. 'Benjamin Lay.'

22. J. Bryan Grimes, *North Carolina Wills and Inventories* (Raleigh, N.C.: For Trustees of the Public Libraries, Raleigh, by Edwards & Broughton, 1912), pp. 557–58.

23. For a full discussion of Pelham's career, see Andrew Oliver, 'Peter Pelham (ca. 1697–1751): Sometime Printmaker of Boston,' in *Boston Prints and Printmakers, 1670–1775* (Boston: Colonial Society of Massachusetts, 1973), pp. 133–73.

24. Ebenezer Turell, *The Life and Character of the Reverend Benjamin Colman* (Boston, Rogers & Fowle and Edwards, 1749), p. 23.

25. Alan Burroughs, *John Greenwood in America, 1745–1752* (Andover, Mass.: Phillips Academy, 1943), p. 48; and 'Centennial Acquisitions: Art Treasures for Tomorrow,' *Bulletin of the Museum of Fine Arts (Boston)* vol. 68, nos. 351–52 (1970): 109.

26. Charles Reak and Samuel Okey to Henry Pelham, Mar. 16, 1775, *Letters and Papers of John Singleton Copley and Henry Pelham 1739–1776* (1914; repr. New York: AMS Press, 1970), p. 308.

27. For a full discussion of Peale's mezzotints, see Wendy J. Shadwell, 'The Portrait Engravings of Charles Willson Peale,' in *Eighteenth-Century Prints in Colonial America: To Educate and Decorate*, ed. Joan D. Dolmetsch (Williamsburg, Va.: Colonial Williamsburg Foundation, 1979), pp. 123–44.

28. Horace Wills Sellers, 'Engravings by Charles Willson Peale, Limner,' *The Pennsylvania Magazine of History and Biography* 57 (1933): 165–66, 168.

29. Wendy C. Wick, *George Washington, an American Icon: The Eighteenth-Century Graphic Portraits* (Washington, D.C.: National Portrait Gallery, 1982), p. 85.

30. Charles Willson Peale to David Ramsey, Feb. 2, 1787, quoted in E. P. Richardson, 'Charles Willson Peale's Engravings in the Year of National Crisis, 1787,' *Winterthur Portfolio* 1 (1964): 169.

31. Shadwell, 'Portrait Engravings of Charles Willson Peale,' p. 141.

32. For discussions of whether or not Savage did his own engraving, see William Dunlap, *A History of the Rise and Progress of the Arts of Design in the United States*, 2 vols. in 3 (1834; repr. New York: Peter Smith, 1969), 1: 321; *Diary of William Dunlap*, 3 vols. (New York: Ayer Company Publs., 1931), 3: 706; Harold E. Dickson, *John Wesley Jarvis: American Painter* (New York: New-York Historical Society, 1949), pp. 35–37; Charles Henry Hart, 'Edward Savage, Painter and Engraver, and His Unfinished Copperplate of "The Congress Voting Independence,"' *Proceedings of the Massachusetts Historical Society* 19 (1905):1–19; and William S. Baker, *American Engravers and Their Works* (Philadelphia: Gebbie & Barrie, 1875), pp. 74–75.

33. John Evelyn to Samuel Pepys, quoted in John Chaloner Smith, *British Mezzotint Portraits*, 5 vols. (London: H. Sotheran & Co., 1883), 1: x.

34. For a discussion of David Edwin's engravings of Washington through 1800, see Wick, *George Washington*, pp. 104–5, 122–29, 138, 154–57.

35. For discussion of Saint-Mémin's career in America, see Ellen Miles, 'Saint-Mémin, Valdenuit, Lemet: Federal Profiles,' in *American Portrait Prints: Proceedings of the Tenth Annual American Print Conference*, ed. Wendy Wick Reaves (Charlottesville, Va.: National Portrait Gallery, 1984), pp. 1–28; and Fillmore Norfleet, *Saint-Mémin in Virginia: Portraits and Biographies* (Richmond: The Dietz Press, 1942).

The Idylls of the Triune Idol,
or the Joys of Publishing in 1820

MARCUS A. McCORISON

THIS IS A TALE that involves three persons caught up in the process of writing, illustrating, and publishing a book on the antiquities of the native Americans of the Ohio region. The book is truly a pioneering one in that it was the first extended treatment of the archaeological remains of the Adena and Hopewell people, who inhabited the present regions of Tennessee, Kentucky, and Ohio about two thousand years ago. The work was also the first substantial publication of the American Antiquarian Society, which had, in 1820, been in existence for merely eight years. Fortunately for the author and for the Society, the individual who supervised the project was Isaiah Thomas, the president of the Society and an experienced editor, printer, and publisher.

The volume that he and his Committee of Publication labored upon was the first volume of *Archaeologia Americana*, or the *Transactions and Collections* of the Society. Issued in 1820, it reprinted a number of documents fundamental to the Society that had previously appeared in pamphlet form. Included were the articles of incorporation, lists of officers and members, and the addresses delivered at the annual meetings. Although the major piece in the scholarly portion of the book was given over to an essay on the Ohio Indians, there were other contributions dealing with a description of Mammoth Cave and of a mummy found therein, a letter on the Caraib Indians of the Antilles, and several communications on a variety of Indian subjects from John Johnston and Dr. Samuel Latham Mitchill.

The author of *Description of the Antiquities Discovered in the State of Ohio and Other Western States* was Caleb Atwater of Circleville, Ohio, a member of the Council of the American Antiquarian Society.[1] Atwater was something of an eccentric and may have been a bit unstable as well, but he was intelligent and extremely energetic. He was born in North Adams, Massachusetts, on Christmas Day, 1778, to a family of modest circumstances. After preparation at Oneida Academy (now Hamilton College), he attended Williams College, graduating with the class of 1804. Atwater taught in the academy connected with the college for a time and received a master of arts degree before leaving for New York City. There he kept a school for girls and studied for the ministry. Atwater's ministerial career was short-lived, for in 1809 he

was admitted to the bar of the State of New York. For several years he successfully practiced law in the central part of that state. When a business venture failed in 1814, he moved to Circleville, Ohio. There, he followed his calling and collected data on the remarkable prehistoric earthworks that fell into his way. Correspondence with Dr. Mitchill, DeWitt Clinton, and others encouraged him to undertake a systematic description of the ancient, flat earthworks that occurred with some frequency in the Ohio River watershed. The illustrated account that resulted provides the subject of this paper.

In 1821, Atwater was elected to the Ohio legislature where he effectively worked for a statewide public school system and for improved transportation facilities. Although he was not the successful candidate for Congress in 1822, he was well enough known to receive a commission in 1829 from President Andrew Jackson to serve as one of the official party that was to negotiate with the Indians of the upper Mississippi at Prairie du Chien. In 1833 he published his account of this episode, along with a new edition of his work on western antiquities, and such lesser articles as *The Writings of Caleb Atwater*. He published his *History of the State of Ohio* in 1838, and in 1841, *An Essay on Education*, which was favorably received.

The remaining twenty-six years of his life were spent in poverty in Circleville, most of them in retirement. That period of his life was so long and complete that at the time of his death on March 13, 1867, it was thought that he had been dead for a decade. In closing his obituary of Atwater, in the *Proceedings of the American Antiquarian Society* for April 1867, Samuel Foster Haven declared, 'The Council are glad of this opportunity to correct their record and to pay a deserved tribute to his memory.'

The record of the publication of the *Description of the Antiquities Discovered in the State of Ohio* is a tortured one. From May 30, 1818, until July 14, 1821, Atwater wrote more than sixty letters to Isaiah Thomas. During 1819 and 1820 the mail must have seemed to be full of long, somewhat disjointed letters sent free from Atwater (who was postmaster in Circleville) to Thomas (who was postmater in Worcester). They were aboil with enthusiasm: requests for loans of needed books; plans for a second volume (before the first was even published); requests for money to pay for surveys (e.g., 'I was obliged either to attend to professional business this week or starve'; suggestions for new members of the Society; thoughts on how to obtain specimens for the Society's cabinet; speculations on the possibility of discovering poetic literature written by the Indians (e.g., 'Such a discovery would do honor to literature in America and to man—it would silence Slanderers of America in Europe—would do honor to our Society [AAS]'). Of particular interest are comments about the proofs of the illustrations and plans to distribute the map of Ohio and of how he 'could sell 1000nds of them here, at a dollar each copy,' or '100's of copies of the book at $5.00.'

In addition to this large amount of commentary and suggestions concerning the book, Atwater sent some fifty letters to Thomas that contained the text of his book. They were mailed as the author finished writing them, not necessarily in the order in which they were to appear in the finished volume. At one point, Atwater wrote to Thomas, 'I want to hear as to your health, how is it, for I depend a great deal on your judgment in correcting what I have written.'

Atwater might well have inquired after the state of Isaiah Thomas's pocketbook, because the Society's founder was not only trying to cope with the flood of correspondence from Ohio but was also paying for the printing, engraving, and binding of the volume. A not atypical instruction to the seventy-year-old editor—who was also in the midst of constructing and paying for a library building for the Society—was sent on January 28, 1820, as follows: 'When I have numbered my letters 1, 2, 3, &c. follow that order until I begin again in the same way 1, 2, 3. Then follow on in the same order the 2nd nos. immediately following the first nos. The conclusion of my essay, was written in haste and needs altering in the construction of some of the very concluding sentences possibly to make the sense clear—if so alter it. . . . Proof sheets would be highly acceptable to me.'

If Atwater was hasty in the composition of his prose, his instructions regarding the illustrations were equally difficult to comprehend, especially since drawings for the plates seem to have been placed on the pages with the text, and of course the drawings for the plates and text illustrations had to be sent to the engraver. For example, Atwater's directions to Thomas, relayed in a letter dated March 3, 1820, about one set of drawings led to confusion: 'I am glad that you have found the works in Perry county, (the *stonefort*). The works at *Piketon are also on the same sheet with the text*. Please to look for it, and take it off. My reason for so placing the stone fort in Perry and the works at Piketon on the *same sheet with the text*, was to prevent expense, thinking that good, wood cuts, which would cost but little, might be placed in the press with the types and thus save paper, press work and engraving. I began to be alarmed at the number of my drawings & fearful of expense and of alarming *you too, on that account.*'

The engraver of the copper plates and the woodcuts was Abner Reed of East Windsor, Connecticut, who was born in Windsor on November 11, 1771, and had served an apprenticeship to a saddler.[2] Reed was endowed with considerable dexterity and intelligence, and at age twenty-one he was teaching school in Albany and Lansingburgh, New York. At that time he wrote, illustrated, and published a short novel of little merit, entitled *Love Triumphant, or Constancy Rewarded* (Troy, 1797). Returning to his native heath in 1798 with his spouse of three years (even then but seventeen years old), Reed started teaching again and continued until November 1, 1803, when he moved to Hartford to carry on the business of engraving, printing, and sign painting. He was a very skillful workman and had an extensive trade. He trained a large number of apprentices, the most famous of whom were Ralph Rawdon and John Warner Barber. The latter recalled his former master and lady with affection and satisfaction. Returning to East Windsor in 1811, Reed continued his business until 1847, when he left the town to live with a daughter in New York City. There, at the age of seventy he published *Reed's Guide to the Art of Penmanship* (1851). Very late in life, he moved to Toledo, Ohio, where he lived with his eldest daughter. Reed died there on February 25, 1866, only a year before his erstwhile colleague, Caleb Atwater of Circleville.

The choice of Reed as the engraver of Atwater's drawings was Thomas's. Atwater wrote to Thomas on July 8, 1819, 'I have been informed by Professor Silliman [of

Yale College and an influential advisor of Atwater's] that a Mr. Bass Otis of Philadelphia engraves very well on stone and he advises me to get Mr. Otis to do all the engraving as being cheaper and nearly as good.' Had Thomas accepted this idea, the Society might have published one of the earliest books illustrated by lithography. However, Thomas chose Reed and directed him to reproduce Atwater's illustrations of artifacts found in the Indian mounds and described in the text as wood engravings, not copperplate engravings as Atwater had assumed would be the case. In fact, Reed had urged Thomas to have the illustrations engraved on copper. He suggested that several illustrations might be grouped on one plate and also pointed out that the quality of details would be much improved without greatly increasing costs. Thomas rejected these ideas, reverting, no doubt, to earlier days when woodcuts seemed to be sufficient. However, the eleven plans and the map of Ohio were engraved by Reed on copper, a practice that was also a reversion to eighteenth-century custom.

FIG. 4.1. Title page, *Archæologia Americana* (Worcester, 1820). American Antiquarian Society.

FIG. 4.2. *Ancient Works at Circleville: Ohio.* Plate in *Archæologia Americana* (Worcester, 1820). American Antiquarian Society.

FIG. 4.3. 'Urn in the possession of Mr. J. W. Collet, Chillicothe, Ohio.' Caleb Atwater Papers, folder 4. American Antiquarian Society.

Thomas's choice of Reed might have been related to his earlier work for Thomas in engraving the certificate of membership for the American Antiquarian Society. The seal used on the certificate was designed by Thomas and drawn by John Ritto Penniman (1782–1841) in 1815. Reed wrote to Thomas on April 29, 1820, asking, 'Would it not be well to have a title page made out of the seal, having that for a vignette? The expense of engraving would be but trifling, and the printing no more.' More suggestions about the design of the title page passed back and forth between the engraver and the publisher. On May 11, Reed wrote to Thomas, 'I think the title would look as well or better to have the name of the Society in German text instead

FIG. 4.4. 'Triune Idol.' Caleb Atwater Papers, folio folder. American Antiquarian Society.

of the line on the top, and perhaps that in old english, or black letter, that is, if there is room. I am fearful that the name will not come into one line of a proper size.' And eleven days later he wrote, 'I had got the title drafted before I recd. your letter, and for want of room I have written the top line in German text, and the other line in Old English which I think will look about as well.' And indeed, the title page to the volume was a handsome addition to the work (fig. 4.1).

When Atwater received proofs of the illustrations, he was, as might be expected, critical. On March 3, 1820, he returned the proof of the *Ancient Works at Circleville: Ohio* and wrote to Thomas: 'The plate representing the works at Circleville, has *not* the great mound 90 feet high, on it. Let the engraver look at the *original drawings*' (fig. 4.2). A day later he wrote about another proof, a wood engraving, 'The urn found near Chillicothe has exactly the same scratches on it as were on the original

drawing—on the one sent to me, no such thing is to be seen. A whole sheet of paper would not be sufficient to point out the difference in size, appearance &c. between these now before me and the ones I sent, or the *articles themselves*' (fig. 4.3).

A number of the letters between Atwater and Thomas concerned the artifact known as the Triune Idol (fig. 4.4). The drawing of this clay vessel was executed by Sarah Clifford, of Lexington, Kentucky, the daughter of its owner John D. Clifford. He had found the object on Cany Fork of the Cumberland River in Tennessee, about four feet below ground level. The vessel is about eight inches high with a capacity of approximately three quarts. Caleb Atwater was greatly excited by this find. On September 4, 1819, he wrote to Thomas, 'From my humble labors in the West, the Mosaic account of the creation and dispersion of man—the Doctrine of the Trinity and many other things, will receive additional support. The three gods of India, the principal god of Ava, have been found here. Many other things, which you little expect, you will see shortly.'

Atwater particularly wished to have this illustration reproduced as a line engraving. Moreover, he wished the Triune Idol to be hand-colored in imitation of Miss Clifford's original drawing. In a letter dated March 24, 1820, he wrote, 'You will recollect I hope, to have the plates coloured exactly like the originals, which represent the *Idols*. They are coloured exactly like the things themselves.' Almost a month later, he still had not seen the proof. Perhaps Thomas withheld it on purpose, fearing Atwater's response. On April 18, Atwater wrote, 'The *Idols* I have not seen yet. The painting is all important, as to them, you know. I want them to resemble the originals exactly. I wish to see them when painted. The original drawing, ought not to be destroyed by any means, until the plates are painted.' In the final publication, the Triune Idol appeared uncolored, engraved on wood. Atwater did not record his disappointment. Fortunately, Thomas did not destroy the drawings, even after the plates were published; they are still preserved in the manuscript collections of the Society. In fact, the verso of the original drawing bears the notation in Thomas's hand that it should 'be framed for the Am. Antiqn. Cabinet.'

The correspondence between Abner Reed and Isaiah Thomas was much less helter-skelter than that to and from Ohio. There are letters between Reed and Thomas in the Society's archives relating to this project. In December 1819, Reed and Thomas got right down to business. They agreed that Reed should have seven hundred impressions of the map of Ohio in exchange for engraving it. To receive some compensation for the project, Reed was going to resell them. He envisioned, however, that 'they will require colouring to ensure the sale, and the expense of colouring and trouble of selling will be considerable; and scarce as money is, they must be sold cheap, or many will be left on hand.' The only difficulty in this arrangement proved to be the fact that Atwater himself had intentions of selling the map as a means of earning something besides honor for his trouble. The imbroglio that followed was never satisfactorily settled and may have been a major factor in the cloud of gloom that settled upon Atwater at the end of this turbulent episode. Reed received $500 in cash for the remainder of the engravings and illustrations. Included with one of the payments was a counterfeit $10 bill, which elicited the following

critique from a master craftsman on February 8, 1821: 'You will see on comparison a plain difference in the writing, also in the B. in the work Bank, (old English) it is unfinished, and the dot to the i in the word City is omitted—these marks will be sufficient to prevent your being deceived by them again.' One trembles to think of Atwater's response had he received the counterfeit bill.

With respect to one of the illustrations for the article on the Carib Indians of the Antilles, Reed wrote on May 22, 1820, 'I send a proof of the other plate as far as done, and wish some explanation respecting the Caraib implements,—what materials they are composed of, &c. and what are the ornaments on the woman's arms and neck, &c. We can alter before finishing.' In contrast to Atwater's letters, these are the words of a reasonable man. In another letter, Reed explains to Thomas that the illustrations would require 'three plates . . . contain each, two *separate* prints, when cut to put in the book; the two we are now engraving contain each four pages, which when separated will make eight pages. So that if what you wanted to know, viz. how many *separate* plates there were when printed and cut to bind, there will be 14, but five plates of copper contain them all, exclusive of the Map.'

The engraved plans and the map of the state of Ohio caused an enormous amount of trouble because of Atwater's lack of precision. A typical example of the problems Reed was to encounter is evident in a plan of the *Ancient Works on Paint Creek*. The details were unclear and the labels were often vague. In particular, that of a plate with two parallel lines, labeled as 'turnpike over a hill,' caused Reed a great deal of trouble (fig. 4.5). He and Thomas knew that it could not be a turnpike going over a hill, but Atwater's corroboration was required. Finally, on March 3, 1820, Atwater wrote: 'I have already anticipated a part of what you asked for, (i.e.) what to call the "turnpike" which word you need *not* put on the plate, but may call it *"A place of Amusement."*' This solution seems as valid as the one calling the construction a turnpike (fig. 4.6).

In April 1820, Atwater and Thomas turned their attention to the large map of Ohio which had been drawn for Atwater by an individual who signed his name A. Bourne (fig. 4.7). This may be Adolphus Bourne (1795–1866), who later became an engraver in Montreal in the 1820s and 1830s.[3] The Society also has a children's book published in Montreal in 1820 with engravings by A. Bourne. According to Atwater, the map of Ohio was to be a major attraction, and Atwater viewed the engraving with great expectations of riches. He was crushed when a rival published a small, cheap map before his was ready and captured the market. Nevertheless, the three men continued. That Atwater's motives were not purely commercial is suggested by a letter of April 18, 1820, in which he wrote, 'I want the map of Ohio, in order to paint it correctly. The *blue* is limestone you will recollect. There are 4 new counties erected in the Indian country last winter—can they be still put on the engraving? Where they are, is now blank in the N. W. part of the state.'

The first allusion is to Atwater's interest in publishing his geological data on the state. The second statement meant only trouble. Not long afterward, he sent Thomas a new map drawn by John Kilbourn with the new counties in the northwest drawn in. However, the details of the map for the remainder of the state did not coincide

FIG. 4.5. 'Turnpike.' Caleb Atwater Papers, folder 4. American Antiquarian Society.

with the first map sent some time before. Reed, always pushing the work forward and having other business besides that of Atwater and Thomas, has already added the new counties and printed nearly five hundred impressions of it. A cry of anguish arose from Atwater.

On June 20, 1820, he wrote: 'In putting the *new* counties on the map of Ohio, no alteration even in the least, ought to be made in the *old* ones. All that was needed, was to fill up a blank space in the Indian Country. Union need not be mentioned because not yet surveyed & laid off. And so I stated. The rivers were more correct on the *first*, than on the 2nd map. I suspect I did not express myself fully enough on that subject, though. I meant to say, that I wanted only the *new* county lines laid down and the names of the counties, *added* to my 1st map. My 1st was made from the field notes of the surveyors—the new map was intended to show what the *Legislature* have done since that time. Kilbourn's streams are all wrong.' One can only speculate why Atwater sent Kilbourn's map to serve as a model if he knew the errors were there.

On July 11, 1820, Atwater sent further instructions:

I return to you the small map with such alterations as seemed most necessary. Fort Ferree, I have struck out altogether—it is another name for Upper Sandusky. Fort Stephenson is Lower Sandusky and there is no such fort in fact. Croghansville, lies near it and is laid down [on] No. 2 [map] correctly. Perrysburg and Fort Meigs are the same place. The

river Sandusky empties into the West end of Sandusky bay, quite at the end of the bay. You will see a small stream rising in a Reservation. It rises from a great spring and the banks of this creek are 500 ft. high of limestone. The two northern lines of Ohio are in dispute between us and Michigan. They are marked on the map returned. I want the hills and hilly country laid down. They are on no map ever published and are laid down from the field notes of the original surveyors assembled at the Surveyor General's office at my expense last summer. This map was made from 40 maps by the original surveyors and is more correct than any ever published. No. 2 wants the hills and some of the prairies and barrens which can be laid down from my first and principal map. I am more encouraged than ever as I see that No. 2 is so nearly finished and needs little correction.

Some of the changes were made; some were not. Neither Fort Ferree nor Upper Sandusky, for example, appear on the published version of the map. Yet the hilly topography of the southeastern part of the state was so indicated.

As late as August 30, after he had received a copy of the volume, Atwater sent to Thomas a long series of additions, not corrections, noting, 'I want no *alterations* in

F1G. 4.6. *Ancient Parallel Wall, Supposed to Have Been Erected for a Place of Amusement.* Plate in *Archæologia Americana* (Worcester, 1820). American Antiquarian Society.

FIG. 4.7. *Map of the State of Ohio*. Plate in *Archæologia Americana* (Worcester, 1820). American Antiquarian Society.

the Map, but a few *additions*, would be desirable (to wit) 1st the Prairies & barrens at Upper Sandusky, as on the *original map*.' Atwater then lists a dozen other additions, including a few changes in the spelling of place names. He asked that Wassaconnetta be changed to Wappaconnetta. These changes were not made on the map. Reed must have had great difficulty reading the original draft of the map. Atwater concluded the letter by requesting delivery of 'the books and Maps as soon as possible, even if these additions are not made.' Despite such troubles, however, the book appeared at last, and on July 11, 1820, Atwater acknowledged the receipt of his first copies of *Archaeologia Americana* sent from Worcester on June 15 or 22. In a letter dated in July, Atwater wrote, 'The whole Vol. is better done than would have been expected. I feel grateful for *all* you and the committee have done for me. Perhaps you have said too much in my favor more than once in the Volume.' The edition numbered two thousand copies in spite of the author's early plea for an edition of ten thousand copies. Even two thousand copies, selling at $3.00 each, were too many, for unbound sheets still exist in a crate in the cellar of Antiquarian Hall. Atwater's expectations were so impossibly high that a great cloud of depression settled over him, and a year later he all but ended his association with the Society for a time. He was disappointed that the illustrations had failed to meet his expectations, although he had failed to communicate very coherently what he wanted. Nevertheless, the book was extremely well received by the scientific community here and abroad. Moreover, it was widely noticed, and when E. G. Squier and Edwin H. Davis issued their further investigations of the same sites in 1847, Atwater's work held up very well indeed.

NOTES

1. For the standard account, see Henry Clyde Shetrone, *The Mound Builders* (New York: D. Appleton and Company, 1930).

2. H. R. Stiles, *The History and Genealogies of Ancient Windsor, Connecticut* (Hartford: Press of the Case, Lockwood & Brainard, 1892), pp. 633–37.

3. For further information on Adolphus Bourne, see Mary Allodi's *Printmaking in Canada: The Earliest Views and Portraits* (Toronto: Royal Ontario Museum, 1980).

Political Cartoons of New England, 1812–61

GEORGIA BRADY BARNHILL

FROM 1812 TO 1861, approximately eight hundred political caricatures were published as separates in the United States. Of those, only forty-seven were issued in New England. An additional ten cartoons were published in New York or Philadelphia that dealt with New England politics. Altogether, this represents a very small portion of the whole body of caricature.[1]

One characteristic of political cartoons of New England between the War of 1812 and the Civil War is an absorption with local affairs. This tendency is in sharp contrast to the output of the cities of New York and Philadelphia, where the political cartoons that were issued dealt primarily with national affairs. The reasons for this regional bias in New England and the themes that predominated in New England are worth exploring.

A discussion of political caricature in New England should first take note of the contributions of printmakers during the American Revolution. In that tumultuous period of American history, Boston was in the mainstream of the political turmoil, and it should not be surprising that the number of political prints issued during that period was high. Beginning with the Stamp Act crisis of 1765, Paul Revere produced several separately published cartoons as well as political prints in periodicals and almanacs. His prints include *A View of the Year 1765, A View of the Obelisk, The Bloody Massacre Perpetrated in King Street Boston on March 5th, 1770,* and *A Warm Place — Hell. A Caricature, being a Representation of the Tree of Liberty and the Distresses of the Present Day* was advertised by Nathaniel Hurd in the *Boston Evening-Post* on November 4, 1765, and in the *Pennsylvania Gazette* on November 21, 1765.[2] Other Revere cartoons were printed as illustrations in the *Royal American Magazine* and in almanacs. Portraits of political heroes were also featured in periodicals and almanacs. Samuel Adams, John Hancock, John Wilkes, and William Pitt were among those who were so honored. During the Revolution itself, portraits of military heroes supplanted those of the politicians. Anonymously created cartoons and portraits appeared each year in *Bickerstaff's Boston Almanack* during the late 1760s, the 1770s, and into the 1780s. Additional political prints, including *America Triumphant and Britannia in Distress* and *The Political Dancing Bear* appeared in *Weatherwise's Town and Country Almanack* for 1782 and 1783, respectively. With Boston at the center of the political scene, political caricature flowed from the presses there at a steady pace.

As the Revolution drew to a close, there was a lull in the production of political satirical prints, although publishers of newspapers, almanacs, and prints did incorporate graphic political symbols in their various publications. For example, Amos Doolittle's *Display of the United States of America* surrounded a portrait of George Washington with the seals of the states interlocked to imply political unity. Indeed, portraits of George Washington were abundant, as is so well documented by Wendy Wick Reaves.[3] The lull in satirical prints was most likely the result of the preoccupation with national unity rather than with political discord. The government established under the Articles of Confederation was weak; dissent, particularly in hopes for reform, did exist but it did not appear in the guise of caricature. Reaction to the economic depression of the 1780s took the form of direct action, as evidenced by Shays's Rebellion in Massachusetts in 1786. Effective political satire thrives on clear-cut issues and a negative point of view, and neither condition existed in the 1780s and 1790s. The situation was very different from that of the Revolutionary era when the issues between Britain and the colonies seemed well defined and the simple visual presentation of complex issues helped sway public opinion. Subjects of political caricature during the 1790s included the move of the capitol from New York to Philadelphia and the fight on the floor of the Senate, which erupted after Roger Griswold of Connecticut spread a rumor that Matthew Lyon of Vermont had been forced to wear a wooden sword in the field because of cowardice during battle. Three cartoons testify to the public interest in this fracas.

After Thomas Jefferson's election in 1800, any factionalism that had previously existed dissipated. Indeed, the election of 1804 saw only fourteen electoral votes cast against Jefferson. In such a political climate, political caricature does not flourish. Not until the Embargo of 1807 and the War of 1812 was there political caricature to match that of the Revolutionary era in vigor and numbers.

Jefferson's Embargo of 1807, which imposed restrictions on trade with France and England, was very unpopular in New England. The region depended on trade, both coastal and foreign, for its economic well-being, a dependence that differentiated the region from others. Also, the New England Federalists, by a strange irony, had considered Great Britain to be the bulwark of liberty, particularly when they compared Great Britain with France and became aware of the atrocities of the French Revolution and the turmoil caused by the complete overthrow of tradition in that country. The leaders of New England sincerely believed that to declare war against England during the height of the Napoleonic wars would hamper England's efforts and cause her downfall.

William Charles was the leading cartoonist of the decade that included the War of 1812. Having arrived from Scotland in 1806, Charles brought with him the English style and tradition fostered by Thomas Rowlandson and James Gillray, foremost practitioners of caricature in Great Britain during the eighteenth century. In his handling of line and color, Charles was no amateur, as some of the earlier creators of cartoons had been. One of his first American cartoons was *Josiah the First* (fig. 5.1), a satire of Josiah Quincy, who was particularly vocal in Congress in his opposition to the declaration of war against England. In the cartoon, Quincy, a New

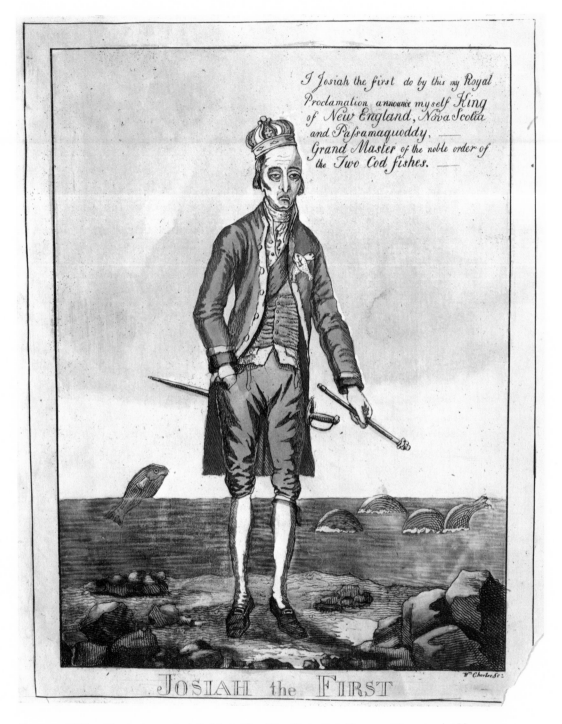

FIG. 5.1. William Charles (1776–1820). *Josiah the First* (New York, 1812). Courtesy, Worcester Art Museum, 1910.48.615.

England leader, denounces the American invasion of Canada as 'cruel, wanton, senseless, and wicked.' The visual image of Quincy—gaunt, pathetic, weak-kneed—is reinforced by the few lines of carefully chosen text that describe Quincy as 'King of New England, Nova Scotia and Passamaquoddy, and Grand Master of the Noble Order of the Two Codfishes.'

The dissension in New England continued throughout the War of 1812. In late 1814, twenty-six delegates from the New England states met in Hartford to discuss several problems confronting the region. Their primary concern was to force the federal government to fund the defense of New England. The delegates to the convention also formulated seven new constitutional amendments, among which were an increase in the Federalist party representation in Congress, a limit of sixty days for embargoes, and the exclusion of foreigners from national elective offices.

However, the popular but incorrect assumption was that the convention was plotting secession. This assumption was depicted graphically through the publication of *The Hartford Convention, or Leap No Leap* (fig. 5.2), issued as the frontispiece to *The Hartford Convention in an Uproar and the Wise Men of the East Confounded* (Windsor, Vt., 1815). Although unsigned, the frontispiece has been attributed to Isaac Eddy.[4] The iconography is simple: on the left, the English king urges the representatives of the New England states to secede and offers them 'molasses and Codfish; plenty of goods to smuggle, Honours, titles and Nobility into the Bargain.' Harrison Gray Otis and Timothy Pickering also appear, reiterating the king's message.

In spite of mixed perceptions about the War of 1812, several cartoons that celebrated American naval victories over the British were published in New England. Amos Doolittle engraved *The Hornet and Peacock, or John Bull in Distress*, to celebrate the victory of the battleship *Hornet*, commanded by Capt. James Lawrence over the British *Peacock*, under the command of William Peake, a battle that took place near British Guiana in the fall of 1812. This cartoon, with its creative use of imagery derived from the names of the two naval vessels, is reminiscent of the style of William Charles.

A second cartoon by Doolittle, *Brother Jonathan Administering a Salutary Cordial to John Bull* (fig. 5.3) is also dependent on Charles for its style. Brother Jonathan, dressed in homespun brown, forces John Bull, resplendent in red, to drink some 'Perry.' Oliver Hazard Perry was America's most famous naval commander during the war, but 'perry' is also conveniently the name of a pear liqueur, which, when drunk with immoderation, causes severe digestive disorders. The central act of forcing John Bull to drink this liquid recalls the earlier prints of 'The Able Doctor' in which a member of parliament forces tea down the throat of America.

Unlike the cartoons issued in Philadelphia by William Charles, which refer to specific battles and incidents in the War of 1812, Doolittle's cartoon serves a different purpose. The impression of the cartoon at the American Antiquarian Society is printed on a large sheet of paper. Half of it carries the print, the other half a letter that reveals Doolittles's motives for publishing the print. The printed letter is dated 'New-Haven, October, 1813,' and reads in part, 'Sir, Although a stranger to you, I

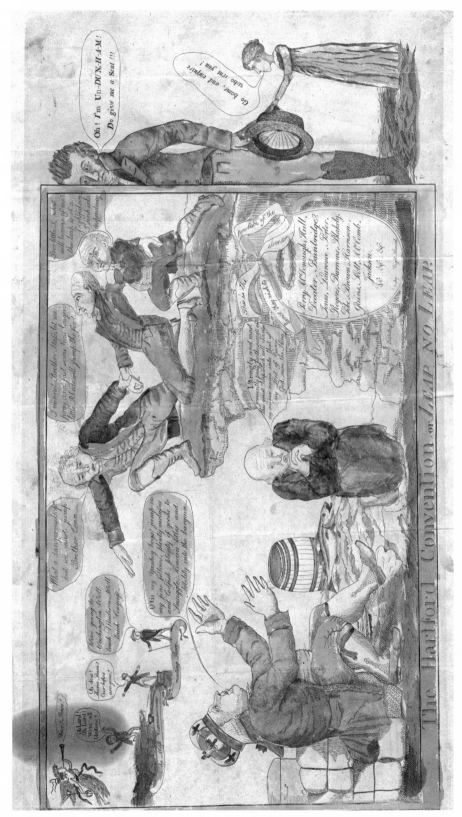

FIG. 5.2. Isaac Eddy (1777–1847). *The Hartford Convention, or Leap No Leap*, issued in *The Hartford Convention in an Uproar* (Windsor, Vt., 1815). American Antiquarian Society.

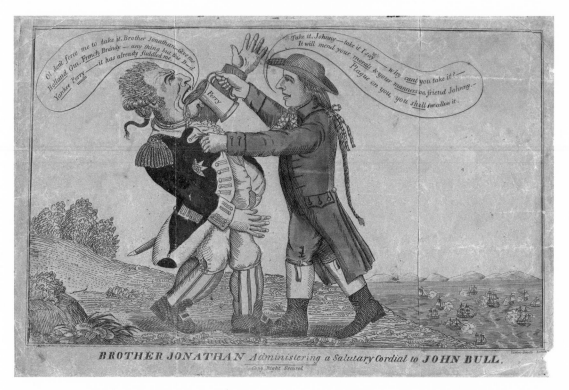

FIG. 5.3. Amos Doolittle (1754–1832). *Brother Jonathan Administering a Salutary Cordial to John Bull* (New Haven, Conn., 1813). American Antiquarian Society. Purchased as the gift of Morgan B. Brainard, 1942.

take the liberty of sending you a Caricature Print, entitled "Brother Jonathan administering a Salutary Cordial to John Bull." Although many caricatures extant are of no use, and some of them have an immoral effect, I flatter myself that this will not answer that description. At the present time, it is believed, it will have a tendency to inspire our countrymen with confidence in themselves, and eradicate any terrors that they may feel as respects the enemy they have to combat.' The patriotism that inspired this print may well be the same that caused Doolittle to engrave his four prints depicting the Battles of Lexington and Concord, as well as his portrait of George Washington.

The impression of this print at the American Antiquarian Society was sent to John Binns, the editor of the *Democratic Press* in Philadelphia. From the text of the letter, we learn that Doolittle expected newspaper editors to publish a description of the print and then act as agents in selling impressions of the print. Apparently, Doolittle sent copies of the print to editors up and down the coast. Since statements about the dissemination of political prints are uncommon, this statement about Doolittle's motives for creating the prints and his means of distribution is significant.

After the conclusion of the War of 1812, there opened what became known as the 'Era of Good Feelings.' Although the United States had not conquered Canada, the

young nation's territory and rights had been left intact. The end of the Napoleonic wars in Europe allowed the American government to ignore foreign affairs and to attend to the internal problems of the nation. To promote political unity, Harrison Gray Otis even urged the Federalists to vote for James Monroe in the 1816 presidential election, over the Federalist candidate Rufus King. Monroe's triumphal tour to the Northeast spelled the end to the strongly sectionalist feelings in New England.

The Era of Good Feelings, which lasted until 1824, is reflected in the number of political cartoons produced after the war's end. Frank Weitenkampf in his study, *Political Caricature in the United States* lists only six. He notes that the topics that they treat are temperance, the 1817 gubernatorial election in Pennsylvania, and religion. One cartoon, listed by Weitenkampf but incorrectly dated 1812, should be added to those issued during this period. *Brother Jonathan's Soliloquy on the Times* (fig. 5.4) should be dated 1819 rather than 1812, for it portrays the economically depressed postwar period, caused mainly by incompetence on the part of the directors of the Bank of the United States. Bankruptcies occurred, land prices fell drastically, and unemployment increased. Banks called in loans and mortgages, thereby increasing the number of debtors and unemployed. The emphasis in this cartoon is on banks and land sales, notices of which are posted at the sheriff's office. The cartoon is signed by Thomas Kensett, who had emigrated from England to New Haven about 1806. Relatively few of his engravings are known, but his oeuvre includes several maps and a memorial print dedicated to the heroes of the War of 1812; he also published several books and prints. His style of engraving in this work is meticulous and precise, yet the print also has a charming naive character.[5]

The presidential election of 1824 witnessed the beginning of a new system of political parties in the United States and a subsequent resurgence in political caricature focusing on presidential politics. The election itself involved five candidates, all of whom are shown in the anonymous etching *The Five Aspirants* trying to ascend a column topped by the presidential chair. David Claypoole Johnston's *A Foot-Race*, is a nonpartisan cartoon depicting the close race of Andrew Jackson, John Quincy Adams, and William Crawford. Henry Clay is shown already lagging far behind. The fifth candidate, John C. Calhoun, is not shown by Johnston for he had withdrawn from the race.

The Five Aspirants and *A Foot-Race* deal with a national event, the 1824 presidential election. A third print, *If the Coat Fits Let Them Wear It* (fig. 5.5), is an anonymous cartoon apparently engraved in Connecticut. This print refers primarily to local issues, and touches upon the 1824 election peripherally. From its style, it seems that the creator was self-taught and inexperienced. There are four parts to the cartoon, related only by references to corruption in government. The subject of one section is the election of 1824. Here, a servant enters a room, announcing that John Quincy Adams and Andrew Jackson have been elected president. William H. Crawford is depicted, lamenting that '[if] I had not turned my Coat so many times I might have then had hopes of something hereafter.' A poem on the table refers obliquely to the congressional caucus that nominated Crawford but was attended by only one quarter of the members of Congress.

The upper right section of the cartoon refers to the granting of liquor licenses to grocers in Connecticut. The justices are shown at a meeting drinking rum and brandy kindly provided by the grocers whose licenses are under consideration, obviously indicating that the cartoonist held a negative stance about this conflict of interest. The third cartoon, at the lower right, also concerns the emerging temperance movement, but the incident that inspired it remains obscure.

The final cartoon of this print concerns justice and judges. The legend reads, 'A Partial Judge merits the detestation of all—But an honest and independent Judge or Jury are an honor to their country and deserve the applause of worlds.' The judge in this case is loaded down with a sack full of sins and ascends a staircase. Unbeknownst to him, the support of the staircase has been cut and will soon topple under the heavy load. One observer states, 'The people know you and your downfall is certain.' Although each segment of this political print is undoubtedly inspired by actual events, the meaning of each is difficult to understand, particularly without proper names to establish a point of reference. The obscurity of this cartoon is typical of those produced in New England that concern local institutions and events.

Between the 1824 and the 1828 presidential elections, the development of lithography as a commercially viable way of producing prints paved the way for a phenomenal growth in the number of prints produced. Portraits, book illustrations, maps, sheet music covers, and town views all proliferated. The numerical growth of political cartoons, however, was not dependent on technology. During the American Revolution and the War of 1812, satirical prints were produced in large numbers. Amos Doolittle had expected to send out hundreds of copies of *Brother Jonathan Administering a Salutory Cordial*. Also, if political caricature were dependent on lithography, one would assume that Boston would be a center for this type of printmaking, since that city had been the setting for the first successful American lithographic firm. But this was not the case. The growth of political caricature depended upon the development of a new and vigorous two-party system, which emerged after the demise of the Federalist party and was characterized by centralized state electoral machines.

The development of state political machines, particularly in New York, with its long tradition of patronage, occurred in the early 1830s. This movement coincided with the great numbers of political cartoons produced throughout the decades of the 1830s, 1840s, and 1850s. In New England, party formation was slow and weak because of the legacy of the Federalist party, which remained a force in local and state elections, even though it ceased to be a national party in 1817. Even in the 1828 election, party organizations were weak. It was this lack of political organization, not a lack of subject matter or disputes, that resulted in the dearth of caricature after the War of 1812. For example, there are no cartoons on the Missouri Compromise, yet that was a controversial issue, to say the least. When parties were formed, there was a change in the political process. Nancy R. Davison suggests that in New York, after the realignment of political parties, the Whig party 'provided a coherent framework for political activities of many kinds. Issues and politicians generally became identified with either the Democrats or the Whigs, although specific policies

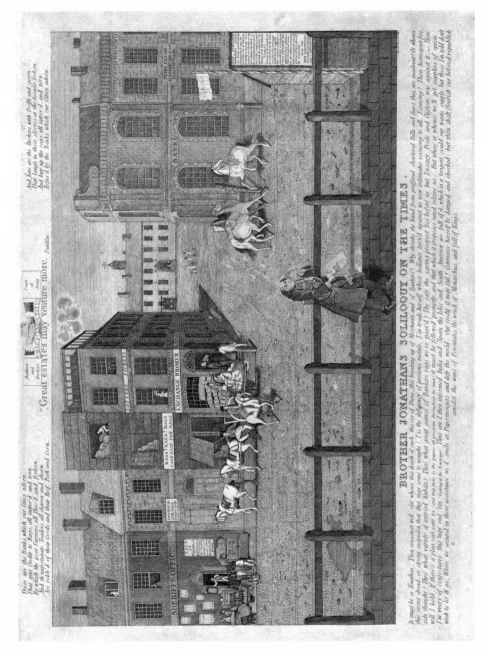

Fig. 5.4. Thomas Kensett (1786–1829). *Brother Jonathan's Soliloquy on the Times* (Cheshire, Conn. 1819). American Antiquarian Society.

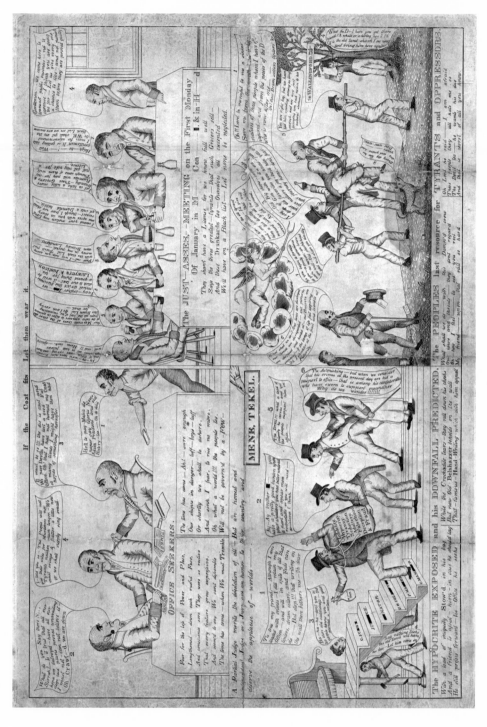

FIG. 5.5. *If the Coat Fits Let Them Wear It.* (Conn., 1824). American Antiquarian Society. Purchase 1954.

and personalities occasionally defined third parties as well. As political interest and activity increased on the local level, especially in New York City, home of Tammany Hall—the oldest American big-city machine—interest in political caricature also grew rapidly.'[6]

In the New England states, even in Boston, this variety of party organization was lacking, and political satires on national issues were only produced when the issues were of some significance to the cartoonist. For example, Davison points out that 'Johnston seems to have drawn political cartoons only on those local and national issues that interested him or appealed to his sense of the ridiculous or outrageous.'[7]

The single most productive political caricaturist in New England was indeed David Claypoole Johnston (1799–1865). He was particularly savage in his treatment of Andrew Jackson in an early caricature portrait of him entitled *Richard I.I.I.* (1824). Johnston's anti-Jackson cartoons continued throughout Jackson's lifetime. Other national events that attracted his attention included the Seminole War, various presidential elections, the annexation of Texas, and the abolitionist movement. Johnston's skill as a draftsman was excellent, and his early career as an actor resulted in particularly literate captions. Moreover, he was extremely forceful in his use of satire. Although others issued cartoons on the same subjects, Johnston's political prints are more trenchant and memorable.

On a local level, Boston politics inspired Johnston to wield his lithographic crayon or etching needle on numerous occasions. Prints such as *Raw Recruits at Drill* and *The Experiment* deal with fire proctection in the city. *A Drop of Long Pond Water Magnified by the Solar Microscope* (fig. 5.6) relates to the introduction of a reliable water supply for Boston in the 1840s. There were two disputes concerning this subject: first, whether the city or private companies should supply the water, and, second, what would be the source of the water. It was finally decided that the water supply would be municipally owned and operated and that the source was to be Long Pond (now known as Lake Cochituate in Natick, west of the city). The dialogue in Johnston's cartoon is as trenchant and witty as the drawing itself. In response to the question 'Why do you prefer Long Pond, doctor?' the learned scientist replies, 'Because with this water we can appease both thirst and hunger; to the poor this water would prove a great blessing.' Despite the presence of a variety of minuscule creatures revealed by the microscope, the poor continued to be hungry after the introduction of water from Long Pond on October 25, 1848.

A major project funded by the Massachusetts legislature was the construction of a railroad tunnel through the Hoosac Range in the western part of the state. The lack of a connecting line between Springfield and Albany prevented the movement of goods by rail from Boston to the lucrative western markets. Construction of the tunnel began in 1852 and continued until 1873. Johnston issued a cartoon at the start of this project bearing the title, *Would-be Governor Defending His Position upon a Great Local Question* (fig. 5.7). In it, a workman emerging from the tunnel announces that he has encountered sandbanks, rocks, and other geological formations while digging, as if he had participated in a spelunking expedition. The Speaker of the

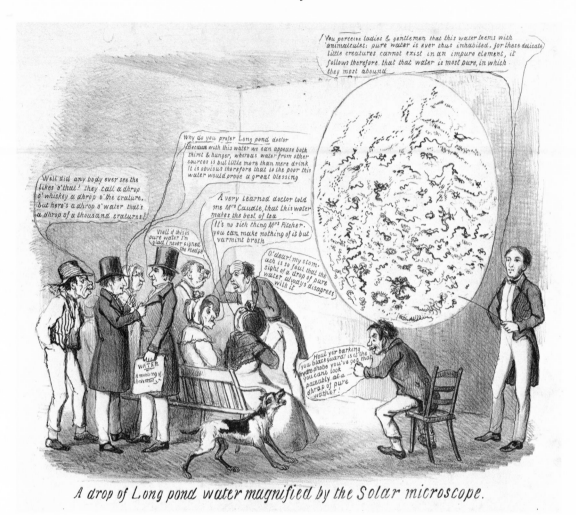

A drop of Long pond water magnified by the Solar microscope.

FIG. 5.6. David Claypoole Johnston (1799–1865). *A Drop of Long Pond Water Magnified by the Solar Microscope*. (Boston, ca. 1848). American Antiquarian Society. Purchased as the gift of Charles H. Taylor, 1933.

House comments, 'Why on the Hole, I think it a considerable Bore,' as another remarks that the progress is 'an inch and a quarter a day, for the present size of the hole,' barely large enough for a man, not to mention a railroad train. The cost? A mere $3,800,000, a substantial amount for the time and for the small measure of progress.

The entrance of the state government into such mammoth public works was apparently controversial, for the railroad tunnel project also aroused another caricaturist. The identity of the creator of the *Committee's Report of Progress on the Hoosac Bore after an Expenditure of $2,000,000* (fig. 5.8) is not known, but the impression of the print at the American Antiquarian Society bears the rare but significant

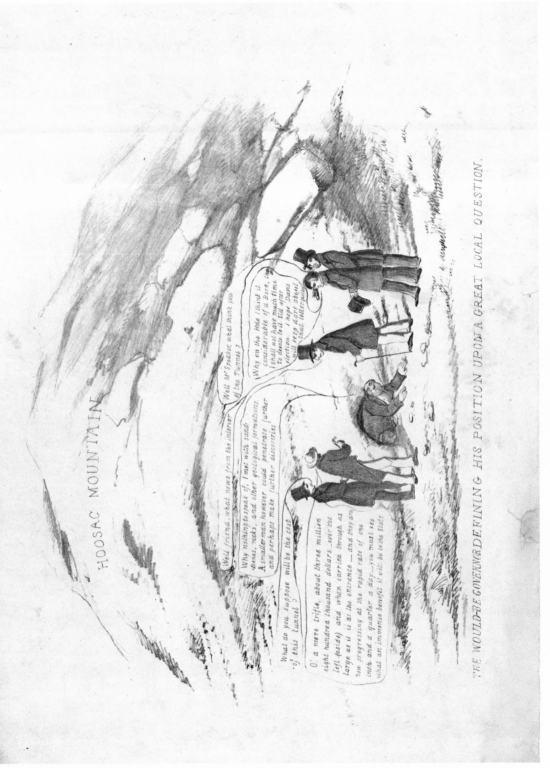

FIG. 5.7. David Claypoole Johnston. *The Would-be Governor Defending His Position upon a Great Local Question.* (Boston, ca. 1851–53). American Antiquarian Society.

legend that the 'caricature [was] presented to the members of the Massachusetts Legislature Session of 1853.'

Another issue that attracted Johnston's talents was temperance. Although perceived today as a social reform movement, the temperance movement in the nineteenth century was also a political issue, for the state attempted to legislate the consumption of alcoholic beverages by restricting the sale of liquor. One of Johnston's first cartoons on the theme was *The Victim of Ardent Spirits*, dated about 1837–41 and published by Whipple & Damrell of Boston. In 1839 Johnston was commissioned by a temperance advocate, Charles Jewett, to draw *Death on the Striped Pig*. This cartoon refers to an incident at a militia muster held in Dedham, at which some people circumvented a law against serving liquor by painting a pig with stripes and offering a dram of rum to those who would pay to see the spectacular animal. In this instance Johnston demonstrates that the law is not necessarily an effective weapon in dealing with intemperance. In 1851 Johnston returned to this issue in *Coalition Nag Used Up* (fig. 5.9), which again relates to the ineffectiveness of

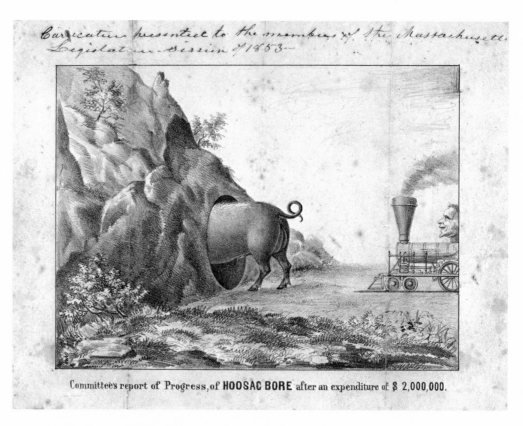

FIG. 5.8. *Committee's Report of Progress on the Hoosac Bore after an Expenditure of $2,000,000.* (Boston, 1853). American Antiquarian Society. Gift of Mrs. Charles Baker, 1937.

[96]

legislation against drinking. Johnston does not present a better alternative, but he did use his artistic efforts to demonstrate the ills of drunkenness in other prints, including etchings entitled *The Stunner, Marker & Sleeper, A Militia Muster,* and *Metamorphosis: Jonathan Soaker after the Governor's Veto to Signature to the Liquor Bill,* which was one of the series of cartoon envelopes. Johnston used this format several times. The envelopes had cutout areas and a movable internal part, which, when pulled by a tab, revealed a new facial expression and a new object in the hand of the bust-length figure. Other envelopes were issued during the presidential campaigns of 1840, 1848, and 1856. Near the end of his life in 1860, Johnston returned to the temperance theme and produced a series of drawings entitled *Slavery: (Voluntary) as It Exists, North. West. East, and South.* This series of thirteen drawings was reproduced photographically for public distribution.

The anti-Catholicism of the Know-Nothing party also drew Johnston's attention. In Massachusetts, which had become home to a flood of Irish immigrants during the 1820s and 1830s, a committee was appointed by the legislature to inspect Catholic schools and convents. This committee derisively became known as the Smelling Committee. Since Johnston had converted to Catholicism in 1844, he lithographed a cartoon entitled *The Convent Committee, Better Known as the Smelling Committee, in the Exercise of Their Onerous, and Arduous Duties at the Ladies Catholic Seminary Roxbury* (fig. 5.10). Johnston's biting wit, both verbal and graphic, is evident in this cartoon, which must have been created as a personal response to a situation that crossed the line between the social and political realms.

An additional satire relating to the Smelling Committee is *William Patterson, Esq.* (fig. 5.11). Patterson was a bandleader on a steamboat whose duties had required an absence from home lasting some four years. In Johnston's cartoon, he is seen shortly after his return, reading a newspaper account of one of the Smelling Committee's trips to Lowell that revealed that his wife had been a member of the group. A pamphlet critical of the trip, written by Charles Hale, stated, 'Another member [Mr. Joseph Hiss] is also supposed to have enjoyed some separate pleasures, but what pertains to his individual behavior does not come within the plan of this pamphlet.'[8] Apparently, the 'separate pleasures' of Mr. Hiss were shared with Mrs. Patterson. The public outrage expressed in print induced the Massachusetts legislature to investigate the committee and to expel Hiss, one of the leaders of the Know-Nothing Party. *William Patterson Esq.* was published in the midst of the legislative inquiry. The cartoon was of sufficient public interest that its availability was noted in the Boston *Daily Advertiser* on April 21, 1855.

This survey of political cartoons of New England has focused on cartoons produced in Massachusetts and dealing with Massachusetts politics, primarily because few cartoons were created in the other new England states. In Connecticut the dearth of political cartoons can be explained by the state's constitution, which prohibited a two-party system. The almost complete absence of graphic satire elsewhere in the region was also due to the lack of the equipment and artists to produce prints of any nature, which meant that political prints relating to other states were printed in Boston.

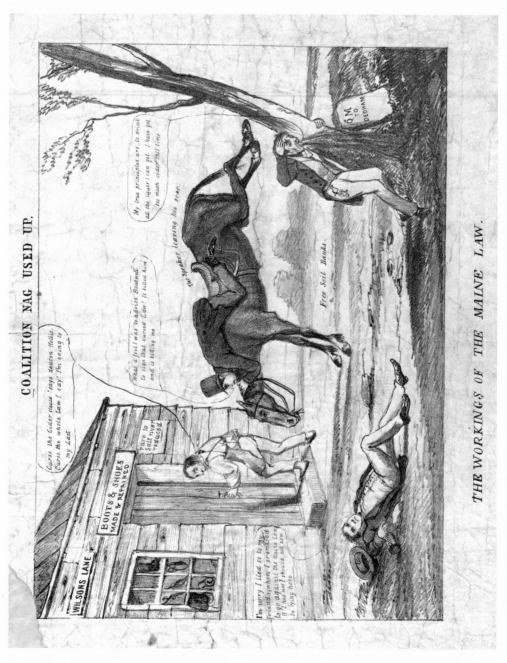

FIG. *5.9.* David Claypoole Johnston. *Coalition Nag Used Up* (Boston, 1851). American Antiquarian Society.

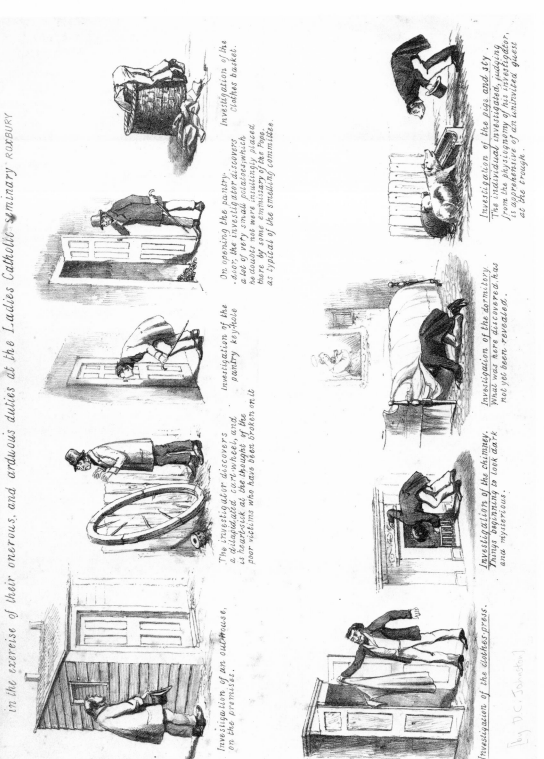

FIG. 5.10. David Claypoole Johnston. *The Convent Committee, Better Known as the Smelling Committee* (Boston, 1855). American Antiquarian Society.

The absence of political caricature in Rhode Isand may have been caused by that
state's denial of universal voting rights. However, Rhode Island experienced a con-
stitutional crisis in 1842–43 that resulted in a flurry of broadsides and cartoons. In
that year, Thomas Dorr convened the disenfranchised citizens, who were not al-
lowed to vote by reason of an antiquated charter dating from 1643. The citizens drew
up a new constitution and elected Dorr governor. When Dorr and his followers
marched on the state house, Gov. Samuel Ward King proclaimed martial law. Dorr
was later tried for treason and sentenced to life imprisonment. His efforts were not
wasted, however, for the legislature did draw up a new constitution that granted
almost universal suffrage for men. This particular civil rebellion resulted in the
cartoon *Trouble in the Spartan Ranks. Old Durham in the Field* (fig. 5.12), which
depicts the imposition of martial law. This cartoon was lithographed by Benjamin
Thayer in Boston in 1843. Another cartoon on Dorr's Rebellion, *Tyrants Prostrate
Liberty Triumphant*, was lithographed in New York by James Baillie a year later.

New Hampshire had a vigorous party system but lacked printmakers. Politics
found its outlet in newspaper essays and pamphlet commentaries. The subject of the
cartoon *The Concord Clique, or, A Peep behind the Curtain of Loco Focoism at the
Manchester House, Manchester, N.H.* (fig. 5.13) remains obscure. Bearing the date 1851,
it apparently concerns a meeting of the Loco Foco Party in preparation for one of
the state elections. Although the copyright for the lithograph was entered in Man-
chester, New Hampshire, the lithograph was probably printed in Boston.

What are the characteristics of New England political cartoons? In the early
period, through the Revolutionary era, the prints are generally copied after English
prints. Their imagery, or pictorial language, is complex and allusive. The so-called
historical prints, such as Paul Revere's or Henry Pelham's depictions of the Boston
Massacre, are straightforward, although propagandist; yet they appealed to a broad
public, for their meanings were readily apparent. In other prints, such symbols as
the serpent and the coffin appeared frequently and were easily comprehended.

During the first quarter of the nineteenth century, caricatures, due in large part
to the arrival of William Charles, were stylistically related to the works of contempo-
rary English caricaturists. The reliance on a complex iconography disappeared, as it
had in England. The complexity of political situations caused a decline in political
caricature during the 1820s. In this period, graphic artists had to face the problem
of finding a new pictorial language. In previous decades, graphic artists borrowed
their iconography from prints published in England. After the War of 1812, however,
few prints were published there that related to the United States and that presented
an iconography useful to American artists. Brother Jonathan, a creation of English
caricaturists, lingered on, yet he appeared quaint and out of place. The transforma-
tion of Brother Jonathan into Uncle Sam was slow. American graphic artists needed
a new source for inspiration and iconography.

In New England, several factors contributed to the relatively small number of
cartoons that related to the United States as a whole. One minor factor was the
physical distance between the region and the nation's capitol. Of greater importance
was the peculiar development of political parties in New England, particularly in

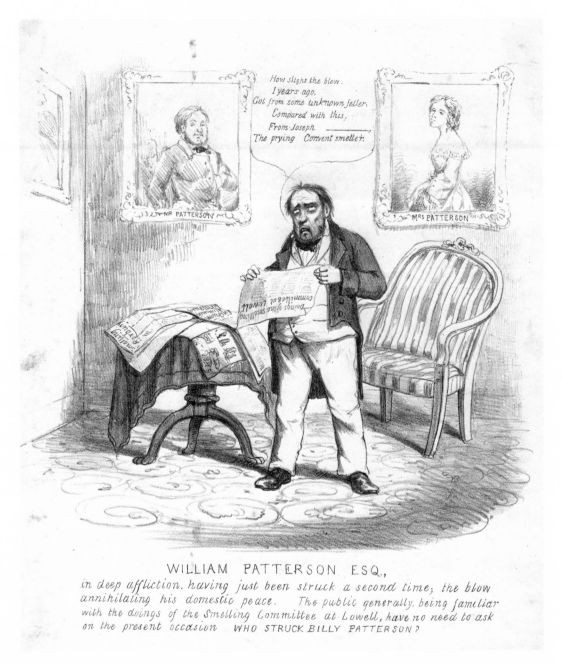

FIG. 5.11. David Claypoole Johnston. *William Patterson, Esq., in Deep Affliction* (Boston, 1855). American Antiquarian Society.

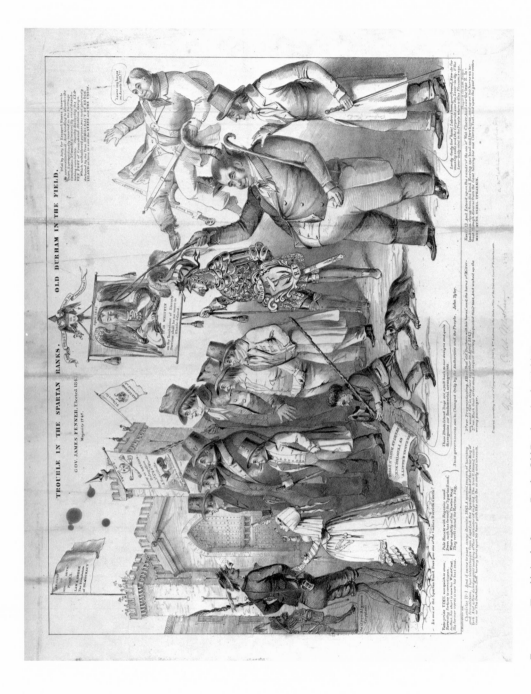

FIG. 5.12. *Trouble in the Spartan Ranks. Old Durham in the Field* (Boston, 1843). American Antiquarian Society.

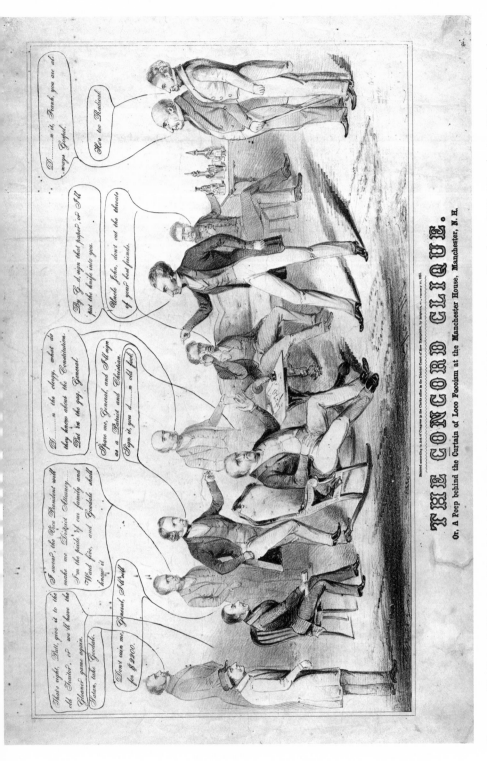

Fig. 5.13. *The Concord Clique. Or, A Peep behind the Curtain of Loco Focoism at the Manchester House, Manchester, N.H.* (Manchester, N.H., 1851). American Antiquarian Society.

Massachusetts. A final factor was the legacy of sectionalist attitudes that were preva-
lent during the colonial period. Frederick Jackson Turner notes that, as late as the
1787 constitutional convention, 'three groups of colonies were seriously considered
as factors in a new government or as substitutes for a single government.'[9] Finally,
as Nancy Davison has suggested, political caricatures of this era were usually national
in character and subject. Davison explains that this was partly the result of the
economic need to reach a wide audience. But she also points out that the broader
political perspective in cartoons issued in New York was influenced by the Demo-
cratic Tammany organization's effort to win victories in local elections by stressing
national issues and party affiliation.[10]

 All these factors together resulted in a collection of political cartoons that relate
to a variety of political and social events in New England. These prints about local
issues are occasionally obscure in their meanings because of the difficulty in identify-
ing the actors on the stage or allusions to matters that failed to be recorded in local
history texts. Nevertheless, these cartoons bear witness to a lively interest in local
affairs, and they are important as documents of the region's history.

NOTES

1. These figures are derived from the entries
in Frank Weitenkampf's *Political Caricature in
the United States in Separately Published Cartoons*
(New York: New York Public Library, 1953).
Weitenkampf's list, of course, omits some car-
toons that were not known to him but includes
some items that are not political. In spite of
omissions from the checklist, the proportion of
New England cartoons to those of the rest of
the United States would not change very much.

2. This print probably is *The Deplorable
State of America*, attributed to John Singleton
Copley. The Revere engravings are discussed
and reproduced in Clarence Brigham's *Paul
Revere's Engravings* (Worcester: American
Antiquarian Society, 1954).

3. Wendy Wick Reaves, *George Washington.
An American Icon* (Washington, D.C.: National
Portrait Gallery, 1982).

4. Vermont Historical Society, *Windsor
County Engravers, 1809–1860* (Montpelier:
Vermont Historical Society, 1982), p. 4. Eddy

also engraved, in 1815, *The Hypocrite's Looking
Glass*. William Charles also produced a cartoon
on the Hartford convention with the same title
used by Eddy.

5. The figure of Brother Jonathan is closely
copied from Plate 2 of Hogarth's prints in the
series *Marriage a la Mode*. David Tatham of
Syracuse University was kind enough to bring
this to my attention.

6. Nancy R. Davison, 'E. W. Clay: Amer-
ican Political Caricaturist of the Jacksonian
Era' (Ph.D. diss., University of Michigan,
1980), p. 266.

7. Ibid., p. 5.

8. Charles Hale, *A Review of the Proceedings
of the Nunnery Committee of the Massachusetts
Legislature* (Boston: C. Hale, 1855), p. 39.

9. Frederick Jackson Turner, 'Geographic
Sectionalism in American History,' *Annals of
the Association of American Geographers* 16
(1926): 86.

10. Davison, 'E. W. Clay,' p. 267.

Franklin Leavitt's
Pictorial Maps of the White Mountains

DAVID TATHAM

I

T HE REMARKABLE CONTRIBUTIONS of Franklin Leavitt (1824–98) to the history of the graphic arts in nineteenth-century America are almost entirely unknown.[1] There are a number of reasons for this ill-deserved obscurity, as will be clear in what follows, but chief among them is the fact that Leavitt's sole vehicle of expression was the tourist map, a genre that, when it has been considered worthy of scholarly study at all, has languished on the periphery of the main interests of most students of American maps and prints.

The genre is an old one, but it enjoyed its first important flowering in the United States in the second quarter of the nineteenth century, when tourist maps became an essential part of the paraphernalia of vacationing Americans. Often bound into guidebooks, but also published as separate sheets, tourist maps displayed the main routes to a region of natural beauty and located that region's chief scenic attractions. They were rarely exact or detailed enough to serve the more serious cartographic functions of survey maps, and they typically offered little more than a very general idea of a region and an approximation of its location in relation to important cities and towns. These maps were sometimes decorated with pictorial views, increasingly so after midcentury. They helped tourists to plan their visits, to enjoy them, and later to remember them. Pictorial unmeasured tourist maps survive to the present day, often in ignominious guises as restaurant placemats. From the 1820s, when the genre was new, to about 1880, tourist maps represented a small but significant part of the job work of a number of American graphic artists and print shops.

The two conditions necessary for the flourishing of the tourist map in America arose together. First, the building of turnpikes, canals, and railroads, and the development of fast coaches, locomotives, and steamboats, made it possible to travel with previously unimagined ease and speed throughout the vast reaches of the United States. At the same time, there arose a new romantic understanding of the American land as an unsullied, beneficent natural world, capable of teaching man how to live his life. This attitude encouraged Americans to use the new means of transportation to seek out nature at its purest, far from the cities, in order to be refreshed in body and spirit, if only for a week or two each year.[2]

Although the twentieth century has found much to study in this nineteenth-century penchant for vacationing close to uncultivated nature, the ubiquitous tourist map has lain largely unexamined, and it is easy to see why this has been so. The maps were, in the main, the routine products of printmakers who copied designs furnished by publishers, who, in turn, had often pirated them from existing maps and prints. The result was that most have a mundane similarity of concept and appearance, and little originality. But there is a striking exception to what is generally true about the genre, and that is found in the extraordinary maps of the White Mountains of New Hampshire drawn and published by Franklin Leavitt.

For twentieth-century viewers, Leavitt and his maps have been a puzzle. In 1911, Allen Bent, in his authoritative *Bibliography of the White Mountains*, listed Leavitt's 1852 map with the comment: 'While this is the first map of the White Mountains, it is more of a curiosity than a real map. . . . In 1859 a revised edition appeared with illustrations.'[3] Bent seemed to know nothing about these maps other than what he saw printed on them: that one Franklin Leavitt who called himself a mountain guide had drawn them; that Leavitt had also published them, apparently in Lancaster, New Hampshire; and that Leavitt's cartography was so unconventional as to deny his prints status as 'real' maps. Bent mentioned only the 1852 and 1859 maps, apparently unaware that Leavitt had designed and published four others as well, in 1854, 1871, 1878, and 1882, with the last reissued in 1888.

In the years following the publication of Bent's bibliography, neither he nor any other White Mountain historian or collector was able to unearth further information about Leavitt. However, as impressions of one or another of his maps found their way into many American collections, interest in this unorthodox mapmaker's 'curiosities' sharpened. Furthermore, the landmark exhibitions of American folk art at the Newark Museum in New Jersey and the Museum of Modern Art in New York in the early 1930s hastened the formation of a taste for what came to be called American 'folk' or 'naive' art. In time, it became clear to those few who looked at his prints that, while Leavitt was not a very good cartographer, he was a highly interesting 'naive' artist. The relationship of his maps to those of professional map-makers can be likened to the relationship of the landscapes of American folk artists to the paintings of the Hudson River School. In both cases, imperfectly understood academic conventions were imitated naively, but with great confidence, and were augmented with original details that often carried highly personal meanings. But to comprehend Leavitt and his accomplishments adequately, we need first to understand his subject, the White Mountains, and the spell they cast on artists, tourists, and entrepreneurs in the nineteenth century.

II

The White Mountains are the highest in the northeastern United States. They were sighted from the sea, seventy-five miles distant, early in the sixteenth century by coastal explorers. The highest summit, which stands nearly 6,300 feet above sea level and, since 1784, has been known as Mount Washington, was first climbed by a white

man in 1642. For almost a century and a half thereafter, the mountains were rarely visited and largely unexplored. They were shown schematically on John Foster's *Map of New England* of 1677, but well into the nineteenth century mapmakers continued to report them only as a generalized mountainous area north of Lake Winnipesaukee.[4]

In the last quarter of the eighteenth century, settlement began in the Coos region of the upper Connecticut River valley—the land around Lunenburg, Vermont, and Lancaster, New Hampshire. The region prospered to the extent that its people sought a passage southeast through the mountains to Portland and Portsmouth, their closest outlets to the sea. By 1785, a cart track threaded its way through a pass then called White Mountain Notch (today known as Crawford Notch). In 1803, the state improved the most difficult section of the road, making it a turnpike. This route soon served not only wagoners but also naturalists, who were attracted to the primeval wilderness and began to explore and record it.

In 1816, the first printed views of the White Mountains purporting to be accurate were published as two unsigned cuts on Philip Carrigain's map of New Hampshire. In 1823, both views were copied in reduced scale and engraved by Abel Bowen of Boston for Farmer and Moore's *Gazetteer of the State of New Hampshire*.[5] One of these is a relief cut entitled *Notch of the Mountains*. The cut shows, in a reversed image, a small section of the upper end of the Notch with the Silver Cascade intersecting the road. It is clearly based on first-hand observation. The other is an intaglio plate entitled *View of the White Mountains from Shelburne*. This view may have begun with studies from nature, but by the time the image reached the Carrigain map it had become fancifully distorted. Bowen's adaptation of the image perpetuated both its strong design and its dubious geomorphology. The northern peaks of what later came to be called the Presidential Range are shown as towering pinnacles of a sort unknown in eastern America. The presentation of this view as pictorial truth in a respected gazetteer is evidence of how little known the appearances of the region were even in the 1820s. Further evidence of this ignorance is found in an engraving from the shop of Nathaniel and S. S. Jocelyn of New Haven, Connecticut. The engraving is taken from a drawing by Gen. Martin Field that appeared in 1828 in Benjamin Silliman's *American Journal of Science and Arts*, then one of the world's foremost scholarly journals.[6] It is the first printed depiction of the natural profile formed by ledges on Cannon (Profile) Mountain, a scenic wonder that had been discovered in 1805. Although Silliman called this likeness a good one, it is not. Only in the late 1840s did more accurate depictions of the Profile appear. The first was that of J. D. Whitney, lithographed by Charles Cook for Charles T. Jackson's *Final Report on the Geology and Mineralogy of the State of New Hampshire* (1844), and the best were those by Isaac Sprague, copied on stone by John Bufford for William Oakes's *Scenery of the White Mountains* (1848). By this time the Profile was popularly known as the Old Man of the Mountains.[7]

In 1826, the attention of the nation was drawn to the White Mountains by a tragic event, the Willey disaster, that marked the beginning of a modern awareness of the region by the general public. In the summer of 1826, the Willey family, a couple and

their five children, lived with two hired men in a small inn that stood alone in the center of the Notch. Fearful of a landslide on the mountain slope that rose steeply for almost two thousand feet directly behind their house, the Willeys built a shelter a few rods south of their home in what seemed to be a more protected spot. Their worst fears were realized during torrential rains on the night of August 28. Tons of earth, stone, and vegetation high on the mountain broke loose and thundered down directly toward their house. A few yards from the rear of the building, the slide was split in two by an outcrop of rock. One branch of the slide tore away most of the Willey's barn; the other swept over the newly built shelter. The two branches converged and ground to a halt some yards in front of the house that, encircled with wreckage, stood miraculously untouched in this scene of devastation. But buried in the rubble of the slide were the bodies of the Willeys and their hired men, all of whom had sought safety outside the house.[8]

The implications of the tragic irony of the Willey disaster were deeply felt throughout America. The slide was, among other things, disquieting proof of nature's capacities for destruction. The natural world that Americans of the 1820s preferred to see as essentially beneficent had now shown its darker side, and in a location, the Notch turnpike, where man had seemed to have tamed the wilderness. The painter Thomas Cole, whose landscapes were often emblematic of cycles of life and death, traveled to the Notch the following summer to see evidence of the disaster. A drawing by Cole of the scarred mountainside was put on stone and published by Anthony Imbert in New York in 1829. Cole's companion in the White Mountains, Henry Cheever Pratt, painted the scene. The exhibition of his view at the Boston Athenaeum in 1827 brought forth first a poem on his painting by William George Crosby and then an engraving of it by Vistus Balch for the 1828 issue of the literary annual *The Token*. In succeeding years, Nathaniel Hawthorne and the poets Thomas W. Parsons and Lydia Sigourney, among others, contributed to the literature of the slide.[9]

The public's morbid interest in documentary views of the site persisted for more than a generation, and many artists labored to satisfy it. In 1839, more than a decade after the event, W. H. Bartlett included the scene among his views for N. P. Willis's *American Scenery*. Bartlett shows the rebuilt turnpike cutting through the rubble of the slide and passing the chimneyed Willey house, with the mountain walls of the Notch enclosing the view. One of Isaac Sprague's drawings for Oakes's *Scenery* of 1848 treats the same subject (fig. 6.1). Like Bartlett, he shows the great cliffs of Mount Willard standing at the head of the Notch. As we will see, these cliffs provided an important detail for Leavitt's earliest maps.[10]

In the years following the Willey disaster, the mountains rapidly became better known not only to scientists and artists but also to the general public. Each summer an ever greater number of hardy tourists traveled by coach to the rustic inns of the region. Many of them, often led by a guide, ascended the footpaths and bridle paths that were opened to a number of mountain summits in the 1830s and 1840s. The culmination of these years of exploration was the publication, in 1848, of Oakes's *Scenery*, the plates of which included several accurate panoramic views of the moun-

Drawn by J. Sprague. J. H. Bufford's Lith. Boston.

FIG. 6.1. Isaac Sprague (1811–95). *The Notch of the White Mountains, with the Willey House*, plate three in William Oakes's *Scenery of the White Mountains* (Boston, 1848). American Antiquarian Society. Gift of the estate of Alexander H. Bullock, 1934.

tains. Many other printings by Oakes during the next ten years made the scenic features of the region known to a vast audience. The printings proved to be an enticement to tourists, who, with the arrival of railroad lines early in the 1850s, were able to travel to the mountains quickly and in relative comfort. The summer hotels that sprang up to accommodate the tourists in the 1850s were celebrated in such handsome prints as the Bufford chromolithograph of the Pemigewasset House at Plymouth (fig. 6.2), a print probably dating from the mid-1850s in which hotel, railroad, and promenading guests all seem at one with nature. Less than fifty years after the opening of the Notch turnpike in 1803, the White Mountains had been transformed in the consciousness of Americans from a remote, hateful wilderness to an accessible, genteel summer playground, set in some of nature's choicest scenery.

Still, as late as 1851 there was no published map of the White Mountains. To be sure, the major ranges had for many years been shown in a general way as a scattering of caterpillars and woolly bumps on maps of the state and New England. Some route maps in guidebooks were slightly more detailed, although seldom very accurate. But no map existed that took the White Mountains as its primary subject and gave them their due, by specifying the ways in which they were different from the Catskills, Adirondacks, and Berkshires, and by showing the location of incidents in White Mountain history. The need for a map was clear, and Franklin Leavitt set out to meet it.

<div align="center">III</div>

Leavitt was born on August 6, 1824, in or near Lancaster, New Hampshire, a prosperous and attractive town on the Connecticut River with a population of about three thousand.[11] For most of his adult life, he lived on a farm in the distant eastern end of Lancaster, near Kilkenny, a bordering township consisting mostly of mountains. In their *Gazetteer* of 1823, the year before Leavitt's birth, Farmer and Moore said of Kilkenny, 'This place . . . contains but 24 inhabitants—they are poor and for aught that appears on the contrary, must always remain so, as they may be deemed actual trespassers on that part of creation destined by its author for the residence of bears, wolves, moose, and other animals of the forest.'[12] It seems fitting that Leavitt dwelled on the Kilkenny side of genteel Lancaster, since by Lancaster's polite standards he was uncouth, to say the least. Yet, in his unschooled ways, he aspired to practice the arts, motivated always by the prospect of making a profit. Leavitt earned his living as a farmer, hunter, woodsman, mountain guide, and laborer. His chief avocation was mapmaking, followed late in life by the writing of verse. Neither activity seems to have altered the roughhewn cast of his outgoing, rustic personality.

As a lad Leavitt began to work in the very heart of the White Mountains.[13] In 1836, at age twelve or thirteen, he was hired by Thomas J. Crawford, proprietor of the Notch House, situated at the northern entrance to the Notch (a building whose setting is well known from the depictions of it by W. H. Bartlett and Thomas Cole, both works made while Leavitt was at the inn).[14] He continued there until 1848, helping Crawford build the first bridle path to the summit of Mount Washington.

In 1851 he helped build another path, on the east side of the mountain, setting a

FIG. 6.2. John H. Bufford (1810–70). *Pemigewasset House, Plymouth, N.H.* (Boston, ca. 1855). American Antiquarian Society.

route to the summit that was later followed by the carriage (now auto) road. For this job he was at least a supervisor, and possibly the contractor. In the same year, he worked on the construction of the Station (later Alpine) House at Gorham, the first of the major hotels to spring up as the Atlantic and St. Lawrence (later Grand Trunk) Railroad approached the nothern end of the Presidential Range. In the 1850s, Leavitt guided parties of tourists from the Alpine House and Glen House up the bridle path to the summit, very likely entertaining them with colorful accounts of local history, including his own deeds of derring-do. By 1855, he was well enough known as a guide — or pilot, as local usage sometimes had it — to be mentioned in an early book about Mount Washington.[15]

In the winter of 1851–52, when the railroad line from Portland to Gorham was almost complete, Leavitt evidently concluded that soon there would be enough tourists to constitute a market for a unique map of the region, not a travel map but a memento of the mountains and of Leavitt the guide.

Leavitt designed such a map and took his drawing (now lost) to Boston. There he arranged to have it copied on stone and printed by John Bufford, Boston's leading lithographer, whose capable work for Oakes's *Scenery* was probably known to Leavitt. The map was printed by March 16, 1852, the date when a copy was deposited for copyright.[16] The extent to which Bufford may have improved on Leavitt's original drawing can only be guessed at, but Bufford (or someone) improved Leavitt's spelling since there is scarcely an error on the sheet. His later maps fall from this high standard.

The 1852 map (fig. 6.3) is a large sheet, about nineteen by thirty-five inches. The orientation of the map is that of Leavitt's common experience. North is at the bottom, near Leavitt's farm at Lancaster and closest to himself as he made his drawing. South is beyond the mountains at the top. In the center, a chain of mountains runs unbroken from Mount Madison at the left to Mount Mooselauke at the right. The Presidential Range constitutes the left part of this chain, its mountains drawn in a style derived from the views in Oakes's *Scenery*. But while all the peaks of the Presidentials are shown, the continuation of the chain to the right (west), beginning with Mount Willard, is a select summary of what actually exists. Leavitt omits many major peaks and links together others that are in fact miles apart. His inclusion of a mountain apparently depended on its significance to him and his work as a guide. As a rule, a mountain was shown if it was prominently visible from a hotel veranda, had a bridle path, was a notable landmark, or was the site of a memorable incident in local history. Still, despite the arbitrary geography, the east to west sequence of mountains is generally correct, and what is depicted stands as a fair summary of what the mind imagines from a place near Lancaster.

In two corners of the map are vignettes of hotels; each view was probably taken from a billhead or advertisement. The Station House at Gorham, from which Leavitt guided parties of tourists to the summit of Mount Washington, is shown at lower left. The impending arrival of the railroad at Gorham had sparked the building of the hotel, and its promise of an influx of tourists may also have inspired Leavitt's map. The Crawford House, newly built near the old Notch House, is shown at upper

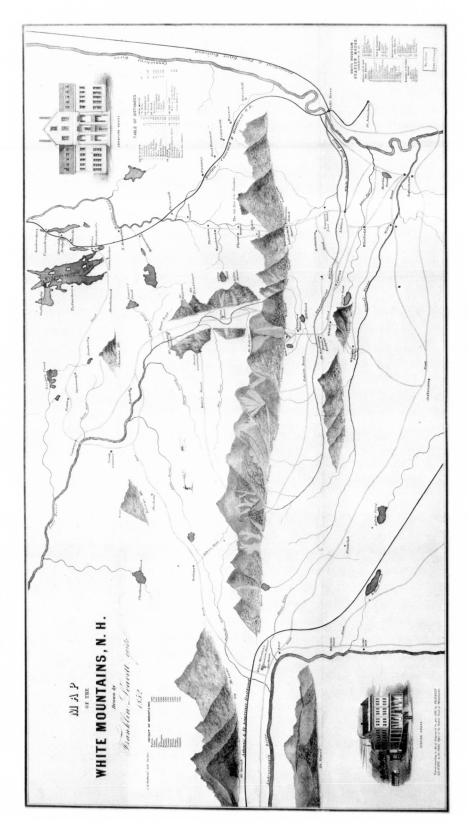

Fig. 63. Franklin Leavitt (1824–98). *Map of the White Mountains, N.H.* (Boston, 1852). Courtesy, Library of Congress.

right. Located at opposite ends of the Presidential Range, both hotels were more commodious than any that had previously served the heart of the mountains, and they heralded the beginning of an era of grand summer hotels in the region. We may be certain that copies of Leavitt's map were sold to guests at both places.

Just right of center in this map, Leavitt shows both walls of Crawford Notch, each in an orientation different from the other as well as from the rest of the map. He pinpoints the site of the Willey House and shows slide tracks converging onto it. He also shows, just to the north, the track of another slide that, falling earlier in the summer of 1826, had caused the Willeys to build their ill-fated shelter. Mount Willard is properly located at the head of the Notch but is spun around so that its cliffs face north rather than south. Leavitt seems to have altered geographic fact in this instance in order to show the locale of an incident of prime importance to himself: his perilous descent to the Devil's Den on Willard's south face (an event that will be discussed in relation to his 1854 map). The Silver Cascade plummets rather than cascades down the northern end of the western flank of Mount Webster; this part of the mountain is shown in a different orientation than that which forms the east wall of the Notch. A few of the place names are now archaic; for example, Mount Brickhouse, south of Crawford Notch, was renamed Mount Lowell in the 1860s. Rivers, roads, and railroads run in a free and general way where they are supposed to, although Leavitt fails to distinguish bridle paths from roads. His Bellows Road and Davis Road are, in fact, bridle paths to the summit of Mount Washington.

Scale is variable throughout the 1852 map. Using the Presidential Range as a standard of measure—even as depicted by Leavitt, straightened out a bit, it stretches for about seventeen air miles—one would expect Mount Chocorua at the top of the map to be only about a dozen miles due south of Mount Willard. In fact, the two are about thirty air miles apart. But, while these are major inaccuracies, it must be remembered that Leavitt had no other map to work from. Not until the following year, 1853, was the first accurate map of the region published. It was drawn by Prof. George P. Bond of Harvard, with elevations determined by triangulation. Although it fulfilled an important cartographic need, it was of scant interest to most tourists.

Although Leavitt's unconventional map has little in common with Bond's or other measured maps, it is worth observing that it shares certain features with quite a different sort of map, the kind that portrays regions of the imagination. These, often called allegorical or hieroglyphic maps in the nineteenth century, charted such unseen places as the complicated terrain of a woman's heart and the diverging routes through the landscape of life of the temperance man and the drunkard. Perhaps an awareness that the American land itself was being so thoroughly explored and recorded suggested the map as a particularly suitable metaphor for much in American life. But whatever the reason, allegorical maps appeared from time to time in books and magazines and also in the bins of popular print sellers throughout the middle third of the nineteenth century.[17] Most allegorical maps served some didactic purpose, and this surely commended the type to Leavitt, who had lessons to teach in White Mountain history. As in allegorical maps, Leavitt's rivers and roads wind

where they make design sense rather than where they would accord with geographical fact. This freedom allowed him to express his ideas about a region whose surface, to him, was the setting for the human dramas of the mountains.

<div align="center">IV</div>

The stock of Leavitt's 1852 map was depleted within two years. To take account of developments in the mountains and his own second thoughts as a cartographer, he drew a markedly different map in 1854 and again took it to Bufford in Boston to be lithographed. His map (fig. 6.4) attempts far more than its predecessor. At the bottom, a saw-tooth frieze of mountains runs margin to margin, accompanied by the explanation 'This view is seen on the southwest side of the mountains.' In fact, the view is not seen on that or any other side. Leavitt has invented a sequential summary of peaks, a kind of meandering schematic cross-section. He also lists the elevation of each peak (the figures apparently taken from the Bond map). Perhaps in an effort to be conventional, he has placed south at the bottom of the map and reversed the sequence of mountains accordingly. The slide tracks that scar the sides of the peaks are stylized versions of those seen in some of Oakes's plates.

A band of tourist hotels runs above the mountains. The two earlier hotels are now augmented by eight others, each no doubt an outlet for the sale of this map. The center of the sheet holds the map proper. Bufford's expert skills in cartographic drawings makes this map seem orthodox at first glance, but a second look quickly reveals how flexible Leavitt's geography is. Connecticut and Massachusetts, flattened by the weight of northern New England, support distorted images of Vermont and New Hampshire. It must have been this map that Thomas Starr King had in mind when he commented disdainfully in his *White Hills* (1859), 'We have even seen maps that were regularly sold in the mountain hotels which represented the Franconia Range as a westerly continuation of the great White Mountains [Presidential] chain and which placed Montreal a little south of Portland.'[18] Although Starr King's recollection of the southward descent of Montreal was slightly inaccurate, he was right in thinking that this map could not be trusted for distances and that it would be foolhardy to travel by it. However, he must have known that Leavitt meant his map to be a picture of the region, rather than a measured plan of it. In redesigning New England to fit attractively into the space available, Leavitt was not unlike many of the landscape painters of his day who regularly altered the relative scale of the components of their pictures to achieve good compositions. Because the White Mountains are the primary subject of the map, Leavitt gives them more space in New England than they actually occupy and prominently identifies Lancaster because it is his home.

At each side of the 1854 map are tables of distances, cribbed from guidebooks and other maps. Across the top of the print are six pictures. Four of these, set as pairs at each end of the map, are views of scenic spots in the mountains that any tourist might expect to see then or now: Crystal Falls and Glen Ellis Falls in Pinkham Notch, the Flume in Franconia Notch, and the Silver Cascade in Crawford Notch. Leavitt probably adapted these views from cuts in guidebooks or from photographs. (I have

<div align="center">[115]</div>

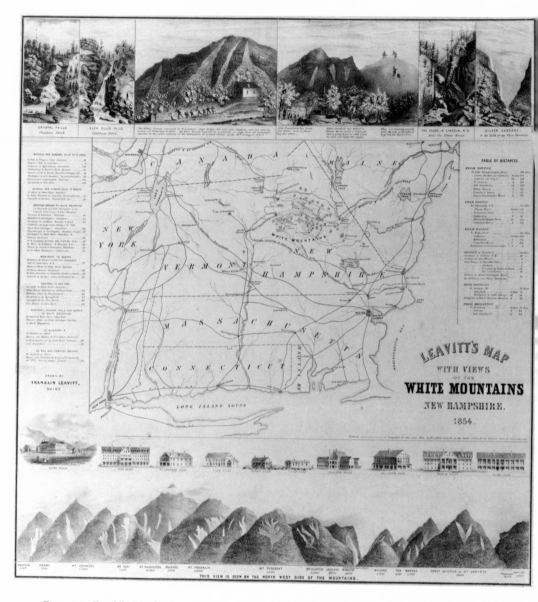

FIG. 6.4. Franklin Leavitt. *Leavitt's Map with Views of the White Mountains, New Hampshire* (Boston, 1854). American Antiquarian Society.

as yet found no close sources for them.) The two larger pictures are of a different sort, for they relate historical events.

One of these views (fig. 6.5) depicts the death of the Willeys. The seven members of the family and the two hired men are shown in headlong flight to the shelter just as the slide overtakes them. Leavitt did not copy his depiction of the shelter from

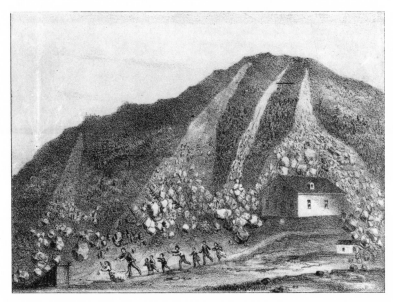

FIG. 6.5. Detail of the Willey Slide, from *Leavitt's Map with Views of the White Mountains* (1854). American Antiquarian Society.

nature, of course, since he was only two years old when it was destroyed in 1826. But because he was well acquainted with people who knew the Willeys, his conception of this ill-located refuge may have some basis in fact. His view of the house is quite accurate, which is not surprising since the building stood, little changed, until 1899. The inscription below the picture reads, redundantly, 'The Willey family consisted of nine persons. Capt. Willey, his wife and children, and two men by names of Nickerson and Allen were buried beneath an avalanche or slide from the mountains attended by the awful calamity of the destruction of a whole family on the 28th of August A.D. 1826.'

Paired with this illustration of the best-known incident in White Mountain history is a composite view (fig. 6.6) of three other occurrences about which few tourists would have any knowledge until Leavitt provided it. Inscriptions identify the three subjects. At left, one inscription states, 'Old Crawford had treed one bear and is shooting the other.' Abel Crawford was a pioneer settler of the Notch who knew the Willeys and also Leavitt. His son Thomas was Leavitt's first employer. The central inscription notes, 'Ethan Crawford has killed a moose. He has treed a wild cat and is going to put a withe [noose] around his neck and lead him home.' Ethan Allen Crawford was another of Abel's sons, and, like him, a legendary figure in the mountains. Finally, the right-hand portion of the picture bears the inscription 'They are lowering Leavitt down the side of Mt. Willard to go into the Devil's Den.' This illustration shows the mapmaker himself in 1850, playing the lead in an adventure

described in 1855 by a fellow resident of Lancaster, John S. Spaulding, in his book *Historical Relics of the White Mountains*:

"The Devil's Den," [a cave] up the side of Mt. Willard . . . appeared like a dark hole in the steep cliffs . . . To F. Leavitt belongs the credit, succeeding [in 1850] by means of a rope. . . . in . . . the daring enterprise of first visiting the spot. Fancy a man suspended over a dark gulf more than a thousand feet deep, by a rope let down from a ragged crag to a dark hole in the mountain, around the entrance of which were scattered skulls and bones of animals. . . . Our hero lost all desire to enter that dismal cavern, and kicking the rope, was again drawn up; and since that time, by his description, no explorer has been found with sufficient nerve and curiosity to make a second attempt.[19]

Leavitt's pictures of the Willeys, the Crawfords, and himself are entirely original. With these subjects, he had neither pictorial sources nor opportunities to sketch from nature. John Bufford's execution on stone probably follows the composition of Leavitt's drawings closely, while improving the draughtsmanship. The originals are not known to exist.

The 1854 version contains most of the elements Leavitt would ever put in a map: a view of the major summits and, separately, more intimate views of scenic waterfalls, an unmeasured and freely drawn map of the roads and railroads of the region set in relation to the rivers they follow, vignettes of tourist hotels, and references to incidents in local history. There is nothing extraneous. Each of these elements appears in the succeeding maps but never again combined in so strong a design. Indeed, the 1854 map is a major example of American folk art, and it is Leavitt's masterpiece.

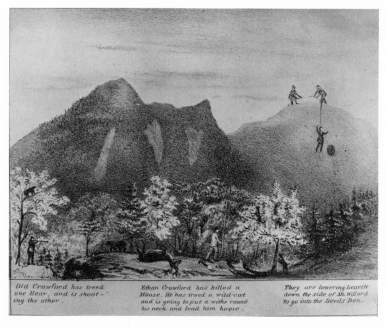

FIG. 6.6. Detail of three anecdotes, from *Leavitt's Map with Views of the White Mountains* (1854). American Antiquarian Society.

v

By the time Leavitt's third map appeared in 1859 (fig. 6.7), he had competition from other mapmakers. A year earlier, in 1858, Harvey Boardman of Connecticut had published a new and quite accurate map of the White Mountains, embellished with vignettes of hotels placed near their sites. The design of Boardman's map may have influenced Leavitt's new effort. The 1859 map was engraved on wood by Samuel E. Brown of Boston and printed from an electrotype replica of the block. North is at the top of the map. In three corners are adaptations of the four small views that first appeared in 1854. At the upper left is a small map of the rail lines connecting the region with the northeastern United States and Canada. Surrounding the mountain mass that occupies the center of the design is an expanded network of roads and railroads, alive with Concord coaches and puffing trains.

The 1859 map presents several design changes from Leavitt's earlier maps. For the first time, Leavitt locates vignettes of hotels along the roads, as Boardman had done, and also for the first time depicts mountains as existing in sequential ranges, with foothills rising before them. In addition, historical incidents are now incorporated into the landscape. In a tiny detail, Leavitt shows himself descending to the Devil's Den and, in the Notch below, the Willeys vainly running for safety. An explanation of each incident appears in type adjacent to its illustration. Old Crawford and his bear stare at each other in the mountains. Above them, on the slopes of Mount Washington, Leavitt introduces three new historical incidents: the deaths of Lizzie Bourne and Benjamin Chandler from exposure and the astonishing survival of Dr. Ball, who was sheltered only by scrub during a three-day storm. These widely reported events had occurred on the mountain in 1855 and 1856, and their inclusion in this map made it timely and topical. Astride the summit of Mount Washington, Leavitt shows the multistory hotel with attached observatory that had been proposed but that would never be built. The Mount Washington Carriage Road, beginning at the Glen House in Pinkham Notch, had not yet been completed to the summit (that would occur in 1861), but the lower part of the road was in use. Leavitt's 'Jenylin Bridge' on that section of the Carriage Road received its name from a purported visit, in 1851, by Jenny Lind. The visit has never been documented, but according to tradition, when the singer arrived at that point on the bridle path and saw the grand view, she burst into song. Leavitt's map also shows the Carriage Road crossing the summit and descending the mountain's west side. In point of fact, hopes for such an extension died when the cog railway was built on that slope in the 1860s.

Like the Boardman map, Leavitt's 1859 map was folded and issued in decoratively stamped boards at a dollar a copy. A first printing of 480 impressions in 1859 was followed by a second of the same quantity in 1860.[20] A number of other printings doubtless followed, since this map is the most commonly encountered of the six published designs.

During the Civil War years, the tourist business in the White Mountains grew, and after the war it burgeoned. Railroads expanded, new hotels were built, and Leavitt planned a new map. His surviving papers at the Lancaster Historical Society

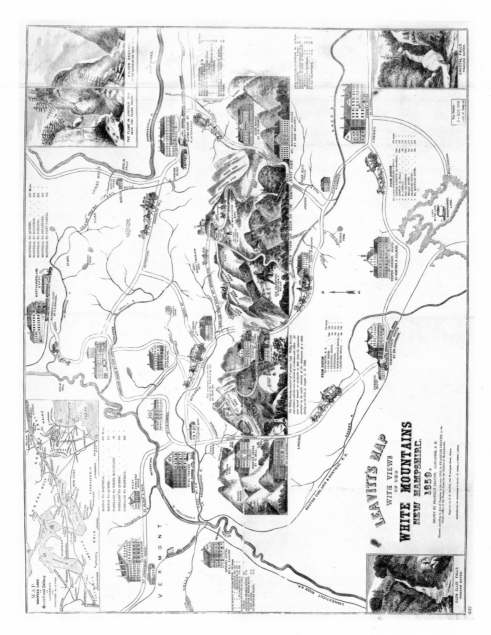

FIG. 6.7. Franklin Leavitt. *Leavitt's Map with Views of the White Mountains, New Hampshire* (Boston, 1859). Courtesy, Library of Congress.

contain a small sketch, about three by four inches, for an 1869 map (fig. 6.8). It shows the Mount Washington cog railway that opened to the summit that year. The view is once again from the north, as it was in 1852. The inadequacy of Leavitt's uncorrected spelling is evident as in *Adms* (Adams), *Plesent* (Pleasant), *Webester* (Webster), and *Waren* (Warren). His drawing is stylized and certainly from memory rather than from nature, except perhaps for the little locomotive and car climbing Mount Washington, a naively drawn but accurate summary of that distinctive rolling stock. This sketch and two manuscript maps of the late 1870s (see figs. 6.11 and 6.12) are the best available evidence of Leavitt's skill as a draughtsman.

Leavitt's sketch for an 1869 map never found its way into print, but in 1871 he published an entirely new map (fig. 6.9). North is at the bottom, with the orientation varying from mile to mile. The Connecticut River runs not only north and south, as it should, but also east and west, as it should not, snaking along two edges of the printed image. On the cog railway is the inclined-boiler locomotive peculiar to that line. The view of the mountains is the most naturalistic of any Leavitt map.

This map's rocky road to publication is well documented by a series of letters that illuminate not only Leavitt's struggles with his printers but also his struggles with the English language. The 1871 map, like its predecessor of 1859, was engraved on wood by Samuel E. Brown of Boston. On May 16, 1871, Brown agreed 'to engrave Leavitt's map . . . for the sum of two hundred and twenty dollars to be done in good style. . . in four weeks.' Three days later, Brown wrote that he had begun work. Early in June, Leavitt began to worry about Brown's progress. On June 12, Brown reassured him, saying, 'the map is progressing as fast as possible. I expect to finish it this week but I shall have to send it to New York to have it put together as no one can do it in Boston and I cannot tell the day yet when I can get a proof.'[21]

Late in June, when the map was still not ready, Leavitt traveled to Boston. On June 28 he wrote home to Lancaster: 'Mr. Brown haint got my map done. it will take All this weake to git it done. he woode not git it elacter tipt [electrotyped]. I have got to git it done my self. it will cost me 45 dollars more he denied that he ever agreed to do it he Said he only agreed to in grave it on woode i am well hope you are the same tak car of things as well as you can i am to the City Hotell Bordin it costs me 2½ dollars a day.'[22]

On July 1, Leavitt took the block to an electrotypist. In order to raise forty-five dollars to pay the bill, he made an agreement with the Boston bookseller and publisher Alexander Williams, whereby Williams covered the cost of electrotyping in return for 125 impressions of the map, plus an option for an unlimited number of impressions from later printings at one-half the retail price of one dollar a copy, as long as the plate lasted.[23] On July 10, the map was registered for copyright. It is the largest of Leavitt's maps, measuring just over twenty-four by thirty-five inches.

The 1871 map strings out its local history in four prominent vignettes of intrepid woodsmen, three of them battling bears and one taking aim at what may seem, at first glance, to be a giant rabbit but which is actually a lynx. The Willey house is shown but its family is not, nor is there any sign of Leavitt's descent to the Devil's Den. Perhaps this last incident was omitted because, beginning in 1859, Samuel

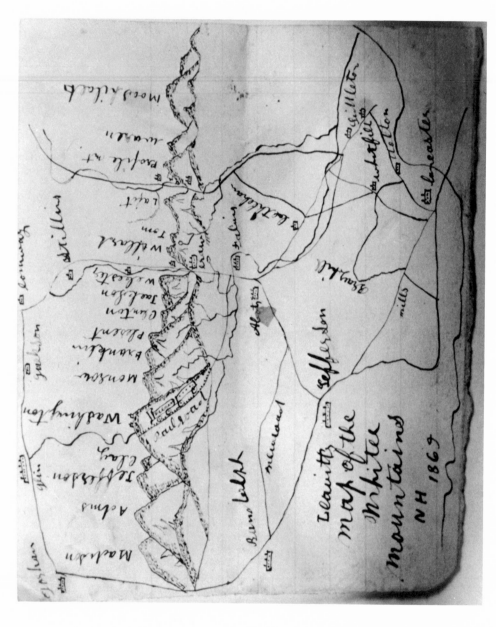

FIG. 6.8. Franklin Leavitt. Sketch for *Leavitt's Map of the White Mountains, N.H.* (1869). Courtesy, Lancaster (N.H.) Historical Society.

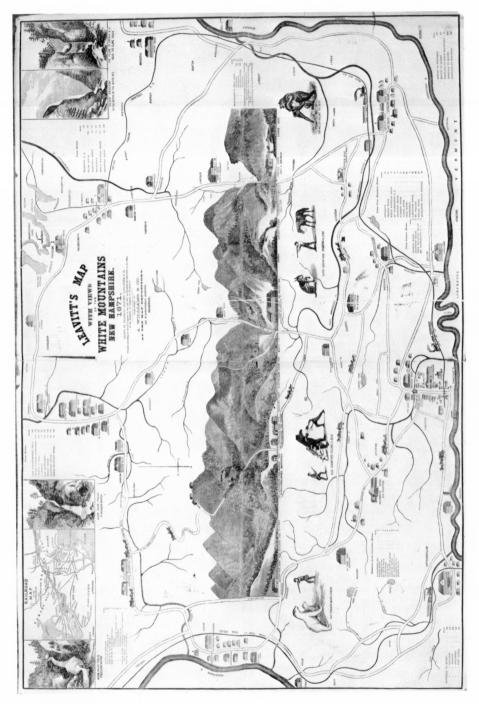

*Fig. 6.9. Franklin Leavitt. *Leavitt's Map with Views of the White Mountains, New Hampshire* (Boston, 1871). Courtesy, Library of Congress.*

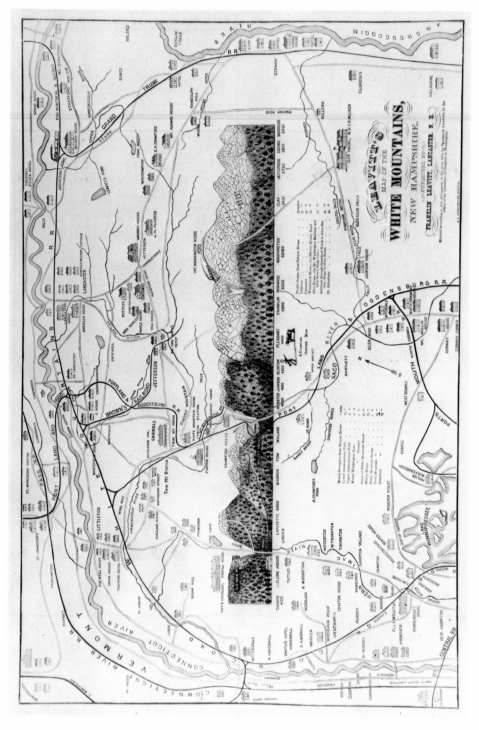

FIG. 6.10. Franklin Leavitt. *Leavitt's Map of the White Mountains, New Hampshire* (Lancaster, N.H., 1878). Courtesy, Douglas Philbrook.

Eastman's *White Mountain Guide* reported in some detail in each of its annual editions a second descent to the Den, accomplished with ease by a tourist from Boston. Without mentioning Leavitt by name, Eastman derided accounts of the earlier exploration.[24] Leavitt may have thought it beneath his dignity to contest this belittling passage, but since he was no longer the sole visitor to the cave, and since the Den had lost much of its mystery now that it was within the reach of common tourists, it never again appeared on his maps. At the bottom of the map, the town of Lancaster is greatly elaborated. In addition to hotels, Leavitt also shows homes, a church, school, depot, town hall, and covered bridge.

In 1878, Leavitt published his fifth map (fig. 6.10), the smallest of the series. This map measures about half the size of its predecessor and is the rarest of Leavitt's maps. It was engraved and printed by G. E. Johnson in Boston. Few tourists ever got to see it, for late in April Leavitt's house burned and the stock of his new map, and probably the printing plate, were destroyed.[25] Only because a small number of impressions had been distributed before the fire is the map known at all. The map shows the new rail line through Crawford Notch and emphasizes the shattered rock surfaces of the summits above the tree line.

The previous year, in 1877, Leavitt had designed a map that was not printed; he did the same in 1879. These drawings (figs. 6.11 and 6.12) show how rapidly he incorporated new developments in the mountains into his own maps. By the summer of 1881, Leavitt had both a new design and enough capital to have it engraved and printed. It was to be his sixth published map. On July 5 of that year, he hired the Boston wood engraver A. C. Russell to cut his design for what must have seemed a bargain, one hundred dollars, less than half of what he had paid Brown a decade earlier. The block was to be ready 'within a month of commencement,' but once again Leavitt was disappointed. On August 2, at the height of the tourist season, Russell wrote that he had started the map on July 19, had diligently worked on it, and expected to complete it by mid-September. On September 13, more than two months after the original agreement, he wrote to Leavitt, 'I do not wonder you are impatient. But I think if you could see for yourself . . . you would be much satisfied. The blocks are done . . . the joining will take a day or two . . . then I have got to cut the connection at the joints.'[26]

Those final steps took rather longer than expected. Two more months passed before Russell finished, in November, what he had promised for August.[27] Knowing that his map would not be ready for the 1881 season, Leavitt obliged Russell to alter the title year to 1882 (although the earlier year remained in the copyright line). Leavitt had the block electrotyped and took the plate to New York for printing. On November 26, he shipped the plate and four hundred impressions to his son Victor in Lancaster.[28] Indeed, Victor was now the publisher of record. Although Franklin had designed the map and seen it through the press, on July 2 he sold the rights of the map to Victor for one hundred dollars, and on November 21 he sold the block and plate to Victor for another hundred dollars.[29] There is no certain explanation for these arrangements, but it is possible that Franklin was retiring from guiding and that Victor was taking his place.

The map is probably quite close to Leavitt's original design. Russell, in one of his early letters to Leavitt, mentioned that the block had just come from the photographer.[30] Following a common practice of the 1880s, Russell evidently cut directly from a photographic image of Leavitt's drawing, printed on the block. In the general design (fig. 6.13), a view from the north is again a variation of the 1871 map, but with summits of shattered rocks as shown in the 1878 version. A number of details are made up of clippings from earlier maps. Bits and pieces of the row of sturdy woodsmen from the 1871 map form a new series of incidents. A formerly freestanding Harry Crawford is now atop the horse that had stood behind him in 1871. The 1871 figure of an attendant to Old Crawford appears twice in the 1882 map, once as Colonel Whipple, inexplicably positioned in the antlers of a moose, and also as Old Gib. Both of these men are new characters, but they are minor ones in comparison with those of the earlier maps. The Willey family, not seen since the 1859 map, returns, still fleeing from their doom more than half a century after the event. Lancaster and its environs now occupies a significant portion of the map, and the neighboring mountains of Kilkenny and Jefferson are shown for the first time. Leavitt identifies his own home, but it is not quite clear whether it is the small building that follows his name or the flag-bedecked house above it. In 1888, a second state of the 1882 map was issued with the final digit of the title year altered from a 2 to an 8. Impressions of this state remained unsold well into the twentieth century.

Leavitt's maps had little to offer to the tourists of the early decades of the new century. These tourists thought of the White Mountains in terms of tennis, golf, skiing, and motoring rather than history; moreover, they had witnessed the devastation of the mountains from logging and their later revitalization as a National Forest. But as records of things that are not subject to cartographic measurement, the maps have a good deal to say to present-day scholars. Informed and consistent (after a fashion), admirable in their economy of means (once they are understood), and pleasing as works of art (according to one's taste), these admirable 'curiosities' have earned their maker an important place in White Mountain history.

<div align="center">VI</div>

Leavitt retired from mapmaking after his design of 1881 and became a self-published poet. His first subject was the Cherry Mountain landslide that had swept down the north slope of this mountain in July 1885. The great scar left by the slide was easily seen from the railroad line that passed the base of the mountain, which is situated between Lancaster and the Presidential Range. Although not in a class with the Willey disaster, the slide was still newsworthy, for it had demolished the farmhouse of the Stanley family and taken one life, that of a farmhand. All summer long, railroads ran excursion trains to the site where observation platforms and refreshment stands were erected.[31] The influx of these tourists, all prospective customers, may have moved Leavitt to consider making a map of the catastrophe—a Lancaster newspaper reported that one was in the works.[32] But in the end, Leavitt offered them a poem on the subject, printed as a broadside.[33] He hawked this sheet to those who

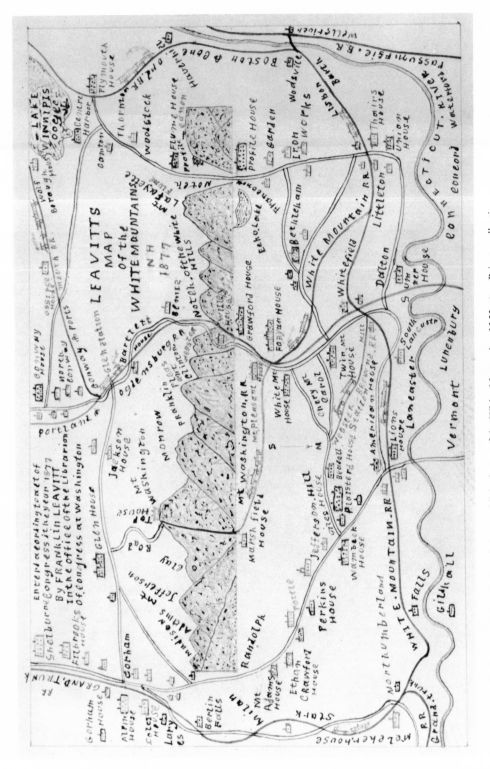

FIG. 6.11. Franklin Leavitt. Sketch for Leavitt's unpublished map of the White Mountains, N.H. 1877. Private collection.

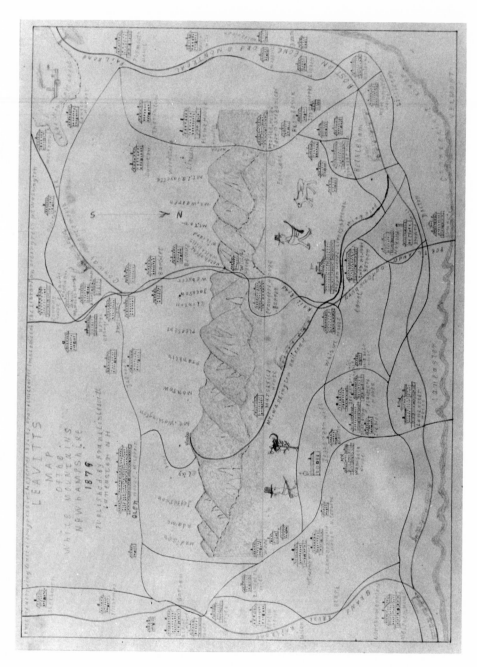

FIG. 6.12. Franklin Leavitt. Sketch for Leavitt's unpublished map of the White Mountains, New Hampshire. 1879. Private collection.

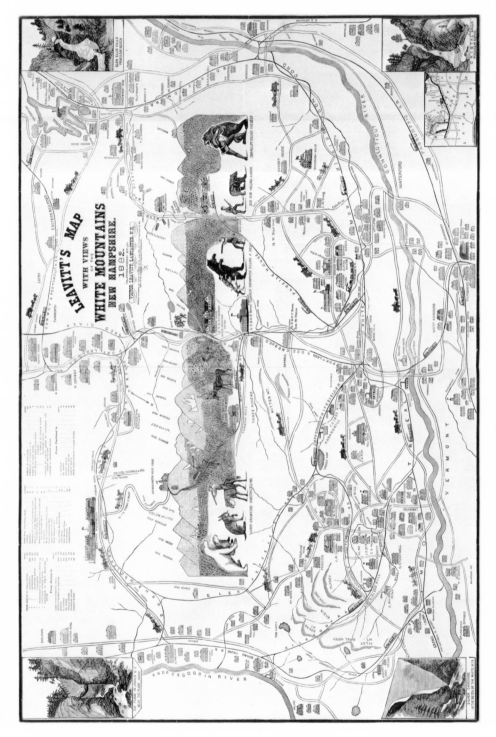

FIG. 6.13. Franklin Leavitt. *Leavitt's Map with Views of the White Mountains, New Hampshire* (Lancaster, N.H., 1882). Courtesy, Library of Congress.

gaped at the aftermath of the slide from the railside platform, and he doubtless peddled it at nearby hotels. Terse and laconic, the poem is as naive in style as its maker's maps.

> *Eighteen hundred and eighty-five*
> *Cherry Mountain down did slide*
> *Past Bordrow's [i.e., Boudreau's] house with a lightening flash*
> *Give stanley's house and barn a smash.*
>
> *It buried all his cattle, horse and hogs,*
> *And covered his farm all over with mud and logs*
> *It buried Walker under the slide*
> *They took him out, four days he died.*
>
> *Now people are coming far and wide*
> *To see that great and wonderful slide*
> *To Stanley it want much of a loss.*
> *He saved the cow, and saved the horse.*
>
> *Great loss to Walker, he lost his life,*
> *If he had lived one day longer he would married*
> *Stanley's girl for his wife.*

Leavitt warmed to this new calling and spun out other poems on a variety of White Mountain subjects. In a second broadside collection, also published in 1885, Leavitt set the story of the Willey slide to verse.[34] Perhaps sensing that he needed some line of defense against detractors, Leavitt explained in a quatrain of 1885 that the publication of his doggerel was the outcome of an encounter on Mount Washington with an unseen advocate.

> *I went up to Tuckerman's Ravine and lay down to sleep,*
> *Some spirit up to me softly did creep*
> *And said, "Frank Leavitt wake up and print your rhymes,*
> *Everybody will buy them if it is hard times."*[35]

A third collection of verse in the same format was published in 1888.[36] The last evidence of Leavitt the poet is a fourth broadside, dated January 31, 1890. This work, Leavitt's longest, was written in the aftermath of a logging railroad disaster, an event that gave the poem its title, *The Kilkenny Smashup*.[37]

Leavitt died in 1898. His wife, Emeline Welch Leavitt, died in 1909. His two sons, Frank and Victor, both well-known woodsmen and storytellers in Lancaster, died without progeny.

In both his maps and his verse, Leavitt followed a general idea of what maps and poems were expected to be but forged ahead to make them by his own lights, undeterred by either his extensive ignorance of conventions or the ridicule of others. Ultimately, our admiration for Leavitt's work stems from his evident success in controlling, in art, the vast world of his experience. Like the Hudson River School

painters, he sought to impose coherence on the wilderness. But where the painters explained the American land as divinely ordered—as the most beautiful work of the Great Designer—Leavitt took the liberty of ordering the wilderness himself. Instead of the Almighty, it is Leavitt and his fellow pioneers—the Willeys, the Crawfords, Colonel Whipple—who are at the center of his scheme of things. His maps and poems deal with the land only in its relation to settlers, tourists, guides, hotelkeepers, railroad builders, and others who shaped the destiny of the region, for better or worse. Indeed, his works are at heart advertisements of himself and of his endless satisfaction in revealing to others the wonders he had come to know. Leavitt aimed at a place in history and expected, no doubt, that his maps would keep his name alive among those who studied the lore of the White Mountains. We can be confident that he would be pleased, though probably not surprised, by the attention his works now claim in an age so distant from his own.

FRANKLIN LEAVITT'S PUBLISHED MAPS

1852
Map of the White Mountains, N.H. Drawn by Franklin Leavitt, guide. 1852. Lithograph, 19¼ x 35 in. (48 x 89 cm.), printed by John Bufford, Boston. DLC, MB, MWA, NhD, NhHi. Deposited for copyright March 16, 1852. The drawing on stone after Leavitt's original (now lost) is unsigned.

1854
Leavitt's Map with Views of the White Mountains New Hampshire. 1854. Lithograph, 25¼ x 23½ in. (64 x 59.7 cm.), printed by John Bufford, Boston. MBAt, MWA, NhD, NhHi. No record of copyright deposit. The drawing on stone after Leavitt's original (now lost) is unsigned but attributed to John Bufford on grounds of style.

1859
Leavitt's Map with Views of the White Mountains New Hampshire. 1859. Wood engraving, 20½ x 26¾ in. (52 x 68 cm.), by Samuel E. Brown, Boston, after Leavitt's original (now lost). DLC, MB, MBAt, NhD. Electrotyped by Dillingham and Bragg, Boston. Deposited for copyright July 6, 1859.

1871
Leavitt's Map with Views of the White Mountains New Hampshire. 1871. Wood engraving, 24⅜ x 35¾ in. (62 x 91 cm.), by Samuel E. Brown, Boston, after Leavitt's original (now lost). Published by A. Williams & Co., Boston.

DLC, MB, MWA, NhD. Registered for copyright July 10, 1871. A small manuscript map by Leavitt, inscribed '1869' (Leavitt papers, Lancaster Historical Society), may be a preliminary sketch for the 1871 map.

1878
Leavitt's Map of the White Mountains, New Hampshire. Wood engraving, 12¼ x 18⅛ in. (31 x 46 cm.), by G. E. Johnson, Boston, after Leavitt's original (now lost). Nh, NhD, NhHi. Copyright record unlocated. Most impressions of this map were destroyed in a fire at Leavitt's home. *Coos Republican*, May 2, 1878. Leavitt's manuscript maps for 1877 and 1879 (private collection) are different designs.

1882
Leavitt's Map with Views of the White Mountains New Hampshire. 1882. Wood engraving, 20 x 30⅜ in. (51 x 77 cm.) by A. C. Russell, Boston, after Leavitt's original (now lost). DLC, MWA, Nh, NhD, NhHi. Begun as Leavitt's map for 1881, the title year was changed to 1882 before publication. Copyright record unlocated. Though the map was designed by Franklin Leavitt, his son Victor published it.

1888
Leavitt's Map with Views of the White Mountains New Hampshire. 1888. DLC, MBAt, NhD, NhHi. This is a later state of the 1882 map with title year changed to 1888.

1. The fact that I am able to offer a reasonably comprehensive account of Franklin Leavitt and his works is in part the result of some happy turns of fate by which a significant portion of Leavitt's surviving personal papers escaped destruction and found their way to safekeeping at the Lancaster (N.H.) Historical Society, just in time to provide answers for many of my questions. Without the helpful cooperation of the society, and especially of Virginia Martin Guiser, who has expertly organized the Leavitt collection, I would have many fewer facts to report. Mrs. Guiser, and Mr. and Mrs. Stanley Costine of Lancaster, have generously shared with me the results of their searches for information about Leavitt and his family in local newpapers and other records. I am also grateful to Douglas Philbrook of Gorham, New Hampshire, for many helpful suggestions made from his unexcelled knowledge of White Mountain history and for the opportunity to consult materials in his collection of White Mountainiana; to Walter Wright, chief of special collections emeritus at the Dartmouth College Library, and a leading White Mountain scholar, for his generous and authoritative answers to many questions; to Stephen Stinehour for resourceful photographic work; and to Doris Adams of Goodspeed's Book Shop, Boston, for introducing me, in 1968, to my first Leavitt map, thereby setting in motion the present study.

2. For some inkling about the attitudes of nineteenth-century Americans toward nature and art, see Hans Huth, *Nature and the American* (Berkeley: University of California Press, 1957), James Thomas Flexner, *That Wilder Image* (Boston, 1962), and Roderick Nash, *Wilderness and the American Mind*, rev. ed. (New Haven: Yale University Press, 1973).

3. Allen H. Bent, *Bibliography of the White Mountains* (Boston: Houghton Mifflin, 1911), p. 84.

4. My summary of the early history of the White Mountains is drawn from Frederick W. Kilbourne, *Chronicles of the White Mountains* (Boston: Houghton Mifflin, 1916), still the standard history of the region. For Foster's map, see Wendy J. Shadwell, *American Printmaking, The First 150 Years* (New York: Museum of Graphic Art, 1969), pp. 16, 17, pls. 2, 3.

5. Impressions of the Carrigain map may be found at the American Antiquarian Society, the New Hampshire Historical Society, the

Dartmouth College Library, and elsewhere. See also John Farmer and Jacob Moore, *Gazetteer of the State of New Hampshire* (Concord, N.H.: Jacob B. Moore, 1823), in which *Notch of the Mountains*, a wood engraving signed in the block *AB* (Abel Brown), faces p. 262; *View of the White Mountains from Shelburne*, a copperplate engraving signed in the plate *J. Kidder del A. Bowen Sc.*, faces page 259. James Kidder's credit for drawing the view probably means that he reduced and adapted the Carrigain map cut for Bowen's use.

6. *American Journal of Sciences and Arts* 14 (1828), pl. facing p. 64.

7. Jackson's *Final Report*, published by order of the New Hampshire legislature, included among its plates seven mountain views. These plates were also included in Jackson's *Views and Map Illustrative of the Scenery and Geology of the State of New Hampshire* (Boston: Thurston, Torry and Co., 1845); William Oakes, *Scenery of the White Mountains* (Boston: Little & Brown, 1848). Thomas Cole reported the nickname 'Old Man of the Mountains' for the Profile as early as 1828. Louis Legrand Noble, *The Life and Works of Thomas Cole* (1853; repr. Cambridge, Mass: Harvard University Press, 1964), p. 67. It seems likely that, both with and without the final *s* in the word 'mountains,' the name was in use earlier.

8. Jeanette E. Graustein, 'The Willey Family,' *Appalachia* 32 (1959): 488–501, contains an excellent summary of contemporary accounts of the slide and its aftermath. It is now widely believed that the Willeys were in the barn, rather than fleeing to the shelter, when the landslide struck.

9. 'View in the Notch of the White Mountains, New Hampshire, by Pratt,' in [William George Crosby,] *Poetical Illustrations of the Athenaeum Gallery of Paintings* (Boston: True and Greene, 1827). Vistus Balch's engraving faces page 154 in *The Token, a Christmas and New Year's Present* [for 1828] (Boston: S. G. Goodrich, 1828). Another more vivid documentary view is the lithograph, after a sketch by Daniel Wadsworth, entitled *Avalanches in the White Mountains,* facing page 69, in [Theodore Dwight,] *Sketches of Scenery and Manners in the United States* (New York: A. T. Goodrich, 1829). It shows the slide tracks on what is now Mt. Willey from a vantage point on what is now Mt. Webster. Hawthorne's 'The Ambitious Guest' (1835) is well known. Thomas W.

Parsons first published his 'The Willey House' in the October issue of *Putnam's Monthly Magazine* (1855): 350. Mrs. Lydia Sigourney's 'The White Mountains after the Descent of the Avalanche in 1826' appeared first in the August issue of *Ladies' Magazine* (1828): 340–42.

10. N. P. Willis, *American Scenery*, 2 vols. (London: George Vertue, 1838 and 1839; repr. Barre, Mass.: Imprint Society, 1971). Bartlett's illustrations of White Mountain views are romanticized, and he takes liberties with the terrain. See Oakes, *Scenery*, pl. 3. Accompanying this plate is Oakes's valuable account of the disaster.

11. Unless otherwise noted, biographical information about Leavitt and his family is drawn from the Leavitt Family Papers, Lancaster (N.H.) Historical Society.

12. John Farmer and Jacob Moore, *Gazetteer of the State of New Hampshire* (Concord, 1823), p. 168.

13. This summary of Leavitt's early career is drawn from a brief account in the newspaper published in season on the summit of Mount Washington, *Among the Clouds*, Aug. 28, 1887. I am grateful to Leslie Holden Dixon for bringing it to my attention. The full text reads: 'Franklin Leavitt of Lancaster, the White Mountain map-man, was recently one of the visitors at the summit. He is an old guide and mountaineer, having begun work in 1836 for Thomas J. Crawford at the Notch House, where he worked for twelve years, for $10 a month. He then went to Gorham and helped build the Alpine House. That was in 1851. The same year he worked at building the bridle path [Bellow's Road on Leavitt's 1852 map] from near the present Glen House to the summit of Mount Washington. The Grand Trunk Railway paid for building the road, which cost $600. The Glen House was built the same year. Mrs. Hayes kept the Alpine House, and Mr. Leavitt was employed there. He went every day from Gorham to the summit and back, walking from the Glen House to the summit and return, for six weeks. The bridle path was five miles long, and in those days the charge for a horse to make the round trip was $3. It used to take three hours to make the ascent. Mr. Leavitt has not lost his old-time vigor, as he recently made the trip from Thompson's Mill in Pinkham Notch to the summit in three hours.'

14. For Bartlett's engraving *The Notch House–White Mountains*, see Willis, *American Scenery* (repr. Barre, Mass.: Imprint Society, 1971), p. 192. Bartlett shows the Notch House

in detail. Cole's 1839 painting, *Notch of the White Mountains*, in the National Gallery of Art, is reproduced in Howard Merritt, comp., *Thomas Cole* (Rochester, N.Y.: Memorial Art Gallery, 1969), p. 89.

15. John B. Spaulding, *Historical Relics of the White Mountains* (Boston: D. R. Hitchcock, 1855), p. 28.

16. Copyright records, 1852, for Massachusetts, Rare Book Division, Library of Congress.

17. Examples of American allegorical maps are the engraving *An Illustrative Map of Human Life*, published in New York in 1842 by J. H. Colton (located in the British Library Map Room), and the lithographs *Map of the Open Country of a Woman's Heart*, 'by a Lady,' published in Hartford by E. B. & E. C. Kellogg, and *The Way of Good and Evil*, a temperance print drawn and published by John Hailer in Northampton, Pennsylvania. Both lithographs are reproduced in Harry T. Peters, *America on Stone* (Garden City, N.J.: Doubleday, Doran, 1931), pls. 56, 81.

18. Thomas Starr King, *The White Hills* (Boston: Crosby and Nichols, 1859), p. 2.

19. Spaulding, *Historical Relics*, pp. 83–84.

20. Bills for printing the 1859 map are in the Leavitt Family Papers, Lancaster (N.H.) Historical Society.

21. Samuel E. Brown to Franklin Leavitt, May 16, 19, and June 12, 1871, Leavitt Family Papers.

22. Leavitt, unaddressed, but probably to Emeline Welch Leavitt, his wife, June 28, 1871, Leavitt Family Papers.

23. Alexander Williams to Franklin Leavitt, July 7, 1871, Leavitt Family Papers.

24. Samuel C. Eastman, *White Mountain Guide Book* (Concord, N.H.: Edson C. Eastman, 1859), pp. 61–62. Eastman credits 'the Crawfords' for the initial descent. Perhaps members of the Crawford family worked the rope for Leavitt.

25. [Lancaster, N.H.] *The Coos Republican*, May 2, 1878.

26. A. C. Russell to Franklin Leavitt, July 5, Aug. 2, and Sept. 13, 1881, Leavitt Family Papers.

27. A. C. Russell to Franklin Leavitt, Oct. 31 and Nov. 20, 1881, Leavitt Family Papers.

28. Franklin Leavitt to Victor Leavitt, Nov. 26, 1881, Leavitt Family Papers.

29. Franklin Leavitt to Victor Leavitt, July 2 and Nov. 21, 1881, Leavitt Family Papers.

30. A. C. Russell to Franklin Leavitt, Aug. 2, 1881, Leavitt Family Papers.

31. The *Lancaster Gazette*, July 31 and Aug.

14, 1885, reported Sunday excursion trains of thirteen and twenty-eight cars. A broadside announcing an excursion to the site from Montpelier, Vermont, on July 19, 1885, is reproduced in *Historical Memories of Jefferson, New Hampshire* (Jefferson, N.H., 1971), p. 16.

32. Unidentified newspaper clipping, Leavitt Family Papers.

33. Franklin Leavitt, *Leavitt's Poems of the White and Franconia Mountains, N.H.* (Lancaster, N.H., copyright 1885), a broadside published by Franklin Leavitt. Impressions have been located at the New Hampshire Historical Society, Lancaster (N.H.) Historical Society, and the Harris Collection, John Hay Library, Brown University.

34. The second broadside, published in 1885, has the same title. Impressions are located in the Harris Collection, John Hay Library, Brown University.

35. This poem is among those on the broadside described in footnote 33.

36. The 1888 broadside has the same title as its predecessors and reprints some of their verse, but it also includes new poems. Copyright 1888, Lancaster (N.H.) Historical Society and the Harris Collection, John Hay Library, Brown University.

37. The 1890 broadside has the same title as its predecessors but carries as a subtitle, *The Kilkenny Smashup*. Copyright 1890, Lancaster (N.H.) Historical Society. All of Leavitt's published verse is printed in David Tatham 'Franklin Leavitt's White Mountain Verse,' *Historical New Hampshire* 33 (1978): 209–31.

Calico Printing

JANE D. KAUFMANN

THE PRODUCTION OF the printed cottons that contributed so much to the color and decoration of the home and the person in nineteenth-century America was not a simple matter, for it involved much labor and many skills beyond those of the designer. This paper will cover briefly the history of printed calico in the United States through the 1840s and then focus on some of the techniques by which pattern and color were produced.

Production methods in Great Britain and the United States were similar, and it is difficult to distinguish American printed calicoes from the English imports. There are a number of nineteenth-century manuals that describe the calico printing processes in detail, and some include fabric swatches. Not surprisingly, English technical treatises were reprinted in the United States, and this fact may help to explain the similarity in the finished products. Particularly useful is the section on 'Dyeing and Calico Printing' in Edward Andrew Parnell's *Applied Chemistry in Manufactures, Arts, and Domestic Economy*. First published in London in 1844, the text was also reprinted two years later in New York by Harper and Brothers in *A Practical Treatise on Dyeing and Calico Printing*.

Calico printing as a large-scale industry did not develop in the United States until the 1820s. England maintained strict controls on the exportation of machinery for the textile trades, and English goods, including printed fabrics, were cheap and plentiful.[1] The English domination of the industry continued for some time. Even as late as 1873, an American writer declared that although the quantity of American printed calico nearly equaled the amount produced in England, the quality of English and French printed calico was superior. 'Calico printing in our country is more remarkable for mechanical power and speed than for taste,' he asserted.[2] Nevertheless, it is worth noting that the consumption of calico in America was greater in proportion to population than in any other country in the world.

Beginning in the 1790s, a number of calico printing operations were started in the United States. A few examples of their simple block printed fabrics survive in public and private collections.[3] Printing companies were established in Boston in 1798, and in Providence and East Greenwich, Rhode Island, at about the same time. Three companies developed in Philadelphia and vicinity by 1803 and another in Baltimore around 1810.[4] These manufacturers were considerably hampered by

foreign competition and by the lack of a protective tariff. Great Britain not only had machinery and skilled labor but also had the capital that enabled merchants to sell British goods on long credit terms, with small profits, and even occasionally at a sacrifice.[5]

Large-scale cotton manufacturing in the United States, combining all of the operations from processing raw cotton to finishing the cloth, but not including calico printing, began with the establishment of the Boston Manufacturing Company in Waltham, Massachusetts, in 1813.[6] By the 1820s, the cultivation of cotton in the United States was increasing, and the price of it was low. The cotton factory at Waltham was extremely successful and was regarded as 'the pride of America.'

The popularity of American cottons was rising in the United States and abroad. Capital was available, not only to expand the manufacture of cotton cloth but also to begin the printing of calico on a large scale.[7] In 1822, two of the principal owners of the Boston Manufacturing Company, Patrick Jackson and Nathan Appleton, looked toward the expansion of the company's operations to the printing of calico. Not finding available water power in Waltham, they purchased the Pawtucket Canal and land on the Merrimack River and incorporated the Merrimack Manufacturing Company; the site later became the city of Lowell.[8] As the illustration on a label (fig. 7.1) for the company suggests, the company wove fabric and also printed cloth.

At about the same time that the Merrimack Manufacturing Company was established, other large-scale print works were founded at Fall River and Taunton, Massachusetts, and at Dover, New Hampshire.[9] These companies used both wood blocks and engraved cylinders to print calico and found it necessary to import British technology and skilled workers to ensure the success of their operations. Early in the history of the Merrimack Manufacturing Company, engravers were brought from England, and in 1826 John D. Prince of Manchester, England, was hired as superintendant of the Merrimack Print Works. He remained in that position for twenty-nine years and was largely responsible for the success and high quality of the company's printed fabrics.[10]

In 1845 there were two calico print works in Lowell—the Merrimack and the Hamilton, both printing over fourteen million yards of calico per year. The operations of the print works were very simply described by Samuel L. Dana, the chemist employed by the Merrimack, in a history of Lowell published in 1845. Colors were achieved with vegetable dyes, such as logwood, madder, and indigo, and a cylinder printing machine was used that was capable of printing up to six colors. Additional colors could be blocked in by hand. The companies employed designers and engravers to create and execute the patterns. The printing cylinders were engraved by the mill and die method.[11] From the surviving swatches, the identifiable output of the print works in New England seems to have been small dress prints rather than the large furnishing designs.[12]

Prior to printing, the newly manufactured cloth had to be singed and bleached. The purpose of singeing was to remove the fine nap that would prevent the sharp definition of the pattern. Singeing was accomplished by drawing the calico over red hot copper cylinders or over a coal gas flame. The importance of the bleaching

FIG. 7.1. Label for the Merrimack Manufacturing Company, Lowell, Mass. (n.p., n.d.) American Antiquarian Society.

process cannot be overemphasized because the color and appearance of the finished print depended on a pure white fabric. Not only was the cloth whitened during the bleaching process, but any dirt, grease, or stains acquired during its manufacture were removed. About 1790 the bleaching process was improved with the introduction of chlorine, but even in the 1840s, Parnell lists sixteen steps to the chlorine bleaching process that were necessary before the cloth was finally mangled and dried.[13]

The final preparatory step was the thickening of the mordant and color to prevent it from spreading beyond the pattern during printing. The usual thickeners were flour, wheat starch, roasted starch (British gum), gum tragacanth, or gum arabic. The thickening agents varied according to the complexity of the design, the particular mordant to be applied, or the method of printing.[14]

The actual printing of the fabrics was accomplished in one of four ways: by carved wood blocks, by engraved copperplates, by engraved copper cylinders, and by a combination of copperplate or cylinder printing with wood blocks.

The simplest way to print calico was with wood blocks into which the design has been cut in relief. The block was gently pressed on a tightly stretched woolen cloth, called a sieve, which was evenly covered with the thickened color. A child, called a

'tearer,' was responsible for keeping the sieve properly coated with color. The printer set the block on the fabric, carefully matching it to previously printed sections, and struck it gently with a mallet to transfer the pattern. Each block could print only a single color; additional colors required additional blocks.[15]

It has been estimated that to print a simple pattern in one color on a single piece of cloth (twenty-eight yards) required the application of the block 448 times. To print one hundred pieces would mean 44,800 strikes of the block. Although blocks were made of hard wood (sycamore, holly, pear, maple), finely cut designs wore quickly under such use. An innovation developed in London about 1802 improved the longevity of each block. Instead of being carved in relief, the pattern was formed by inserting flattened brass or copper wire, standing about one-eighth of an inch high, into the wood. Solid parts of the pattern were formed by filling the space between the wires with felt. Printing blocks constructed in this manner were presumably ten times as durable as the carved blocks. By 1844 stereotyped plates for the printing surfaces of blocks were introduced.[16]

A second method for printing calico involved the use of engraved copperplates. This method was developed by an Irishman in the mid-eighteenth century and involved a modification of the copperplate printing press that was used to produce engravings on paper. In this second method, the engraved copperplate was coated uniformly with the thickened color, which was then wiped from the surface of the plate. The color that remained in the engraved lines was picked up by the cloth when it came in contact with the plate under pressure.

Calico printed by copperplates became immediately popular. This process resulted in prints of finer detail and of larger scale than could be achieved with wood blocks, and many beautiful designs, in the manner of engravings on paper, were produced. One drawback to this method was that only one color could be printed. Additional colors had to be applied with blocks or stencils. For this reason, copperplate printing never replaced block printing. A second drawback to this process was shared by block printing. The copperplates, which could be as large as a yard square, had to move through the press and back for each repeat of the pattern. The joining of the patterns was difficult, particularly when the machines were operated by hand, and the aligning of the patterns had to be done by eye.

In spite of mechanical improvements to the copperplate press and the reduction of the size of the plate, this was a slow and expensive method of printing calico. By the early nineteenth century, the cylinder machine superseded copperplate printing for fabrics, except for the production of handkerchiefs.[17] Since copperplate calico printing was outmoded before larger factories were established in the United States, it was not a factor in American calico printing.[18] However, certain specialty items such as maps and souvenir handkerchiefs may have been printed from copperplates. A large map of New York City, for example, was engraved by Peter Maverick of New York and printed and published by Piror and Bowne of New York in 1829 (fig. 7.2). A large, unsigned handkerchief featuring the text of the Declaration of Independence (fig. 7.3), surrounded by the seals of the states and portraits of the founding fathers, is similar to two copperplate engravings on paper, one that is anonymous and the

FIG. 7.2. Thomas H. Poppleton. *Plan of the City of New-York* (New York: Piror & Bowne, 1829). American Antiquarian Society. Gift of Bruce LeRoy, 1983.

FIG. 7.3. *The Declaration of Independence* (textile). (n.p., n.d.) American Antiquarian Society.

FIG. 7.4. *Declaration of Independence* (paper). (n.p., n.d.). American Antiquarian Society.

other engraved by Atwood and Story and published by Phelps and Ensign in New York in 1844 (fig. 7.4).

The technique of cylinder printing, patented by James Bell in England in 1783, revolutionized the calico printing industry. Cylinder printing was a continuous process, rather than an interrupted one, and was much faster than block or copperplate printing. Briefly, the cylinder press consisted of an engraved copper cylinder mounted so that it revolved between two other cylinders. The lower of the two supplied the engraved cylinder with color. The upper one provided an elastic surface upon which the cloth was printed. On one side of the engraved cylinder, a sharp-edged steel blade, called a 'color doctor,' removed excess color from the revolving engraved cylinder, while on the opposite side a similar blade, the 'lint doctor,' removed any lint picked up from the calico. Machines with additional engraved cylinders and color cylinders were developed to print additional colors, and by the 1840s designs having as many as eight different colors could be printed on a single machine in one operation.[19]

The amount of labor saved by these innovations was staggering. Parnell estimated that a cylinder machine, operated by one man, could print as many pieces (a standard length of twenty-eight yards) as one hundred men and one hundred girls could print by blocks in the same time, and in four minutes the machine could print the yardage that would take four hours by the hand-block method.[20]

Cylinder machines could be used to print almost any kind of pattern: a pastoral scene in the style of copperplate prints, historical scenes such as Zachary Taylor in battle (probably derived from a Currier & Ives lithograph), gay floral prints used for furnishings, and various small patterns used for dressmaking.

The diameters of the cylinders varied from four to twelve inches or more; the length ranged from thirty to forty inches. At first, the cylinders were made by forming copperplates into a cylindrical shape and brazing the joint. However, the cylinder wore quickly on the joint, and cylinders bored and turned from a solid piece of metal were found to be more satisfactory. In the early days of their operation, the Merrimack Print Works ordered cylinders not only from England but also from Mason and Baldwin in Philadelphia, the first American firm to engrave cylinders for calico printing.[21]

Cylinders were generally engraved by a mill engraving machine at about one-eighth of the cost for engraving the cylinders by hand. With this machine, the pattern was transferred to the cylinder by the pressure of a small steel roller, or mill, which carried the pattern in relief.[22] In June of 1828, the Merrimack Manufacturing Company paid $576 for forty-eight mills plus five dollars paid to the mate of the ship *Amethyst* 'for fetching the mills from England.'[23]

Another means of transferring a pattern to the cylinder was invented by Milton D. Whipple at the Merrimack Manufacturing Company in 1843. His innovation involved the creation of a rotary pantograph. In this method, a stylus moving along the lines of a pattern engraved on a metal plate, activated a series of points that cut repetitively along the length of a varnish-covered cylinder revolving beneath them. The cylinder was then etched in nitric acid.[24]

Vegetable dyestuffs were used in the production of printed calicoes until the early nineteenth century. The most common dyes were made of madder, quercitron bark, and indigo. Fast colors, which would not fade or run, were produced by blending madder, a dye made from the root of the madder plant, or quercitron, made from the bark of an American black oak, with mordants, chemicals that fixed dyes in the fabric by 'forming an insoluable compound with the coloring matter.'[25]

Even after the introduction of mineral dyes, madder was still considered an important dyestuff because of the variety of brilliant and permanent colors that could be produced from it. Madder used with an alum mordant produced red; when used with an iron mordant, the result could be lilac, purple, and black; and when madder was combined with a mixture of the two mordants, various shades of chocolate were created. Quercitron produced yellow with an alum mordant, drabs with an iron mordant, and olive colors with a mixture of the two. Overprinted on madder red, quercitron created an orange color. Quercitron replaced weld, a more expensive and less permanent vegetable dye, as a yellow coloring agent.[26]

Indigo, of course, was used to create the range of blue tones, and, when overprinted on yellow, produced shades of green. The technique of printing with indigo differed from printing with madder because indigo is insoluble in water and must be reduced to a soluble, or white, stage with iron sulphate, after which indigo was ordinarily dissolved in lime. A mixture of iron sulphate, undissolved indigo, and a thickener resulted in the popular color known as china blue.[27]

The use of the three vegetable dyestuffs made possible the printing of as many as twelve different colors in one pattern. Other common vegetable dyestuffs such as logwood and brazilwood, which produced colors similar to madder, and French or Persian berries, which were another source of yellow, could also be used for coloring fabrics.[28]

By the second decade of the nineteenth century, mineral colors were introduced. Mineral colors were the product of the successive application of two solutions. The coloring material did not exist separately in either of these solutions, but the final color was the result of the mixture of the two. By the 1840s, such colors as antimony orange, arsenate of chromium (a grass green), manganese bronze, orpiment (bright yellow), iron buff, prussiate of copper (cinnamon), Prussian blue, and arsenite of copper (Scheele's green) were also in use.[29]

By the second quarter of the nineteenth century, colors could be applied through any of six different styles of work, or by a combination of these styles. The styles were known as madder, steam, padding, resist, discharge, and china blue.

The madder style was applicable to the dyestuff madder and to the other vegetable dyes, with the exception of indigo; it was the most extensively used of all the styles. In this method, the cloth was first printed with the mordant (or mordants, if more than one color was desired). Since the mordant was almost colorless, it was customary to tint it with a small amount of dye, so that the printed areas could be distinguished from the unprinted areas before dyeing. The cloth was dried and aged for two or three days to make the mordant insolubly attached to the cloth.[30]

The next step was called dunging. The printed cloth was drawn through a solu-

tion of cow dung, or dung substitute, and water. The purpose of this operation was to remove the thickening paste and any loose mordant that might stain the unprinted parts of the cloth. Dung was used in great quantities. The usual proportion was one bushel to one hundred gallons of water. It is interesting to find that the printing and bleaching department at the Merrimack Print Works was charged $634.28 in April of 1827 for keeping cows. A decade later there is an entry of $331.62 for the purchase of 3,205 bushels of cow dung. Although it was an efficient cleansing material, there were certain drawbacks to its use. In addition to its inherent unpleasantness, it was necessary to keep cows near the print works if a steady supply was not available from a farm. There was also the problem of collecting dung when the cows were in pastures. A substitute became available in 1839 when one was patented by the English chemist and calico printer John Mercer and by John D. Prince, superintendent of the Merrimack Print Works.[31]

After dunging, the cloth was well washed, then drawn on a reel or a wince through the dye liquid. This part of the process in the dye took two or three hours, while the temperature was raised to the boiling point. When this operation was completed, the cloth was washed and cleared of any dye staining the unmordanted parts by wincing it through three separate solutions of hot water and bran, soap, and chloride of soda or lime. Finally, as in all styles of work, the calico was washed, starched, and calendered or glazed. Then it was ready for market.[32]

To decrease the length of the dyeing process and its cost, it was possible to mix the mordants and the dyestuffs, although the colors produced then faded on exposure to soap, water, daylight, and oxygen and were known as 'spirit colors.' However, if calico thus printed was exposed to steam by being wrapped around a perforated copper cylinder, the colors became fast and bright.[33] Parnell considered steam printing to be 'one of the most important modern improvements in calico printing.'[34]

The padding style of coloring fabric produced an evenly saturated colored ground for a design printed in other colors. The cloth was impregnated with the dyes by being drawn between two cylinders, the lower of which revolved in a trough filled with the slightly thickened coloring solution. Padding seems to have been generally used with mineral colors, but it was also applicable to the madder style of printing. The records of the Merrimack Print Works show that a 'wall for the Padding Room' was laid by January of 1824, proof that the madder style of printing was practiced there.[35]

The resist style of dyeing cloth involved printing the cloth with a paste that would resist the dye or prevent the cloth from receiving the dye. This style was used to form a white background for a colored pattern, common in furnishing prints of the eighteenth century, or to create a white pattern on a colored ground, as seen in dress prints. As dyeing techniques became more sophisticated, it became possible to include components of mineral or madder style colors in the resist paste and to complete either of these processes after dyeing the background, a procedure that resulted in colored patterns on a colored ground. Resist pastes could also be used to protect a pattern already printed on a white ground during later dyeing of that ground.[36]

FIG. 7.5. Thomas Jefferson. *The Inaugural Speech of Thomas Jefferson* (Washington, D.C., 1801). American Antiquarian Society.

FIG. 7.6. *Sacred to the Memory of Mrs. Henry K. Frothingham* (Boston: Abel Bowen, 1840). American Antiquarian Society.

In the discharge style, a white pattern was produced on a cloth already mordanted or dyed by printing it with an acid mixture that bleached or 'discharged' the mordant or dye. This style was applicable to both mineral and vegetable dyes. As in the resist style, colored patterns could also be produced on colored grounds by the inclusion of ingenious combinations of chemicals in the discharge paste.[37]

The china blue style was developed by the English in the 1740s for the direct printing of indigo. Undissolved indigo was mixed with copperas (ferrous sulphate), orpiment (sulphate of arsenic), and a thickener to form a paste for printing. After being printed and dried, the calico was dipped in solutions of lime, copperas, and caustic soda so that the indigo would be dissolved and absorbed by the cloth and the blue pattern would appear. The china blue style was particularly adapted to printing with engraved copperplates or cylinders because the technique provided sharp definition to finely engraved designs. As produced by nineteenth-century calico print firms, china blue printed fabrics were 'distinguished by having blue figures, usually of two or three depths of color associated with white.' The depths of color were controlled by varying the proportions of thickener and water in the printing paste.[38]

In addition to considering the printing of fabrics for furnishings and clothing, a brief mention should be made of letterpress printing on textiles. Documents, such as commemorative pieces, political speeches, religious and educational items, news-papers, and advertisements, seem to have been printed by job printers using linen or silk instead of paper. Type was used for the texts of these items, and relief cuts, wood engravings, or stereotype blocks, were used for borders and illustrations. The collection of broadsides printed on textiles at the American Antiquarian Society includes *Jefferson's Inaugural Address*, printed on silk in 1805 (fig. 7.5), *Mr. Johnson's Report to the Senate* of 1829, a memorial to Mrs. Henry K. Frothingham, printed on silk by Abel Bowen in 1840 (fig. 7.6), and *A Child's Picture Alphabet* (fig. 7.7), printed by Abel's brother, Henry Bowen, at the Boston Chemical Printing Company.

Knowing the complexities of calico printing, the question arises about different ink formulas being used by job printers to print on paper and on cloth. Henry Bowen was a job printer and publisher of books and periodicals, among them *The Univer-salist Magazine* from 1819 to 1828. Many examples of Henry Bowen's handkerchiefs that were printed on fabric still survive. On these, he called his company 'Henry Bowen's Chemical Print,' but no description of his operation, or any similar one, has come to light. What did the word 'chemical' mean? Was it necessary to use a special ink formula if fabric rather than paper were to be printed? What were the special problems, if any, for the letterpress printer who wished to print on fabric? These questions remain unanswered for lack of any documentation in the literature about textile printing.

The production of the printed calicoes that are now in museums, restored houses, and in great-great-grandmother's worn patchwork quilts, and whose patterns are so often reproduced for use today, was a complex process. Remarkable progress in the mechanics and chemistry of calico prints was made at the end of the eigthteenth century and continued during the first half of the nineteenth century and thereafter.

FIG. 7.7. *The Picture Alphabet* (Boston: Boston Chemical Printing Company, n.d.). American Antiquarian Society.

The size of the industry was impressive also; for in only fifteen years after the establishment of the first large New England print works, 120 million yards of calico were printed in the United States.[39] George S. White, author of a *Memoir of Samuel Slater*, expressed his wonder at these developments: 'A printing establishment, like a cotton mill, is a wonderful triumph of science; and when the mechanical and chemical improvements of both are viewed together, they form a splendid and matchless exhibition of science applied to the arts, and easily account for a rapidity of growth and a vastness of extension in the manufacture, which has no parallel in the records of industry.'[40]

NOTES

1. J. Leander Bishop, *A History of American Manufactures from 1608–1860*, 3 vols. (1868; repr. New York: Johnson Reprint Corp., 1967), 1: 378, 396–98.

2. Horace Greeley, et al., *Great Industries of the United States* (Hartford: J. B. Burr and Hyde, 1873), p. 526.

3. Florence M. Montgomery, *Printed Textiles, English and American Cottons and Linens, 1700–1850* (New York: The Viking Press, 1970), pp. 182–93.

4. Bishop, *History of American Manufactures*, 2: 55, 59–60, 100, 157.

5. Ibid., 2: 157–58.

6. Ibid., 2: 196.

7. Ibid., 2: 284.

8. Ibid., 2: 268–69; Nathan Appleton, *Introduction of the Power Loom and Origin of the City of Lowell* (Lowell, Mass.: Printed for the Proprietors of the Locks and Canals on the Merrimack River, 1858), pp. 23–25; Typescript history, 1821–1906, Merrimack Manufacturing Company, Baker Library, Harvard University.

9. Bishop, *History of American Manufactures*, 2: 275; Appleton, *Introduction of the Power Loom*, p. 25; Caroline Sloat, 'The Dover Manufacturing Company and the Integration of English and American Calico Printing Techniques, 1825–1829,' *Winterthur Portfolio* 10 (1975): 51–68.

10. Appleton, *Introduction of the Power Loom*, pp. 26, 27; (Lowell) Courier-Citizen Co., *Illustrated History of Lowell and Vicinity, Mass.* (Lowell, 1897), pp. 221–22, 235; Sloat, 'Dover

Manufacturing Company,' p. 52; Samuel Hopkins Emery, *Supplement to the History of Taunton, Mass.* (Syracuse, N.Y.: D. Mann and Co., 1894), p. 694.

11. Henry A. Miles, *Lowell as It Was, and as It Is* (Lowell, Mass: Powers and Bagley and E. L. Dayton, 1845), pp. 84–94. The journals of the Merrimack Manufacturing Co., which are in the Baker Library at Harvard, indicate a more complex operation. Dana's description, which is accurate as far as it goes, was probably simplified for readability.

Samuel L. Dana, M.D., was an American, born at Amherst, New Hampshire, in 1795. He was educated at Phillips Exeter Academy and Harvard. He had broad scientific interests and became a chemist for the Merrimack Manufacturing Company in 1834, having been consulting chemist from 1830 to 1833. Prior to this, he had established a chemical factory for the manufacture of oil of vitriol and bleaching salts. He seems to have made important contributions to the bleaching process and to have discovered the substitute for dung. See John O. Green, *Memoir of Samuel Dana, M.D., LL. D., A.A.S. Contributions of the Old Residents Historical Association* (Lowell: Stone, Bachellor and Livingston, Printers, 1879), 1:366–67.

12. Surviving fabric swatches lead one to this conclusion. See also Montgomery, *Printed Textiles*, pp. 343–49.

13. Miles, *Lowell as It Was*, pp. 84–85; Edward Andrew Parnell, 'Dyeing and Calico Printing,' printed from his *Applied Chemistry in*

Manufactures, Arts and Domestic Economy, 1844, (London: Taylor, Walton and Maberly, 1849), pp. 43–44; Charles O'Neill, *Dictionary of Calico Printing and Dyeing* (London: Simpkin Marshall and Company, 1862), pp. 26–27; Sydney M. Edelstein, *Historical Notes on the Wet-Processing Industry* (essay published in commemoration of the Perkin Centennial, 1956, by the *American Dyestuff Reporter*), p. 21.

14. Thomas Cooper, *A Practical Treatise on Dyeing and Calico Printing* (Philadelphia: Thomas Dobson, 1815), p. 319; Andrew Ure, *A Dictionary of Arts, Manufactures and Mines,* 2 vols. (New York: D. Appleton and Company, 1858), 1: 228; Parnell, *Applied Chemistry,* pp. 127–28.

15. Parnell, *Applied Chemistry, pp.* 117–18.

16. George S. White, *Memoir of Samuel Slater* (Philadelphia: n.p., 1836), pp. 398–99; Parnell, *Applied Chemistry,* pp. 117–18.

17. Details about copperplate calico printing are found in the following: Peter C. Floud, 'The English Contribution to the Development of Copper Plate Calico Printing,' *The Journal of the Society of Dyers and Colorists* 76 (1960): 425–34; Peter Floud and Barbara Morris, 'English Printed Textiles,' a series of articles in volumes 71 and 72 (1957) of *Antiques* for the months of Mar., Apr., May, June, Sept., Oct., Nov., and Dec.; Peter Floud, 'Pictorial Prints of the 1820s,' *Antiques* 72 (1957): 457; Parnell, *Applied Chemistry*; Jean Francois Persoz, *Traité Théorique et Practique de l'Impression des Tissus,* 4 vols. (Paris: Victor Masson, 1846), 2: 343–50, and Atlas, plate 7; Charles O'Brien, 'Of Engraving,' *The British Manufacturer's Companion and Callico Printer's Assistant* (London: printed for the Author, 1795).

18. Jane D. Kaufmann, 'Copper Plate Calico Printing, History and Technology' (unpublished essay, 1973).

19. Commissioners of Patents, *Abridgements of Specifications Relating to Bleaching, Dyeing, and Printing Calico and Other Fabrics and Yarns* (London: George Eyre and William Spottiswoode, 1859), patent number 1378, p. 41; Parnell, *Applied Chemistry,* pp. 120–22.

20. Parnell, *Applied Chemistry,* pp. 230–32.

21. Merrimack Manufacturing Company Journal (hereafter MMC Journal), no. 1, vol. 14, Aug. 1823, p. 93; ibid., Dec. 1824, p. 269; ibid., Dec. 1825, p. 381; Bishop, *American Manufactures,* 2: 275.

22. Parnell, *Applied Chemistry,* p. 122; Miles, *Lowell as It Was,* p. 93.

23. MMC Journal, no. 2, (vol. 15), June 1828, p. 288.

24. John L. Hayes, *American Textile Machinery* (Cambridge, Eng.: Cambridge University Press, John Wilson and Son, 1879), p. 45; Parnell, *Applied Chemistry,* p. 123.

25. George Gregory, *A Dictionary of Arts and Sciences,* 3 vols. (New York: William T. Robinson, 1821), vol. 1; Parnell, *Applied Chemistry,* p. 50.

26. F. Crace-Calvert, *Dyeing and Calico Printing* (Manchester, Eng.; Palmer and Howe, 1876), p. 22; Parnell, *Applied Chemistry,* pp. 31–38; Peter C. Floud, 'The English Contribution to the Chemistry of Calico Printing before Perkin,' *Ciba Review* 1 (1961): 8–14.

27. Parnell, *Applied Chemistry,* pp. 31–38.

28. Gregory, *Dictionary of Arts and Sciences*; Parnell, *Applied Chemistry,* pp. 31–38.

29. Parnell, *Applied Chemistry,* pp. 38–48; MMC Journals, 1822–41. The names of chemicals appearing in the journals seem to indicate the capability of producing most of these colors.

30. Charles Tomlinson, ed., *Cyclopedia of Useful Arts and Manufactures* (London and New York: Charles Virtue, 1852); Parnell, *Applied Chemistry,* p. 132.

31. Parnell, *Applied Chemistry,* pp. 91–92, 131–37; Samuel Parkes, *Chemical Essays,* 2 vols. (London: printed for the author, 1823), 1: 260, footnote; MMC Journals, no. 2 (vol. 15), Apr. 1827, p. 95; ibid., no. 5 (vol. 18), Apr., 1837, p. 341; Floud, 'English Contribution . . . before Perkin,'; Parnell, *Applied Chemistry,* pp. 91–92.

32. Parnell, *Applied Chemistry,* pp. 106–10.

33. Parnell, *A Practical Treatise on Dyeing and Calico Printing* (New York: Harper and Bros., 1846), p. 579.

34. Parnell, *Applied Chemistry,* pp. 152–53.

35. Parnell, *Applied Chemistry,* p. 167; Tomlinson, *Cyclopedia of Useful Arts and Manufactures,* 1: 283; Miles, *Lowell as It Was,* pp. 92–93; MMC Journals, no. 1 (Jan. 1824), p. 382.

36. Parnell, *Applied Chemistry,* pp. 186–95; Parkes, *Chemical Essays,* 1: 394–411.

37. Parnell, *Applied Chemistry,* pp. 197–214.

38. Peter C. Floud, 'The English Contribution to the History of Indigo Printing,' *Journal of the Society of Dyers and Colorists* 76 (1960): 347–48; O'Neill, *Dictionary of Calico Printing,* pp. 124–25; Cooper, *Practical Treatise,* pp. 385–87; Parnell, *Applied Chemistry,* pp. 214–15.

39. White, *Memoir of Samuel Slater,* p. 404.

40. Ibid., p. 401.

Checklist of Exhibitions

EARLY ENGRAVINGS OF NEW ENGLAND
May 12 – July 21, 1976
*An Exhibition at the American Antiquarian Society,
Drawn from the Society's Collections*

Engravings by James Turner

Bookplate of John Franklin. Boston, ca. 1743.

Bookplate of Isaac Norris. Philadelphia, ca. 1755.

Bookplate of Sir John St. Clair Bart. Philadelphia, ca. 1755.

Bookplate of J. Leddel. Philadelphia, ca. 1755.

Bookplate of James Hall. Philadelphia, ca. 1755.

View of Boston. *The American Magazine and Historical Chronicle*, vol. 1. Boston, 1744. Engraving. Gift of Matt B. Jones, 1930.

View of Boston. *The American Magazine and Historical Chronicle*, vol. 1. Boston, 1743–46. Relief cut. Gift of Matt B. Jones, 1930.

A Plan of the City and Harbour of Louisbourg, &c. Boston, 1745. Gift of the Gen. Artemas Ward Memorial Fund Museum, 1975.

Isaac Watts D. D. Frontispiece to Watts's *Sermons on Various Subjects, Divine and Moral*. Boston, 1746. Bequest of Samuel A. Green, 1919.

[Map of the Atlantic coast from Boston to Cape Hatteras.] Plate in *A Bill in the Chancery of New-Jersey*. New York, 1747. Exchange, The John Carter Brown Library, 1946.

Trade card for Joseph and Daniel Waldo. Boston, 1748. Purchase, 1950.

Chart of the Coasts of Nova Scotia. Boston, 1750. From the library of John W. Farwell, 1944.

Introductory text and music for John Barnard's *New Version of the Psalms of David*. Boston, 1752. Purchase, 1939.

Portrait Prints

John Foster (1648–81). *Mr. Richard Mather*. Boston, ca. 1680. Bequest of William Bentley, 1819.

James Franklin (1697–1735). Portrait of Hugh Peters. Frontispiece to Hugh Peters, *A Dying Fathers Last Legacy to an Only Child*. Boston, 1717. Purchase, 1931.

——. Portrait of James Hodder. Frontispiece to James Hodder, *Hodder's Arithmetick: Or, That Necessary Art Made Most Easy*. Boston, 1719. Gift of Charles H. Taylor, 1931.

Nathaniel Morse (ca. 1685–1748). *Matthaeus Henry. Obt. June 22, 1714 Aet. 52*. Frontispiece to Matthew Henry, *The Communicant's Companion*. Boston, 1731. Purchase, 1973.

Peter Pelham (ca. 1697–1751). *The Rev. Joseph Sewall*. Boston, ca. 1740. Bequest of William Bentley, 1819.

Nathaniel Hurd (1729–77). *Britains Behold the Best of Kings* [medallion portraits of William Pitt, James Wolfe, and George III]. Boston, 1762. Purchase, 1930.

———. *Joseph Sewall D. D. Pastor of Old South Church Boston.* Boston, 1768.

Paul Revere (1735–1818). *Philip. King of Mount Hope.* Plate in Benjamin Church, *The Entertaining History of King Philip's War.* Newport, 1772.

John Norman (1748?–1817). *His Excy. John Hancock, Esq: Late President of the American Congress.* Frontispiece to vol. 1 of *An Impartial History of the War in America.* Boston, 1781–84.

Richard Brunton (d. 1832). *George Washington, Commander in Chief of Ye Armies of Ye United States of America.* Frontispiece to Charles Henry Wharton, *A Poetical Epistle to His Excellency George Washington.* Providence, 1781.

Joseph Hiller (1777–95). *G. Washington.* N.p., 1794. Gift of Waldo Lincoln, 1930.

Amos Doolittle (1754–1832). *Gen. George Washington, Commander in Chief of the Armies of the United States.* Frontispiece to Benjamin Trumbull, *The Majesty and Morality of Created Gods.* New Haven, 1800.

[Samuel Wetherbee.] *G. Washington, President of the United States.* Illustration on the cover of *The Battle of Prague*, composed by Franz Kotzwara. Boston, ca. 1811.

Landscape Prints

James Trenchard (b. 1747). *A View in Canaan, between the Green Woods and Salisbury, Connecticut.* Plate in *The Columbian Magazine.* Philadelphia, March 1789. Collection of Isaiah Thomas.

Samuel Hill (1766?–1804). *View of the Bridge over Mystic River & the Country Adjacent from Bunker's Hill.* Frontispiece to *The Massachusetts Magazine.* Boston, September 1790. Collection of Isaiah Thomas.

———. *View of the Seat of the Hon. Moses Gill Esq. at Princeton, in the County of Worcester, Massats.* Frontispiece to *The Massachusetts Magazine.* Boston, November 1792. Collection of Isaiah Thomas.

David Augustus Leonard (1771–1818). *A View of Siasconset a Fishing Village on Nantucket.* Frontispiece to David Augustus Leonard, *The Laws of Siasconset: A Ballad.* New Bedford, 1797.

John Rubens Smith (1775–1849). *Pawtucket Bridge & Falls.* Frontispiece to *The Polyanthos.* Boston, December 1812. Gift of the Worcester County Atheneum.

James Kidder (1793–1837). *A View on Boston Common.* Frontispiece to *The Polyanthos.* Boston, June 1813. Gift of the Worcester County Atheneum.

Political Prints

Paul Revere. A View of the Year 1765. Boston, 1765. Purchase, 1913.

———. Relief cut of the Boston Massacre on *A Monumental Inscription on the Fifth of March.* Boston, 1772.

Thomas Kensett (1786–1829). *Brother Jonathan's Soliloquy on the Times.* Cheshire, Conn., 1819.

Anonymous. *If the Coat Fits, Let Them Wear It.* Connecticut, 1824. Purchase, 1954.

Checklist of Exhibitions

NEW ENGLAND PRINTS BEFORE 1850
April 7 – May 16, 1976

*An Exhibition at the Worcester Art Museum, Drawn from the Collections of the
Worcester Art Museum and the American Antiquarian Society*

James Akin (1773–1846). *Infuriated Despondency.* Engraving, 1805. American Antiquarian Society (hereafter, AAS).

——. *Lord Timothy Dexter.* Engraving, 1805. Worcester Art Museum (hereafter, WAM), 1910.48.16.

John W. Barber (1798–1885). *The Drunkard's Progress.* Etching, 1826. WAM, 1910.48.406.

——. *A Miniature of the World in the Nineteenth Century.* Etching, 1826. WAM, 1910.48.3391.

Lodowick H. Bradford (active 1845–59). *View of Boston.* Photolithograph, ca. 1856–59. AAS, gift of Charles H. Taylor.

——. *View of Boston.* Photolithograph, ca. 1856–59. AAS, gift of Charles H. Taylor.

Richard Brunton (d. 1832). *Commercial Mail Stage.* Engraving, 1815. AAS, purchased as the gift of Charles H. Taylor, 1931.

John H. Bufford (1810–70). *Souvenirs of the Hunter.* Lithograph. WAM, 1910.48.3407.

——. *Andrew Jackson at the Hermitage.* Lithograph, 1830. AAS, gift of Charles H. Taylor.

Esteria Butler. *N. W. View of Waterville College.* Lithograph, ca. 1830. AAS.

William Charles (1776–1820). *Josiah the First* (Josiah Quincy). Etching and aquatint, 1812. WAM, 1910.48.615.

Thomas Clarke (active 1797–1801). *Sacred to the Memory of the Illustrious G. Washington.* Stipple engraving, 1801. AAS.

S. H. Colesworthy. *View of the Whig Pavilion-Mount Joy.* Engraving, 1837. WAM, 1910.48.3424.

James A. Cutting and Lodowick H. Bradford. *Portrait of James A. Cutting.* Photolithograph, ca. 1860. WAM, 1910.48.715.

Amos Doolittle (1754–1832). *America.* Stipple engraving, ca. 1790. WAM, 1910.48.3660.

——. *Bonaparte in Trouble.* Etching. WAM, 1910.48.3446.

——. *A New Display of the United States.* Engraving, 1803. AAS.

——. *The Hornet and the Peacock, or John Bull in Distress.* Etching, 1813. AAS, purchase, 1973.

——. *Brother Jonathan Administering a Salutary Cordial to John Bull.* Etching, 1813. AAS, purchased as the gift of Morgan B. Brainard, 1942.

Oliver Eddy (1799–1868). *Death of General Pike, at L. York.* Etching and engraving, ca. 1813. AAS.

Robert Field (active 1793–1819). *Portrait of Lord Nelson.* Stipple engraving and etching, 1806. WAM, 1910.48.3467.

James Franklin (1636–1735). *Divine Examples of God's Severe Judgments upon Sabbath Breakers.* Woodcut, 1708. WAM, 1910.48.3468.

Samuel Hill (1766?–1804). *Salem Marine Society Membership Certificate*. Etching and engraving, after A. Northey, Jr. WAM, 1910.48.3350.

William Morris Hunt (1824–79). *At the Fountain*. Lithograph, ca. 1860. WAM, 1910.48.3500.

——. *Deer in the Snow*. Lithograph, ca. 1860. WAM, 1910.48.3499.

Nathaniel Hurd (1730–77). *Trade Card of Ziphion Thayer*. Engraving. WAM, 1910.48.1473.

——. *H-ds-n's Speech from the Pillory*. Engraving, 1762. WAM, 1910.48.1471.

David Claypoole Johnston (1797–1865). *The Victim of Ardent Spirits*. Lithograph, ca. 1837–41. AAS, purchase, 1931.

——. *Marker and Sleeper*. Watercolor, 1855. AAS, purchased as the gift of Charles H. Taylor, 1933.

——. *Marker and Sleeper*. Pencil drawing, 1855. AAS.

——. *Marker and Sleeper*. Etching, 1855, first, third, and fifth states. AAS.

——. *A Militia Muster*. Watercolor, 1828. AAS.

——. *A Militia Muster*. Lithograph, ca. 1828. AAS.

——. *Illustrations of the Adventures and Achievements of the Renowned Don Quixote and His Doughty Squire Sancho Panza*. Etching, ca. 1837. WAM, 1910.48.3509.

Thomas Johnston (1708–67). *Bookplate of William P. Smith*. Engraving. WAM, 1910.48.1675.

James Kidder (1793–1837). *A Representation of the Great Storm at Providence, Sept. 23, 1815*. Etching and aquatint. AAS, gift of Charles H. Taylor, 1939.

Fitz Hugh Lane (1804–65). *Auxiliary Steam Packet Ship Massachusetts*. Lithograph, hand-colored, ca. 1845. AAS.

——. *Steam Packet Massachusetts in a Squall, November 10, 1845*. Lithograph, hand-colored, ca. 1845. AAS.

——. *Millbury Village*. Lithograph, ca. 1840. AAS.

John Perry Newell (ca. 1832–98). *Ship Independence*. Lithograph, after Clement Drew, ca. 1853. AAS, gift of Charles Henry Taylor.

John Norman (1748–1817). *His Excellency, George Washington, Esq*. Engraving, after Benjamin Blyth, ca. 1782. AAS, gift of C. O. Thompson, 1874.

Samuel Okey (active 1765–75 in America). *The Reverend James Honyman*. Mezzotint, 1774. WAM, 1910.48.3356.

Rembrandt Peale (1778–1860). *Washington*. Lithograph, 1827. WAM, 1910.48.3546.

Henry Pelham (1749–1806). *The Fruits of Arbitrary Power, or the Bloody Massacre*. Etching, hand-colored, 1770. AAS.

Peter Pelham (1697–1751). *A Plan of the City and Fortress of Louisburg*. Mezzotint, 1746. WAM, 1910.48.3563.

——. *Sir William Pepperell*. Mezzotint, after John Smibert (1688–1751), 1747. AAS, bequest of William Bentley, 1819.

——. *Thomas Hollis*. Mezzotint, after Joseph Highmore (1692–1780), 1751. AAS, bequest of William Bentley, 1819.

——. *The Reverend Timothy Cutler, D.D.* Mezzotint, 1750. AAS, bequest of William Bentley, 1819.

——. *The Reverend Charles Brockwell, A.M.* Mezzotint, 1750. AAS, bequest of William Bentley, 1819.

Paul Revere (1735–1818). *A View of the Obelisk Erected under Liberty Tree in Boston.* Engraving, 1766. AAS, bequest of Mary Eliot, 1927.

——. *A Westerly View of the Colledges in Cambridge, New England.* Engraving, hand-colored, after Joseph Chadwick (active ca. 1770), 1768. AAS, gift of Mrs. Henry E. Warner, 1950.

——. *The Bloody Massacre Perpetrated in King Street Boston.* Engraving, hand-colored, after Henry Pelham (1749–1806), 1770. AAS.

William Rimmer (1816–79). *The Roarers.* Lithograph, 1837. AAS.

——. *The Fireman's Call.* Lithograph, 1837. AAS.

——. *Portrait of a Man.* Lithograph, WAM, 1910.48.2590.

——. *The Entombment.* Lithograph. WAM, 1910.48.2589.

——. *Head of Christ.* Lithograph. WAM, 1910.48.2588.

Edward Savage (1761–1817) *Muscipula.* Mezzotint, after Sir Joshua Reynolds. WAM, 1910.48.3590.

——. *The Eruption of Mount Etna in 1787.* Color mezzotint, after Jean-Baptiste Chapuy (French, 1760–1802), 1799. AAS.

——. *The Eruption of Mount Etna in 1787.* Color mezzotint, two impressions (same as above), 1799. WAM, 1910.48.3670, WAM, 1910.48.3671.

Jean-Baptiste Chapuy. *The Eruption of Mount Etna in 1766.* Color aquatint, after Alessandro d'Anna (Italian, active ca. 1750–1800). WAM, 1925.1090, gift of Mrs. Kingsmill Marrs.

Edward Savage (1761–1817). *The Eruption of Mount Vesuvius in 1779.* Color mezzotint, 1799. AAS.

——. *George Washington.* Mezzotint, 1793. WAM, 1910.48.3672.

William Sharp (active 1839–62). *The Reverend F.W.P. Greenwood.* Color lithograph, 1840. WAM, 1910.48.3605.

John Rubens Smith (1775–1849). *A View of the Mansion of the Late Lord Timothy Dexter in High Street, Newburyport.* Aquatint, 1810. AAS.

——. *Major General Benjamin Lincoln.* Mezzotint, after Henry Sargent (1770–1845), 1811. AAS.

——. *His Excellency Elbridge Gerry, L.L.D.* Mezzotint, 1811. AAS.

Moses Swett (active 1826–37). *Arcade, Providence: South Front.* Lithograph, 1829. WAM, 1910.48.3624.

J. A. Underwood (active ca. 1840). *The Arcade, Providence, R. I.* Lithograph, ca. 1840. WAM, 1910.48.3635.

Mrs. —— Webber. *Bellows Falls, Vt.* Lithograph, ca. 1830. AAS.

Anonymous. *Sea Serpent.* Engraving, hand-colored, ca. 1817. AAS.

——. *The Hartford Convention or Leap No Leap.* Etching, 1815. AAS.

——. Published by Pendleton's Lithography, ca. 1825–35. *Mortgaging the Farm.* Lithograph. AAS, gift of George S. Barton, 1932.

——. *Lifting the Mortgage.* Lithograph. AAS, gift of George S. Barton, 1932.

——. *The Last Scene in "Gustavus."* Lithograph. AAS.

——. *View of Lowell, Mass.* Lithograph, after E. A. Farrar, 1834. AAS.

——. *View of the City of Bangor, Maine.* Lithograph, after A. H. Wallace, 1835. AAS.

APPENDIX

NORTH AMERICAN PRINT CONFERENCES AND PUBLICATIONS

A series of locally organized conferences held in the United States and Canada on subjects relating to the history of prints in North America.

1. *Prints in and of America to 1850.* March 19–21, 1970, Winterthur Museum, Winterthur, Del. Proceedings, edited by John D. Morse, published by University Press of Virginia, 1970.

2. *Boston Prints and Printmakers, 1670–1775.* April 1–2, 1971, Colonial Society of Massachusetts, Boston. Proceedings, edited by Walter Muir Whitehill and Sinclair Hitchings, published by University Press of Virginia, 1973.

3. *American Printmaking before 1876: Fact, Fiction, and Fantasy.* June 12–13, 1972, Library of Congress, Washington, D.C. Proceedings published by Library of Congress, 1975.

4. *Philadelphia Printmaking: American Prints before 1860.* April 5–7, 1973, Free Library of Philadelphia; Historical Society of Pennsylvania; Library Company of Philadelphia; and Philadelphia Museum of Art. Proceedings, edited by Robert F. Looney, published by Tinicum Press, 1976.

5. *Eighteenth-Century Prints in Colonial America.* March 28–30, 1974, Colonial Williamsburg, Va. Proceedings, edited by Joan Dolmetsch, published by University Press of Virginia, 1979.

6. *Art and Commerce: American Prints of the Nineteenth Century.* May 8–10, 1975, Museum of Fine Arts, Boston, Mass., in association with other Boston institutions. Proceedings published by Museum of Fine Arts, Boston, 1978; distributed by University Press of Virginia.

7. *Prints of New England.* May 14–15, 1976, American Antiquarian Society and Worcester Art Museum, Worcester, Mass. Proceedings, edited by Georgia Brady Barnhill, published by American Antiquarian Society, 1991; distributed by University Press of Virginia.

8. *American Maritime Prints.* May 6–7, 1977, New Bedford Whaling Museum, New Bedford, Mass. Proceedings, edited by Elton W. Hall, published at the Whaling Museum by Old Dartmouth Historical Society, 1985.

9. *Prints of the American West*. May 4–6, 1978, Amon Carter Museum, Fort Worth, Tex. Proceedings, edited by Ron Tyler, published by Amon Carter Museum, 1983.

10. *American Portrait Prints*. May 15–17, 1979, National Portrait Gallery, Smithsonian Institution, Washington, D.C. Proceedings, edited by Wendy Wick Reaves, published by National Portrait Gallery, 1984.

11. *Canada Viewed by the Printmakers*. May 6–8, 1980, Royal Ontario Museum, Toronto. Proceedings, edited by Mary Allodi, forthcoming.

12. *New York State Prints and Printmakers, 1825–1940*. May 14–16, 1981, Syracuse University; Everson Museum of Art; and Erie Canal Museum. Proceedings, edited by David Tatham, published by Syracuse University Press, 1986.

13. *Mapping the Americas*. October 15–17, 1981. Historical Society of Pennsylvania, Philadelphia. Proceedings, edited by Peter Parker, forthcoming.

14. *The American Illustrated Book in the Nineteenth Century*. April 8–9, 1982, Winterthur Museum, Winterthur, Del. Proceedings, edited by Gerald W. R. Ward, published by Winterthur Museum; distributed by University Press of Virginia, 1987.

15. *Images by and for Marylanders, 1680–1940*. April 27–30, 1983, Maryland Historical Society, Baltimore, in association with other Baltimore institutions. Proceedings, edited by Laurie A. Baty, forthcoming.

16. *The Graphic Arts in Canada after 1850*. May 9–12, 1984, Public Archives of Canada and National Gallery of Canada in cooperation with National Library of Canada and Remington Art Museum, Ogdensburg, N.Y. Proceedings, edited by Jim Burant, forthcoming.

17. *Aspects of American Printmaking, Nineteenth and Twentieth Centuries*. April 25–27, 1985, Grace Slack McNeil Program in American Art, Wellesley College, and Museum of Our National Heritage, Lexington, Mass., in cooperation with Boston Athenæum, Museum of Fine Arts, and Boston Public Library. Proceedings, edited by James F. O'Gorman, published by Syracuse University Press, 1988.

18. *Prints and Printmakers of New York City*. April 10–12, 1986, New-York Historical Society, New York, N.Y. Proceedings, edited by Wendy Shadwell, forthcoming.

19. *Prints and Printmakers of New Orleans and the South*. April 29–May 1, 1987, Historic New Orleans Collection, New Orleans, in cooperation with Louisiana State Museum and New Orleans Museum of Art. Proceedings, edited by John A. Mahe II, forthcoming.

20. *Prints & Printmaking of Texas*. November 9–12, 1988, Texas State Historical Association, Center for Studies in Texas History, Harry Ransom Humanities Research Center, Archer M. Huntington Art Gallery, Texas Memorial Museum, Eugene C. Barker Texas History Center, College of Liberal Arts of the University of Texas at Austin. Proceedings, edited by Ron Tyler, forthcoming.

21. *Graphic Arts & the South*. March 14–17, 1990, High Museum of Art, Atlanta Historical Society, Clark Atlanta University, Emory University. Proceedings, edited by Judy L. Larson, forthcoming.

Index

Index

Contributors

Georgia Brady Barnhill is the Andrew W. Mellon Curator of Graphic Arts at the American Antiquarian Society.

Martha Gandy Fales is a museum consultant and author.

Jane D. Kaufmann is a resident of Dover, New Hampshire.

Marcus A. McCorison is president and librarian of the American Antiquarian Society.

Wendy Wick Reaves is curator of prints at the National Portrait Gallery.

David Tatham is professor of fine arts at Syracuse University.

Stefanie Munsing Winkelbauer is a resident of London, England.